TREASURES OF
CHATSWORTH

TREASURES OF CHATSWORTH

A private view

The Duchess of Devonshire

Constable London

First published in Great Britain 1991
by Constable and Company Limited
3 The Lanchesters
162 Fulham Palace Road
London W6 9ER
Copyright © 1991 The Trustees of the Chatsworth Settlement
ISBN 0 09 470940 8
Design by Paul Reeves
Set in Monophoto Palatino by
Servis Filmsetting Ltd, Manchester
Printed and bound in Great Britain by
Clays Ltd, St Ives plc

A CIP catalogue record for this book
is available from the British Library

Contents

Introduction

My mother-in-law asked the schoolgirls who were evacuated to Chatsworth during the war, 'How do you like living with these pictures?' After a long silence one of them answered, 'Well, you get used to them.'

Living in this house you get used not only to the pictures but to all the other ten thousand and one works of art and curiosities with which the place is littered.

'Things', as Sybil Cholmondeley used to call the matchless works of art at Houghton, have devolved upon Chatsworth from the other Cavendish houses no longer used by the family: Hardwick Hall in Derbyshire, Chiswick House near London, Compton Place in Eastbourne and Devonshire House in Piccadilly. Paintings, sculptures, miniatures, incunabula, books, plate, gold and silver objects, furniture, textiles, tapestries, china, pottery, drawings, *objets de vertu*, jewels, bronzes, antique gems, letters, firearms, diaries, estate records, carpets, prints, minerals, household necessities and oddments of all kinds, dates and descriptions are gathered under the $1\frac{1}{3}$ acres of roof.

Visitors who come to look round during the summer see the formal tip of the iceberg. As it is, they totter out into the fresh air exhausted, after three furlongs of red carpet, a hundred and one stairs up and sixty-two down, and with a strained cultural digestion. If they were subjected to inspecting six staff flats, attics, cellars, stone passages, pantries, kitchens, lamp-room, boiler-house, offices, telephone exchange, porter's lodge, store-rooms, carpenters' shop, muniment-room, dark-room, still-room, sewing-room, theatre, billiards-room, sculleries, water towers, nurseries, wash-ups, rooms full of cushions, braids, fenders and fire-irons, laundry, and fifty-nine lavatories, plus the not inconsiderable part of the house we live in, the first-aid room would have to be enlarged. Few would survive to return another day.

In spite of the floor, wall and cupboard space, there is no more room to put anything: paintings, books and furniture are stacked all over the place. Under everything there is something.

The 'things' illustrated in this book come from rooms both public and private. Some I see every day, passing them on the way to lunch or having the luck to be able to gaze at one or two in my sitting-room. Some are locked and super-locked away in what Americans call 'optimal archival conditions', and it is a puzzle to know where to find them and how to get in to look at them when at last you have hit upon the right door.

I go round the rarely visited rooms now and again to remind myself of what's where, and every time I go I see something I've never seen before. After forty years of intimacy with the house and its strange jumble of contents there are still surprises and delights — and, rarely, shocks and disappointments. The conscious and subconscious effect of living among such objects deepens with the years. It gives you an underlying feeling of quality which you learn to recognize wherever you go and which enhances the pleasure of seeing such things elsewhere.

Fashion in taste changes fast, and the longer you live the quicker it seems to whizz from one style of artefact to another. Praise is heaped on the work of some artists and craftsmen; a few years pass and their names, with some classic exceptions, are not spoken of for a while. Art historians change attributions with alarming speed. Chatsworth has kept its unfashionable

things, sometimes putting them in rooms which were not used, Calke Abbey style, and sometimes banishing them to Hardwick, only to retrieve them years later.

As each generation has added to the collections there is something to please everyone, from Egyptian antiquities to paintings and sculptures of today, and others which make people draw in their breath over their ugliness: that is Chatsworth.

The second Duke (1672–1729) was a collector from boyhood. In 1707 he succeeded to a house and garden at Chatsworth which had been made as nearly perfect as could be during the years 1686 to 1707, by his father. The first Duke's passion for architecture was equalled by his son's love of paintings and drawings. He bought liberally of works of art, including prints, medals, coins, books and engraved antique (Greek and Roman) gems, cameos and intaglios, as well as paintings of most European schools and the Old Master drawings. Most of the collection (except the medals and coins which were sold by the Bachelor Duke in 1844) is now at Chatsworth. In the second Duke's day it was kept at Devonshire House, where he granted the 'easiest and readiest' access to scholars.

The Old Master drawings acquired by him are the most comprehensive collection in private hands in this country, after the Royal Collection. Those illustrated in this book have often been exhibited at home and abroad but are not seen by visitors to Chatsworth because they are kept in cases in a darkened room of their own. For years they were hung in the Sketch Galleries behind the State Rooms on the second floor.

They were described by the Bachelor Duke in his Handbook of 1844 addressed to his sister, Lady Granville:

You now retrace your steps, and, beginning from the great staircase, you find arranged here the collection of drawings made entirely by the second Duke of Devonshire. I have classed them according to the several schools of painting; but I am sure that the arrangement must be very imperfect, and it is beyond me to make any description of the merits of this rich and valuable possession. Few things at Chatsworth are more admired. If I obtain a good account of them, written to my mind, you shall have it – but I know not to whom to apply; amateurs would run into fanciful theories, artists would be prolix. Madame de Meyendorff should really come again to do it: she used to copy here at daybreak in the summer mornings, and her admiration of the sketches was without bounds.

They hardly ever saw the light of day in my Father's time, nor in mine often, till I rescued them from portfolios, and placed them, framed, in the South Gallery below.

Before that, a very few amateurs now and then got a peep at them in London – Lawrence, Mr Ottley, Mr Payne Knight, and so on. Sir Thomas, mad about his own collection of drawings, got from me three studies by Raffaelle for the Transfiguration: there were five of them, and I retained the two best. I resisted long; but he was so very anxious, and so full of promises of devoted service, of painting anything for me, that I gave them at last. The way would have been to have given them for his life: he soon after died, and the sketches were sold with his collection.

M. Flink's drawings were bought at Rotterdam in 1723. Monsieur Crozat called them in his letters the finest and best collection he ever saw. They are all included here.

My husband Andrew's grandmother Evelyn, Duchess of Devonshire (1870–1960), wife of the ninth Duke, did a 'rescue' of another kind and put them back in their portfolios when she arrived

in 1908, to prevent further fading. My mother-in-law told me that Granny used to get them out now and again, more as a housekeeper's duty than for pleasure, flip through a box of Raphaels, put them back, snap the fastener and say, 'There — *they've* been aired for the year.'

When I first knew the house the portfolios were in specially made tables in the library. Once having mastered the mystery of the keys, our guests could take them out and enjoy them. Their great value, plus modern ideas of conservation, have put paid to such frivolity now.

Through the marriage of the third Earl of Burlington's only surviving daughter and heiress, Charlotte Boyle, to the Marquess of Hartington, afterwards the fourth Duke of Devonshire, the extraordinary series of Lord Burlington's architectural drawings came into the possession of the Cavendish family. In 1894 many of them were deposited with the RIBA in Portman Square as 'a gift in trust' or 'on permanent loan'. The definition, in this case, of this seemingly contradictory term is a strange one — while a descendant of Queen Victoria is on the British throne the drawings stay with the RIBA.

From the same source came the fascinating works of Inigo Jones — his designs for the Court masques of James I and Charles I, both stage scenery, using perspective in drawings of streets of classical architecture, and elaborate costumes worn by the kings and queens and courtiers in the performances written for them by the dramatist Ben Jonson and others. The masques took place first in the old Banqueting House in Whitehall, and, after 1622 when Jones's new Banqueting House was finished, in that incomparable building. Jones's costume designs have been the inspiration of imitators over the centuries. One of his 'sixteen pages like fierie spirits, all their PAGE 123 attires being alike composed of flames with fierie Wings and Bases bearing in either hand a Torch of Virgine Waxe' is among the most strikingly beautiful of his inventions.

Some years ago we had blown-up photographs made of both scenery and costumes, which are hung on the walls of the Cavendish Hall at Edensor. They give an air of quality to that room, which serves as village hall and is often used for stage performances.

PAGE 127 Liotard's pastel of Mrs Garrick, wife of David Garrick the actor, hangs in a bedroom in our part of the house. Her husband is opposite her, wearing the brightest blue coat you ever saw.

PAGE 129 Of the later 'works on paper' one of the most satisfying must be Samuel Palmer's *The Bellman*. Andrew bought it, and its companion *Morning*, in 1977 at the height of the Keating forgery scandal. Several skilful drawings by Tom Keating pretending to be Palmer were floating about some reputable London galleries at the time. These water-colours are a valuable addition, not only for their intrinsic beauty, but because there is little of their date in the collection. *The Bellman* was painted in 1881, the year before the artist died. It illustrates a passage from Milton's 'Il Penseroso':

And the Bellman's drowsy charm
To bless the doors from Nightly harm.

The collecting passion seems to have died down after the death of the sixth Duke in 1858. Anyway his princely extravagance had to be put to rights by a period of quiet. His heir, grandson of his uncle, was more interested in business and his vast land-holdings than the arts. He started industries in Barrow-in-Furness and elsewhere, which prospered to start with. When circumstances turned against them and they suffered heavy losses he bolstered them up with his own money till he was more worried about financial problems than his predecessor had been. Had he bought contemporary works of art — that is, the Impressionists — instead of investing in

industry, imagine what it would have meant to Chatsworth.

PAGE 207
PAGE 209
PAGE 205
Nevertheless, the seventh Duke added the volumes of Humboldt, Gould, Joseph Wolf, Malherbe, Elliot and other large works on natural history. Perhaps his most exciting purchase was the double elephant folios of John James Audubon's *Birds of America* – four of the most prized volumes in the library.

His son, the eighth Duke, was absorbed in politics and found his relaxation in racing. He was not at all interested in his possessions, treating them as part of the furniture. He unwittingly added a picture which in the 1990s is high fashion and loved by all – the Sargent portrait of PAGE 59 the Acheson sisters, his wife's grand-daughters by her previous marriage to the Duke of Manchester. For years this cheerful picture of three girls with figures like dream models and dressed in full *belle époque* fig was banished by Granny to a back passage or sometimes lent to a PAGE 53 gallery. Now, with the Reynolds of Georgiana and her baby, it is the star of our drawing-room.

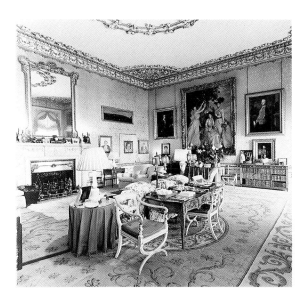

*The Blue Drawing-Room
in the private apartments*

The dismal task of the ninth Duke (1868–1938) was to sell rather than buy. Death duties began to be a force to be reckoned with, and out went the First Folios of Shakespeare's works, and Caxton's printed books. They literally went west as they were bought by the Huntington Library in California. Devonshire House in Piccadilly was sold to a developer (1920) and Chiswick House was handed over to the tender mercies of Brentford Council (1929).

The family still did the annual rounds from Chatsworth to Lismore Castle in Co. Waterford, Hardwick Hall, Bolton Abbey, Compton Place and London. They took No 2 Carlton Gardens after Devonshire House was sold, and the 'London' furniture and pictures looked fine in the big reception rooms of a house built more for entertaining than bringing up a family. A quantity of these have found wall and floor space at Chatsworth. Some of the others from Hardwick (handed over to the government in lieu of death duties and given by them to the National Trust), Compton Place (now let to a school), 2 Carlton Gardens and Chiswick House have also come to rest at Chatsworth.

There is no plan over the arrangement of rooms here. Furniture and ornaments find their place by luck rather than good management. Dates, colours, shapes and styles shake down together: polished and painted, wood and stone, silk and wool, patched and new, glass and china, English, Dutch, French, German, Russian and Italian are side by side, creating a nightmare for an interior decorator with a preconceived scheme.

However, so powerful is the atmosphere of the house itself that it seems to answer. Perhaps the reason is that furniture and decorative objects of different origins can exist together in harmony as long as the common denominator is quality.

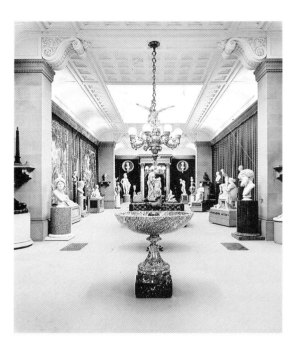

*The Sculpture Gallery
in the North Wing*

From Ancient Egypt to Epstein, sculptures are a trademark of Chatsworth. The sixth, the Bachelor Duke (1790–1858) as he is always known, was the man whose love of stone and the wonders which spring from it was responsible for the portraits in marble by artists of his own time. He bought antiquities as well as contemporary works, Egyptian figures and steles, Greek and Roman figures, a Greek altar of the second century BC, a sarcophagus of the fourth century BC, the Colossal Foot and many fragments, all of which are at Chatsworth.

PAGE 67

A Sculpture Gallery is part of Wyatville's wing of the 1820s. It was built to house the majority of the sixth Duke's purchases and commissions of contemporary works, including the Canovas illustrated in this book. Its creator describes it himself:

My Gallery was intended for modern sculpture, and I have almost entirely abstained from mixing with it any fragments of antiquity: it was vain to hope for time or opportunities of collecting really fine ancient marbles. In addition to the statues, my wish was to obtain specimens of all the rare coloured marbles as pedestals for them. Some persons think that the

columns, vases, &c, should be removed, as diminishing the effect of the statues. It may be so, but I am too fond of them to make the change. . .

PAGE 83

Campbell took about fourteen years to complete the statue of the Princess Pauline Borghese: she sat repeatedly to him for the bust, and gave him casts of her hand, foot, and nose. She was no longer young, but retained the beauty and charm that made her brother strike the medal in honour of the Sister of the Graces. Campbell used to bring his modelling clay to a pavilion in the garden of her villa, close to the Porta Pia. It had a little door opening to the street, independent of the entrance, through which Jerome Bonaparte and his wife came to see the progress of the work. The Princesse de Montfort was a sister to the King of Wirtemberg, very like our royal family — mother to the charming Princesse Mathilde, who has married Anatole Dimidoff. The little luncheons on those occasions were delightful: for the Princesse Borghese, when compelled not to talk about dress, was extremely entertaining, and full of the histories of her times. . .

PAGE 79

Canova kept the large bust of Napoleon in his bed-room till his dying day. He finished it from the study of the colossal statue, now in the possession of the Duke of Wellington. Lady Abercorn, who was a great friend, bought it immediately after the death of the Abbate Canova, his brother, and left it by her will to me. I know of no other authentic bust of Napoleon by Canova; and I believe that none exists, though everybody calls their own so.

PAGE 81

Madame Mère! first acquired treasure, next to Endymion the most valued! Renouard, a French bookseller, negociated the purchase for me at Paris in 1818. Canova made no repetition of it; but, after his death, Jerome, Prince de Montfort, got Trentanove to copy the original cast in marble, and that or another copy saw I in Palazzo Bacciochi at Bologna. But Canova was truth, and he told me there was no other by him. The old lady herself used to receive me at Rome, and rather complained of my possessing her statue, though my belief is that it was sold for her advantage. . .

PAGE 85

I conclude with Endymion.

If evidence were wanting of its having been finished by Canova, I have plenty of letters in my possession that establish that point; but none can be required when you contemplate the admirable perfection of the work. The quality of the marble is so fine, so hard, so crystalline, that Canova would not change it on account of the stain in the arm; that on the cheek he liked, and thought it represented the sun-burnt hunter's hue. He had often inquired of me what subject I preferred, and which of his works, and I told him always the sleeping Genius of the Archduchess Christine's tomb at Vienna, and also the Genius on Rezzonico's monument. He accordingly promised me something that I should like still better. I had really attached myself to him very much; and it was with mingled feelings of grief and exultation, of boundless admiration and recent bereavement, that I first saw my group in the well-known studio, where I had passed so many happy hours with the most talented, the most simple, and most noble-minded of mankind.

What anxiety for its voyage to England! A cast of it, sent from Leghorn to Havre, was lost at sea: it was to have been copied in bronze at Paris. In other respects, good fortune has attended all my cargoes; and the contents of this room afford me great satisfaction and pleasure, and are among the excuses for an extravagance that I can neither deny nor justify, nor (when I look at Endymion) repent.

The Greek altar was put in the garden south of the Great Conservatory. Evergreen shrubs —

laurels, *Rhododendron ponticum*, hollies and more – grew unchecked in this seldom visited place. In 1987 we began to clear the impenetrable thicket and, lo and behold, what should we discover but the altar. On it had been put a headless Victorian statue. The relentless growth of the surrounding rhododendrons had pushed it to the ground. Both altar and statue were green with mould from the continual damp. Now the altar has a place of honour above the hundred steps we made on the steep bank from the Conservatory garden to the turf drive above. The torso of the statue has been reunited with its head, which was found in an outhouse.

PAGE 89 Epstein's portrait head of our daughter Sophy (1959) was the penultimate to be finished by him. He died a month after it was cast. She was two years old when she 'sat' to him and to persuade her to stay still for minutes at a time was almost impossible. Our Nanny was a masterly story-teller, but even her ingenuity was highly tested during the sittings. Epstein himself was captivated by her tales and they made great friends.

PAGE 69 The seated Mother and Child (Roman, first century AD) in the North Front Hall where visitors start their tour is pushed into a corner and probably noticed by very few. Those who do glance her way usually think it is a Victorian copy because it is so well preserved. The Bachelor Duke bought this one at the Wanstead sale in 1822 for £105. I am told that seated portraits of Roman women are very rare.

The series of portrait busts by Angela Conner were commissioned or bought by Andrew in the 1970s. On the West Stairs you can see moustached and bespectacled Roy Strong (then Director of the V & A, and Angela's first attempt at a portrait), Harold Macmillan, Lord Goodman, John Betjeman, Paddy Leigh-Fermor and Andrew. A self-portrait followed, and a bust PAGE 91 of Lucian Freud, which is illustrated in this book. Lucian's head is near his big picture of his PAGE 61 mother and a bare-bosomed girl, called *Large Interior W1*, which Andrew bought in 1974. You sometimes hear tut-tutting over her breasts from the visitors, who never murmur at those of Tintoretto's *Delilah* which they have passed on the stairs and which are just as explicit. But I must say Delilah's are prettier.

PAGE 77 *Samson Slaying a Philistine*, a seventeenth-century masterpiece in lead, after Giambologna, is, at the moment, in a gap in the yew hedge of the rose garden. We moved it from its more central position there to allow an uninterrupted view from the terrace below the Display Greenhouse across the Salisbury Lawns up the Serpentine Hedge to Campbell's bust of the Bachelor Duke on its plinth of Sunium marble. Perhaps Samson, about to bash the poor Philistine with terrifying Old Testament violence, will find himself the focal point of a garden made on purpose for him before long.

PAGE 67 The well-named Colossal Foot in the Chapel Passage was long thought to be a Victorian copy of a classical original. A few years ago its pair, the right foot, was found in the cellar of a museum in East Berlin. Now the cornless, bunion-less left foot in a Dr Scholl-like sandal is said to be Hellenistic and made about the time of the birth of Christ. In spite of its great weight, it made the journey to Washington for the famous 'Treasure Houses of Britain' exhibition in 1985/6.

PAGE 71 The half-figure of a man holding a scroll in the Painted Hall is passed by our visitors with hardly a glance when they first enter that lofty room with their eyes on the painted walls and ceiling. He is Roman, third century AD, unrestored and in pristine order.

There are heads, bodies and legs all over the house and garden: dogs, chickens, goats, gods, boars, lions and a wolf, as well as worthies and other humans. The older I get the more I understand why the Bachelor Duke loved them so. Vases, urns, columns, a marble bath or two

and washing-up basins in materials from granite to Blue John are scattered all over the place.

No group of objects has been subject to such a major turn-around of taste in my lifetime as have nineteenth-century neo-classical sculptures. Forty or fifty years ago they were scoffed at and totally disregarded as works of art. All of a sudden they began to be talked about in a different way, and their values have soared. The present generation of arty folk would be astonished to learn that the whole of the silent population of the Bachelor Duke's Sculpture Gallery, in which repose works by Thorwaldsen, Gibson, Barużzi, Schadow, Finelli, Tadolini, Tenerani, Bartolini, Gott, Kessels, Chantrey and Westmacott, as well as six Canovas, was valued for death duties in 1950 at a few hundred pounds.

They are prime examples of the swings and roundabouts of taste. The statues haven't changed; their critics have.

We have started a programme of conservation of works in stone and lead, specially those which are out of doors. Some which Granny disliked and banished to the garden have returned to the Sculpture Gallery. The bulkiest removals were the immense lions she put on the garden side of the doors to the Orangery, now back in their original positions in the Gallery. They are copies by Rinaldi (the *Sleeping Lion*) and Benaglia (the *Crouching Lion*) of those by Canova in St Peter's, Rome. The latter weighs 3½ tons. Now they crouch and sleep without getting cold and wet. I didn't dare watch the move.

PAGE 65 Even lead and granite suffer from the weather. This year *Hercules*, the *Gladiator*, and *Pan*, whose battered body lay by the back door for twenty-five years, have returned in a fine state of health from the lead-restorer. The two Sekhmet lion goddesses with heads of lions and arms, bosoms and presumably legs of women (though it is hard to guess what happens under their granite skirts), are of great antiquity, being nearly 3,500 years old. The Bachelor Duke writes of them in the garden: 'Here are two statues in red and black granite from the great temple of Carnac, sent home by a famous traveller and purchased by me in the New Road.' In 1991 they have been brought to a warmer, drier home in the Chapel Passage where their powerful personalities, as well as their size, make themselves felt in no uncertain way.

The first Duke was not a serious collector of pictures, but he bought a few 'easel' paintings, perhaps including the Vouet which somehow escaped its three mates in the Louvre and, typically here, is hung sky-high over a door on the West Stairs.

We owe to the first Duke not only the best part of the house itself but also the display pieces of silver and silver-gilt made by the refugee Huguenot goldsmiths of the time of William and Mary. He was a fervent supporter of that King and Queen and received a dukedom in 1694 for his part in bringing them to the English throne.

PAGE 139
PAGE 137
PAGE 141 The silver-gilt Dutch pilgrim bottles (1688) were copied from the medieval leather water-bottles carried by pilgrims. The twenty-three piece toilet service by Prévost (1670) bearing the arms of the King and Queen was generously given by them to the Duke. The perfume-burner of 1690, whose maker's mark is before the beginning of the Goldsmith's Hall registers, is thought to be the work of a Huguenot silversmith. It is said to be the largest and heaviest English example of such an object. Does that matter much?

PAGE 143 The massive silver chandelier which hangs in the State Dressing Room must have been in the making at the time the fourth Earl of Devonshire became a Duke because it has both earl's and duke's coronets represented on it. This weighty object has a wonderful travelling-box, a

Brobdingnagian jewel case, for the journeys by coach from Devonshire House in London to Chatsworth and back, with sometimes a spell at Hardwick on the way.

The gold and silver cupboards are in the bowels of the house. They are cheerfully lit so their contents are a joy to look at. They range from the precious objects above to many a spade and trowel which have dug first sods and laid foundation-stones. In 1947, when there were no toys to be bought, we took a couple of trowels and a heavily engraved miniature silver spade to the seaside so the children could build sandcastles. There is a huge leather dog-collar for Hector, a mastiff belonging to the sixth Duke. It is silver-mounted, with the name of its owner engraved upon it, the inevitable coronet and snake, and a silver padlock and key to fasten it. The collar weighs nearly 3 lbs.

Baize-lined drawers in wooden chests hold row upon row of knives, forks and spoons. There are services of silver and silver-gilt plates and dishes, some with the royal arms, perquisites of various Devonshire Lords Chamberlain, and many curiosities. Among them is a set of gilt dessert knives and forks with green glass handles, a fearful hazard when it comes to washing up.

PAGE 177

Of this century there is a Fabergé box with a picture of Chatsworth on the lid, given to Granny by Queen Mary, whose Mistress of the Robes she was.

The latest addition is the silver-gilt King George VI and Queen Elizabeth Stakes cup won at Ascot by Andrew's horse Park Top in 1969, as well as the fruits of some lesser triumphs by that remarkable mare.

A quantity of silver is put out on show when the house is open. The silver steward who looks after it spends his working hours cleaning and polishing in his subterranean den, and I hope you think the result of his labours is more than satisfactory.

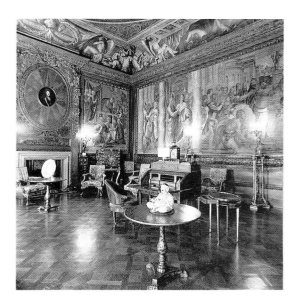

The State Drawing-Room
on the second floor

Furniture and all things wooden, like everything else, have been picked up here a .ere by fourteen generations of acquisitive Cavendishes. Unlike the contents of some of the greatest houses in England, such as Harewood House and Houghton Hall, where most of the pieces were

PAGE 229 made for the positions they still hold, ours are a hotch-potch of dates, makers and nationalities.

Even the State Rooms are full of variety. In the State Drawing Room a Roentgen desk, c. 1780 and French to the core (in spite of its German maker), rubs shoulders with a set of 1730 very English, Kent-like chairs, plus some coromandel chests. The latter were originally used to panel the walls of the State Dressing Room. Later they were made into cabinets and have been ferried to Hardwick and back several times over the centuries. Their tops show signs of damage by over-watering vases of flowers rashly put on them years ago.

PAGE 227 Here are the coronation chairs of King George III and Queen Charlotte, confections of carved frames and silk covers blending together in a pale gold haze. They were perquisites of the fourth Duke as Lord Chamberlain, and arrived with no reminder necessary to the royal household.

Two reigns later things were not so straightforward. The vast coronation chairs of King William IV and Queen Adelaide were also destined for some Devonshire house as the sixth Duke was their Lord Chamberlain. The Duke wrote:

> The Majesties of William IV, and Adelaide the charitable were crowned in Westminster Abbey in those two chairs. After the ceremony, during which I was Chamberlain, I thought they would, almost of their own accord, drop into the State Rooms here, because their predecessors, that held George III and the virtuous Charlotte, had stared me in the face here all the days of my life: and that the 'Prince of Whigs' (so called by the King's mother, when he was humbled – qu., honoured? – by being dismissed from Lord Bute's Council) should have permitted the tokens of his servitude to remain here appears to me to have been an exemplary condescension.
>
> However, the chairs did not arrive spontaneously; and really had it not been for the cordial advice of the dear old fat Princess Augusta, I should hardly have encountered the difficulties made to prevent my obtaining them. The official underlings actually got the Queen's chair placed in the House of Lords, under the canopy, as if there was no other to be had for the purpose. Nevertheless, here they are, and in my turn I was turned out myself; and you remember well that it was in good company, with Lords Lansdowne, Holland, Melbourne, &c. When pressed to reassume my place with them, I had learned by experience my unfitness for it; and that, though the indulgence felt by George IV towards me led him to think me the best of servants, and to ask those who displeased him how they could be so un-devonshirelike, those qualities might be less apparent to the bluff and unkinglike William.
>
> Experience had also taught me no longer to mistake affection for loyalty. On one of the chairs reposes a souvenir of Queen Victoria's, a cushion on which I carried one of the Swords of State. To conclude the confidences into which these chairs have led me, let me farther illustrate my feelings on the subject by declaring to you, that die, as I certainly would for Queen Victoria, so would I also rather do, than become her Chamberlain.

He describes the carving in the State Dining Room:

> It dined in, that I know of – the first room of this great unappropriated apartment, which c ...nes in useless display the best habitable part of the house. What bed-rooms might have been made here, with the South sun, and beautiful views! I was much tempted, but finished conservatively by repairing the sinking floors and threatening ceilings; and, as a

museum of old furniture, and a walk in bad weather, I am well contented to retain this dismal ponderous range of Hampton Court-like chambers.

Gibbon [i.e. Grinling Gibbons] is generally believed to have been the carver employed here. Whoever carved, his triumph is in this first room: the game, fish, and fruit, over the chimneypiece, are perfection. I hope to find Gibbon's receipts, or some proof of his having served, but at present there is none; and Mr Ashton who was Sir Jeffry's foreman, and succeeded him, has sent me a most curious collection of papers, formerly entrusted to Sir Jeffry, in which I find that Talman, the surveyor and architect, had employed Thomas Young for carving in 1688, and in 1693 Joel Lobb and Samuel Watson, who engaged to finish the carving of the Queen of Scots' apartment, and not to work at the South rooms till that was done; and in 1694 they received 'my Lord his Grace's order to buy Limetree, to finish the carving in the great chamber'. The oak boards for the floor for the upper story were ordered in 1689.

In the winter of 1990/91 the carving, where dried out and brittle, or dotted with holes made by woodworm, was painstakingly restored by Neil Trinder and his team. They laid out sheets of white paper on which were written what the sometimes unrecognizable damaged pieces were — '. . . stalks, leaves, fruit, fins, claws, beaks, feathers . . .' Where each tiny piece was taken down a spot of white paper with the corresponding number to that of the ailing fragment was lightly stuck on the base of the carving. After treatment, all the bits of fruit, fish, birds and flowers were returned to their places with, I hope, another hundred years of existence in front of them. When they are dusted, they are not touched, but the dust is gently blown off them.

PAGE 217

I heartily agree with the Bachelor Duke's description of Boulle furniture: 'After the peace in 1814 there came a rage for collecting and repairing the old furniture called Buhl: cabinets, tables and pedestals, were sold at enormous prices, and some fortunate people found their garrets full of the commodity, rejected by the changes of fashion in decoration. One of these tables was found here, another in a lumber-room at Chiswick, and another was bought for me by a lady as a wonderful bargain at £140. They are, after all, a disagreeable possession; beautiful when newly furbished up, but apt to soil, and to get broken, from parts of the inlaid work that will start, however discreetly rubbed. I have done with collecting Buhl goods.'

PAGE 213

It is indeed a liability in its delicate construction, and looks to me too foreign to settle in an English house. I feel the same about the Florentine cabinets of *pietra dura*, not beautiful to me but admired, I know, by some.

The English furniture, on the other hand, is wonderful to look at, suited to its surroundings and a proper part of the indoor landscape wherever it is found. Much of it is of the date of William Kent, friend of Lord Burlington and designer supreme.

In the State Dining Room are a pair of walnut and parcel-gilt armchairs decorated with carved eagles' heads, made about 1730. It is difficult to know how and where to place such exceptional objects as these. We have tried all ways and ended as we began by putting them side by side, facing the music as it were, with no suggestion of anyone's using them for the purpose for which they were made, that is, to sit on.

The brown leather upholstery on one of them is in better condition than that on its pair and reminds me of the continual debate as to whether coverings should be renewed or not. People feel passionately either way, and when the leather on the George II chairs and settees in the Painted Hall began to disintegrate, with heaps of ancient cotton wool escaping from the gaps —

a depressing sight – someone had to decide what to do about them. I heard a man say to his wife, 'It looks as if they need a new three-piece suite.' Still, some people said, 'Leave them as they are.' We have taken the plunge and had them all re-covered. It won't be long before light (the enemy, or in this case perhaps the friend) and wear and tear change their dangerously new look.

PAGE 229 The Roentgen desk in the State Drawing Room, and its chair, have been joined by a side table by the same *ébéniste* which I found in the bedroom of a footman of yesteryear. Several prized pieces on show have turned up in unexpected places. Granny found the bedside tables now in the State Bedroom in the postillion's lodgings over the stables.

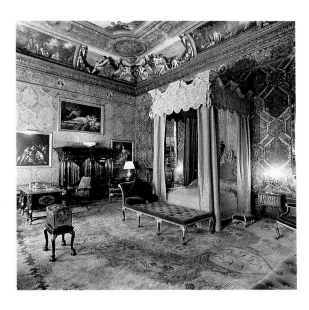

The State Bedroom
on the second floor

Chatsworth has sixty-four clocks to be wound every week. During the years that the house was empty, after the school left in 1946 till we moved in in 1959, the clocks were kept in working order by the house carpenters. It was strange to come into the cold, deserted rooms and hear the chimes sounding in unison at midday.

People who are unaware of other clockmakers know the name of Thomas Tompion. Chatsworth has two examples of his work. One, in a walnut long-case, is more or less lost in the crowded scenery of the South Sketch Gallery, only drawing attention to itself at striking times. I have a friend who is such a light sleeper that her night is ruined by a clock several rooms away. Even ticking makes her nervous, so it is as well that the State Bedroom is no longer used for guests (it was until 1939) or there would be loud complaints in the morning about poor Tompion's work.

PAGE 231 In the Queen of Scots Dressing Room is the *lit à la Polonaise*, a grand and comfortable single bed, its domed canopy filled with swags and bobbles of blue silk only visible to the prone occupant. It is covered with the glazed chintz I love above all others and which I have never seen outside Chatsworth. Several rooms are blessed with curtains and bed-hangings of this design, including my own bedroom: sometimes the ground is white, sometimes pale yellow.

Little chrysanthemums and dahlias make the 'filling' – the main part of the design – and the deep borders, which are woven in one with the filling, are huge, exuberant, blowsy peonies: the best of high summer preserved for ever in the very English chintz.

PAGE 225
On the landing of the Great Stairs there are three prams – you could say three extraordinary prams. The one designed by William Kent for the third Duke's children is made for a goat to pull. The leather collar and iron, leather-clad traces, which also do duty as shafts, and the springs, are in the shape of snakes. The lucky baby sits in a shell under a crimson hood with miniature carriage lamps outside. Cleaning the gilded wheels after a muddy walk would be the last straw for a modern nanny. Neither would she relish looking after the goat.

PAGE 219
We moved the glorious *verre églomisé* looking-glasses from a dim bedroom to the Yellow Drawing Room where they shine and glitter to rival the glass chandelier. The imagination and the application of the inventor of the intricate process by which they are made are surely second to none. The mottled tortoiseshell red in the glass sandwich goes exactly with the red in the silk on the walls (copied from the Bachelor Duke's wall-hangings, which had died from 135 years of south light, by Stephen Walters of Sudbury in 1990), and the gold goes with everything.

PAGE 235
The last two pieces of wood make one question whether they are the work of a human hand. They seem as if they must have been carved by some supernatural artist using magic tools. Grinling Gibbons's lace cravat, as fragile as a wren's skeleton, is surrounded by willow leaves, pea-pods and a self (?) portrait in a medallion. It is the only authenticated work by him in the house, but, as the Bachelor Duke says in his notes, I wouldn't be surprised if papers turn up some day which give his name to other carvings here. This one is worthy of a long, long stare and the longer you stare at it the more you must marvel at what you see. It is carved in lime.

PAGE 233
How and why did Henry VIII's rosary find its way from the royal collection to the strong-room at Chatsworth? You might well ask. Presumably it escaped from its regal owner after the Reformation. Several decades later it belonged to the Jesuit Père de La Chaise (of the Paris cemetery fame), confessor to Louis XIV. It remained the property of his Order till 'when their goods were sold, it was bought by the Abbé Brotier, editor of Tacitus; and the nephew of Brotier sold it to Messieurs Rundell and Bridge, and they to me. It cost – £200. Was that much or little?' wrote the Bachelor Duke. The rosary is made of boxwood.

The worth in money of a unique object is not known because there is nothing to compare it with. In mentioning the price the Duke foresaw a touch of the present-day media who are only interested in money (and scandal). If you are foolish enough to submit yourself to an interview on radio or television and they don't smell a scandal, you may be sure money will be the topic they prefer.

PAGE 223
Furniture does not escape the regular re-attribution by experts and I have to be careful to remember the latest name in the maker's game. The 'owl' desks and mirrors, or more correctly pier glasses, are in a passage on the way to lunch and so enter the subconscious every day. They were made in 1735 for Lady Burlington, born Savile, whose family crest is an owl. William Kent designed them, John Boson made them: that's the latest, anyway. They used to be attributed to Benjamin Goodison, and then to William Vile. The Duchess of Beaufort, showing some friends similar pieces of furniture at Badminton, said, 'They're Vile.' Her friends answered, 'Oh, d'you think so? We think they're lovely.'

Goodison, Vile, or Boson, mahogany and gold, they're lovely all right.

PAGE 215
Further along the passage are a pair of walnut and 'seaweed' marquetry cabinets of Dutch origin; made about 1700, so most probably bought by the first Duke. They give the necessary

height to their long thin situation and if you stop to look carefully at them you will be astonished at the delicacy of the workmanship, the way the darker-coloured inlaid woods make the overall pattern, the ease with which the drawers pull in and out, and the tiny locks and keys which work effortlessly.

Either Andrew's grandmother or his mother, I can't remember which, used to say in a vague sort of way, 'The trouble with Chatsworth is there's no china.' True, there is a nasty lack of Chelsea cauliflowers and cabbages or Blind Earl of Coventry dessert plates, but you don't have to look very far to find pieces to please most tastes.

PAGE 169

I retreat at once from trying to describe the Oriental pieces. The lack of appreciation of such objects is my loss, I know, but I cannot see the beauty of the Japanese carp, their bulldog heads sprouting horns and a few other things, and the Chinese pottery teapots might have come from the sixpenny stall at the WI jumble sale for all I could guess. Crass ignorance, I am afraid, but I don't know any better.

PAGE 161

The European stuff is a different cup of tea, starting with the Italian Medici Cruet of 1580. The idea of the Medicis having a cruet seems indescribably comical. However, it is not a cruet as we understand the word, but a vessel for oil and vinegar. This curious object is on loan to the Fitzwilliam Museum in Cambridge and I have only seen it once.

PAGE 171

The Berlin dinner and dessert service of more than 200 pieces, plus a chest of silver dessert knives, forks and spoons with china handles from the same factory, belonged to Warren Hastings, Governor-General of India. He lived at Daylesford and so was a neighbour of Lord Redesdale at Batsford, near Moreton-in-Marsh. Hastings was forced to sell much of the contents of his house in 1795 to pay for his seven-year-long trial and Redesdale bought half of what must have been an immense number of pieces of this service. Who bought the other half I don't know.

In due course my father inherited it. My mother used it on special occasions, including the rough-and-tumble of ball suppers. As we were six girls in our family there were a number of these entertainments and no doubt there were breakages.

My only brother was killed in the war and without him my father lost what little enthusiasm he had for possessions. He sold his French furniture and much more besides. The Berlin service appeared in a London sale-room in 1948. Having always known it and having always been fascinated by it as a child (specially by the insects painted over faults in the china on the underside of the plates), I persuaded Andrew to buy it. We were afraid his father would see a line or two which appeared the next morning in the *Daily Telegraph*: 'Lord Hartington pays top price at Sotheby's', thinking it a ridiculous extravagance. Luckily nothing was said. It is a continual pleasure to see it around. It cost £400. In the words of the Handbook, 'Was that much or little?'

PAGE 173

The Bachelor Duke commissioned the Derby service about 1815. The plates are decorated with paintings by Robert Brewer of the Cavendish houses, their parks and gardens. Thick and heavy, with deep blue and gilded rims, some of them held together with old-fashioned rivets, they are lovely to look at and to eat off.

The original round water-colour designs for the plates are framed, and hang in a dingy passage for anti-fading's sake.

There is a great deal more, from Sèvres, Vincennes and the thinnest, see-through Belleek to

cupboards full of giant lids with handles of radishes and mushrooms whose dishes were smashed in games of Steward's Room football many years ago.

PAGE 175 More curiosities turn up under the sweeping title, *objets de vertu*. The Kniphausen Hawk of 1697, a bird encrusted with garnets, amethysts and citrines, perched on a turquoise-studded rock, turns out to contain a silver-gilt drinking-cup which you find by unscrewing the poor thing's head. You can make the hawk look in any direction by twisting his neck till he fixes you with his predator's eye. German-born, he flew from his Dutch nest in the eighteenth century. It is thought the Bachelor Duke must have bought him, because his next appearance was at the Great Exhibition of 1851, lent by the Duke.

Some years ago the then Baron Kniphausen wrote asking Andrew if he could buy back his hawk. But he is not for sale.

PAGE 237 In which section of this book do you place a toy tinplate aeroplane of 1909? It is not furniture, neither is it a sculpture, a book, a painting or even an *objet de vertu*, but it drives old-toy people into paroxysms of excitement. Michael Pearman, librarian at Chatsworth, found it in a cupboard under the Great Stairs about ten years ago. It is untouched by childish hand and is in good enough order to fly the Channel with a miniature Blériot in the cockpit. I believe the only other one like it was once in the nursery of the King of Siam, or should I say Thailand.

PAGE 181 The set of jewellery known as the Devonshire Parure is a combination of 'antique' and sixteenth-century engraved gems, cameos and intaglios. They were mounted in high Victorian settings of gold and enamel by C. F. Hancock, designer of the Victoria Cross. Hancock was inspired by the Renaissance style for this work, which was commissioned by the Bachelor Duke for his niece by marriage, Lady Granville, to wear at the coronation of Tsar Alexander II in Moscow in 1856. The workmanship and beauty of the individual gems are a little lost in the medley of colours and shapes in this extraordinary display of finery. They are not easy to wear now because the settings were designed to go with the Court dresses, veils, trains and complicated hair-dressing fashionable in 1856.

Once I wore some of them for a Women's Institute jollification when I was the Oldest Miss World In The World. They are very prickly; Lady Granville must have been sternly brought up on the theory that you have to suffer to be beautiful as the balls and festivities in Moscow were marathon events and these hedgehog-like bits of jewellery must have made holes in her head and neck.

PAGE 183 The big diamonds were taken out of their settings in the parure to make the tiara illustrated in this book. It was made for the 'Double Duchess', the German-born Louise von Alten, who was the widow of the Duke of Manchester when she married the eighth Duke of Devonshire in 1892.

Louise was the hostess of the celebrated Devonshire House Ball held in honour of Queen Victoria's Jubilee in 1897. It was described in a book by my daughter, Sophy.* That night the crowds of guests in fancy-dress wore enough jewels to sink a ship. Louise's tiara was one of the biggest. It is fender-type, that is to say it is high all round and doesn't disappear into a band under the hair. Once fixed on your head you can't pretend it isn't there; it shows. Years ago, in all innocence, I wore it for dinner and a dance at Windsor Castle. Imagine my humiliation on

* *The Duchess of Devonshire's Ball* by Sophia Murphy, published by Sidgwick & Jackson, 1984.

arriving in the drawing-room to find I was the only woman wearing a tiara. I had to bear it at dinner, but as soon as the dancing began I took it off and put it under a chair.

I suppose Windsor is the only house where you could be sure to find such an object again when it was time to leave.

My mother-in-law was Mistress of the Robes to the Queen and wore the tiara at the coronation in 1953. Anyone who saw her fulfil her important role during that lengthy ceremony will never forget the impression she made in her robes of velvet and ermine, her beautiful head decorated with the shining diamonds of this tiara: all exactly right for her, and for the occasion.

Eight of the paintings chosen for this book are from the rooms open to the public and ten are from our private rooms. They span five centuries, from Veronese (b. 1528) to Freud (b. 1922), and include artists who were Flemish, Italian, French, Spanish, German and English.

Most of the Old Masterpieces of painting at Chatsworth were bought by the second Duke and the collection was vastly enriched by the addition of the third Earl of Burlington's possessions in 1753. The third Duke added several of first importance, notably Rembrandt's *King Uzziah Stricken with Leprosy,* and he was left the Van Dyck of Arthur Goodwin MP in the will of his friend Sir Robert Walpole.

PAGE 45 AND PAGE 51

On Lord Burlington's death in 1753 his many houses and possessions came to the Cavendishes through the marriage of his daughter and heiress Charlotte to the fourth Duke. The two Frans Hals portraits of the man and the woman have come together through this alliance. We don't know which originally belonged to Devonshire and which to Burlington, but now they cohabit peacefully under the same roof.

PAGE 41

After the death of the third Duke, buying of Old Masters more or less ceased but the family were painted by the fashionable artists of their day. They have given us some memorable portraits.

The indolent fifth Duke was painted lolling against a marble column in Rome by Pompeo Batoni. He is dressed in scarlet and bright blue, totally eclipsing his brother Lord Richard Cavendish, by the same artist, in drab coat and waistcoat as befits a younger son.

PAGE 53

The fifth Duke's famously charming wife Georgiana Spencer and their baby daughter by Sir Joshua Reynolds is one of the artist's best-loved works. It has been reproduced in many forms and people seeing the original for the first time greet it as an old friend. Twenty-five years earlier Reynolds painted Georgiana as a baby with her mother Lady Spencer, and he made another likeness of her as well as a portrait of Lady Elizabeth Foster, her husband's mistress and mother of two of the Duke's children.

PAGE 55

Maria Cosway's romantic picture of Georgiana emerging from a cloud was said by her son the Bachelor Duke to remind him of his mother more than any of the other portraits of her; and for this reason (and because it is very big and covers a silk-less bit of wall) it has a good place.

In the parade of faces Lady Caroline Lamb (1785–1828) by Thomas Phillips stands in footman's clothes ready to serve grapes to whoever will take them. Her irritating little face shows no signs of the madness which came later to ruin her life and make miserable her husband and relations.

The Bachelor Duke was often painted. My favourite likenesses of him are Reinagle's, which shows him shooting woodcock in the Old Park at Chatsworth with a friend, gamekeeper and spaniels, and Landseer's portrait of him in a box at the opera, the programme balanced on the

ledge in front. He commissioned many portraits of friends and relations, none of them of outstanding merit but all redolent of their time and fashion.

PAGE 57 Some of the most attractive portraits are of dogs. The Landseer court scene of 1842 called *Trial by Jury*, or *Laying Down the Law*, gives the dogs human characteristics and their roles as people are easily recognizable. The poodle sitting in a grand red chair, his beautifully painted paw holding down a page of an open book and his spectacles to hand, is the judge. The lawyers, officials and jurors are a motley collection: a bulldog, greyhound, black retriever, deerhound, bull terrier, mastiff, spaniels, and an Irish terrier. Bony, the Duke's beloved Blenheim spaniel, was painted in at his master's request. Perhaps this picture is the forerunner of the humanized animals, dressed in pinnies and frock-coats, which soon began to appear: a cult started in earnest by Beatrix Potter and still going strong.

Watts, Millais and de Laszlo produced the necessary portraits of the seventh, eighth and ninth Dukes. One of Sargent's least successful efforts is of Evelyn, wife of the ninth Duke. Painter and subject obviously did not hit it off. My father-in-law sat to Sir Oswald Birley, my mother-in-law to Sir James Shannon. Andrew appears in his robes as Chancellor of Manchester University by Theodore Ramos, and I hang in the same row by Pietro Annigoni.

Some very different images by our old friend Lucian Freud are in the drawing-room. Andrew, his mother, his sisters Elizabeth Cavendish and Anne Tree, our son and myself are hung in a group. They never fail to get a reaction, usually violently for or against.

Lucian doesn't like his sitters (or anybody else) to see a painting before it is finished. He works slowly, and I don't know how many times I went to his house till *Woman in white shirt* was done. Eventually Lucian told Andrew he could have a look. When he arrived at the studio a workman (or was it a bailiff?) was already there. Andrew looked long at the painting till the man asked, 'Who is that?'

'It's my wife.'

'Well, thank God it's not my wife,' he said.

The Bachelor Duke wrote in 1844: 'The books comprise four libraries. One I found here, another in London, the third was Mr H. Cavendish's [the scientist, 1731–1810] and the fourth Dampier, Bishop of Ely's.'

He altered the gallery at Chatsworth to receive his books. 'In 1815 I began to pull out the panels, and convert them into bookcases, by doing which I not only endangered the security of the walls, but approached certain flues much too nearly. For books the room is now well suited.'

The library is my favourite room, lined from stem to stern with leather and gilt bindings in bookcases of mahogany with narrow brass pillars. The curtains of red and green cut velvet have been there for 150 years. With a coal fire on a winter's night it is about as pleasant as a room could be. If the sofas were more comfortable I could happily sleep there.

PAGE 187 The Bachelor Duke lovingly arranged his thousands of volumes himself – booking, he called it; and he was always adding to them. He bought left and right in the 'insane days of the Roxburghe sale' in 1812. This enriching attack of madness produced two of the wonders of our little world, the Bruges manuscripts of c. 1470, magically illustrated with grisly scenes of battles in front of buildings with tall, thin windows of an oddly modern look. The brilliance of the colours after 500 years defies description. When my sister Diana comes to stay she has these volumes by her bed for a midnight read.

PAGE 191 Henry VII's prayer-book, inscribed by him to his daughter Queen Margaret, wife of James IV

of Scotland, is as unlikely a possession of this house as is Henry VIII's rosary. How did it find its way into the strong-room? Oh, because General Wade gave it to Lord Burlington for designing a Palladian house* for him. And how did General Wade, builder of military roads and beautiful bridges, come by it? He bought it from a magistrate in Bruges in 1717. And why did the magistrate have it? I don't know, so that's the end of the provenance.

Anyway, it is here now, and what an astonishing little volume it is, a nature notebook of c. 1500, including a page which is a calendar bordered by scenes of the twelve months: pansies, pinks, strawberries, roses and periwinkles, birds and insects exquisitely painted in miniature *trompe l'oeil* all over the page.

There was a serious gap in the illustrated botanical books in the library, which is surprising when you consider the Bachelor Duke's love of gardening and the opportunities he had to buy such books with Joseph Paxton always at his elbow.

Andrew, however, has made a great contribution to this section over the last twenty years and I am told the collection of botanical books is now one of the finest in the country. His additions include Redouté's classic volumes on roses and lilies, Thornton's *Temple of Flora*, Samuel Curtis' *The Beauties of Flora*, three of Ehret's delectable flower books, the gargantuan *Banks' Florilegium* and more than thirty others. A speciality has been fine books on camellias, reflecting his love of these beautiful flowers.

PAGE 201 AND PAGE 199
PAGE 203

We rescued Mary Lawrance's *A Collection of Roses from Nature* from the enforced sales for death duties of much of the contents of Compton Place in Eastbourne, together with volumes on insects and shells.

PAGE 207 AND PAGE 209
PAGE 205

Gould and his birds are well represented, Elliot's cats make a change, and then there is the Audubon. The four double elephant folios used to be in the Ante Library. A well-wisher wrote to Andrew and said: 'Do you realize there are some very valuable books on the public route of the house which could easily be stolen?' They are not exactly trifles to be slipped into a pocket: each measures $39\frac{1}{2}''$ high, $27''$ wide and weighs 5 stone. A thief, keen to have the set, would have to carry $2\frac{1}{4}$ hundredweight of awkwardly shaped books past the wardens, through several rooms and the garden, before reaching the getaway car. Nevertheless they have been removed and the one on show is in a glass case.

The dangers of burglaries and fire are ever present, of course; but a far greater hazard for a collection like that at Chatsworth is taxation. After the death of my father-in-law in 1950 death duties at 80 per cent were levied on everything he owned. We were living in the village of Edensor at that time and for years the future of the house was discussed. All kinds of possible uses for it were suggested, but the one which was never mentioned was that the family should go back to live there.

Huge sales of land took place and the Treasury took Hardwick Hall and its contents, and some of the rarest works of art. The payment took seventeen years. During that time the strictest economy was the order of the day, both inside the house and on the estate. In 1959 we took the bold decision to move back into the house, a decision which neither of us has ever regretted.

In 1980 Andrew and our son formed a charitable trust to which the house, its essential contents, the garden and the park are let on a ninety-nine-year lease. By this means it is hoped that the public (who have been welcome to visit Chatsworth ever since it was built) will always be able to enjoy the house and its surroundings.

* In Great Burlington Street, demolished 1935.

THE CAVENDISH FAMILY

1505-1557 Sir William Cavendish = Bess of Hardwick *c.* 1527-1608
son of Thomas Cavendish of Suffolk | *later Countess of Shrewsbury*

1552-1625 William Cavendish = Anne Keighley *d.* 1625
1st Earl of Devonshire (1618) | *dau. of Henry Keighley*

1590-1628 William Cavendish = Hon. Christian Bruce 1595-1675
2nd Earl of Devonshire | *dau. of 1st Lord Kinloss*

1617-1684 William Cavendish = Lady Elizabeth Cecil 1619-1689
3rd Earl of Devonshire | *dau. of the 2nd Earl of Salisbury*

1640-1707 William Cavendish = Lady Mary Butler 1646-1710
4th Earl of Devonshire
1st Duke of Devonshire (1694) | *dau. of the 1st Duke of Ormonde*

1673-1729 William Cavendish = Hon. Rachel Russell 1674-1725
2nd Duke of Devonshire | *dau. of William Lord Russell*

1698-1755 William Cavendish = Catherine Hoskins *d.* 1777 Lord Charles Cavendish = Lady Anne Grey *d.* 1733
3rd Duke of Devonshire | *dau. of John Hoskins* *d.* 1783 | *dau. of the Duke of Kent*
1731-1810 Henry Cavendish *the scientist*

1720-1764 William Cavendish = Lady Charlotte Boyle 1731-1754
4th Duke of Devonshire | *dau. of the 4th Earl of Cork and 3rd Earl of Burlington; estates in Yorkshire and Ireland, Chiswick House, Burlington House*

1757-1806 (1) Lady Georgiana Spencer = William Cavendish 1748-1811 = (2) Lady Elizabeth Foster 1754-1834 Lord George Cavendish = Lady Elizabeth Compton
dau. of the 1st Earl Spencer | **5th Duke of Devonshire** | *(née Hervey) 1759-1824 dau. of the 4th Earl of Bristol* *1st Earl of Burlington (2nd creation)* | *1760-1835 heiress to the 7th Earl of Northampton; estates in Sussex*

1790-1858 William Spencer Cavendish Lady Georgiana Cavendish = George Howard 1773-1848 1783-1812 William Cavendish = Hon. Louisa O'Callaghan
6th Duke of Devonshire | 1783-1858 | *6th Earl of Carlisle* *killed in carriage accident* | *d. 1863 dau. of the 1st Lord Lismore*

1803-1881 Lady Caroline Howard = Rt. Hon. William Lascelles 1798-1851 1812-1840 Lady Blanche Howard = William Cavendish 1808-1891
son of the 2nd Earl of Harewood | *2nd Earl of Burlington (2nd creation)*
7th Duke of Devonshire

1838-1920 Emma Lascelles = Lord Edward Cavendish 1838-1891 1833-1908 Spencer Compton Cavendish = Countess Louise von Alten 1832-1911
8th Duke of Devonshire | *"The Double Duchess"; formerly Duchess of Manchester*

1868-1938 Victor Cavendish = Lady Evelyn Fitzmaurice 1870-1960
9th Duke of Devonshire | *dau. of the 5th Marquess of Lansdowne*

1895-1950 Edward Cavendish = Lady Mary Cecil 1895-1988
10th Duke of Devonshire | *dau. of the 4th Marquess of Salisbury*

b. 1920 Andrew Cavendish = Hon. Deborah Mitford *b.* 1920 1917-1944 William Cavendish = Kathleen Kennedy 1920-1948
11th Duke of Devonshire | *dau. of the 2nd Lord Redesdale* *Marquess of Hartington killed in action* | *sister of President Kennedy*

b. 1944 Peregrine Cavendish = Amanda Heywood-Lonsdale Lady Emma Cavendish = Hon. Tobias Tennant Lady Sophia Cavendish = (1) Anthony Murphy
Marquess of Hartington | *b.* 1944 *b.* 1943 | *son of the 2nd Lord Glenconner* *b.* 1957 | (2) Alastair Morrison

b. 1969 William Cavendish Lady Celina Cavendish Lady Jasmine Cavendish Isabel Tennant Edward Tennant Stella Tennant
Earl of Burlington | *b.* 1971 | *b.* 1973 | *b.* 1964 | *b.* 1967 | *b.* 1970

PAINTINGS

Following a pattern common to most country-house collections, the paintings at Chatsworth are of two main kinds: family portraits, commissioned by the Dukes of Devonshire and their relations, and pictures by the Old Masters that were collected as works of art.

Early portraits of the family, from the time of Bess of Hardwick (c.1527–1608) until her great-grandson the third Earl of Devonshire (1617–84), are now at Hardwick Hall, the family's former seat eighteen miles to the east; but from the first Duke of Devonshire (1640–1707) up to the present day there is an unbroken series of portraits at Chatsworth of twelve generations of the Cavendish family (that of the Dukes of Devonshire), as well as many portraits of the Boyle family (that of the Earls of Burlington) which became part of the collection following the Burlington inheritance in 1753. Only portraits that have become famous in their own right as works of art are included in the selection that follows, notably two by Sir Joshua Reynolds and one of the grandest of all Edwardian group portraits, *The Acheson Sisters* by John Singer Sargent.

Among the collection of Old Masters several of the best happen also to be portraits, for example those by Frans Hals, Van Dyck and Velasquez. The Old Master collection as a whole was formed by three principal collectors, the second and third Dukes of Devonshire and the third Earl of Burlington, all of whom lived in the first half of the eighteenth century. As a result it reflects the taste of that period, which favoured artists of the first half of the previous century, the seventeenth, in particular. The period also saw the establishment for the first time in England of a true art market, with picture-dealers and regular auction sales, so that older paintings like these became generally more available at that time. In theory, connoisseurs like the second Duke of Devonshire always considered that the best artists were Italian, and included with them French painters like Nicolas Poussin and Claude Lorrain who formed their style in Italy. In practice, though, Dutch and Flemish painters were almost equally popular and are equally represented at Chatsworth.

Visitors to the house are sometimes surprised not to find more nineteenth-century pictures, considering the vast sums spent on collecting and building by the sixth Duke of Devonshire (1790–1858), the Bachelor Duke. His interests lay elsewhere, however, and the few commissions he gave to Sir Edwin Landseer and other artists of the day were dictated more by the subjects he chose than enthusiasm for paintings as such.

The presence of pictures by Lucian Freud (b. 1922) in a country house like Chatsworth also usually causes surprise, but the series of them bought or commissioned by the present (eleventh) Duke of Devonshire has already become well known, like the Old Masters, through their frequent inclusion in international exhibitions.

Paolo Veronese (c.1528–1588)
The Adoration of the Magi

Oil on canvas, 138.5 × 209 cm

The attribution to Veronese had been doubted by some, but
the picture is now generally believed to be an autograph
replica by him of a larger version of the subject he painted
which is in the Dresden Art Gallery.
The painting's quality, however – in particular, the richness of
colouring – has always been admired. The picture was bought
by the second Duke of Devonshire in 1726
for £367 10s $\frac{1}{2}$d.

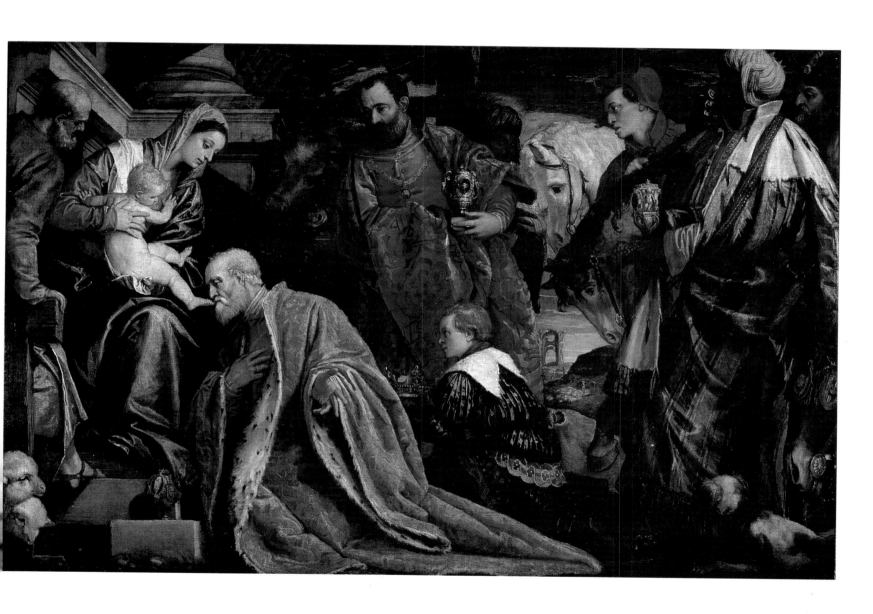

Sebastiano Ricci (1659–1734)
Susannah and the Elders

Oil on canvas, 83 × 102 cm

The picture is signed and dated 1713, and was bought by the
second Duke of Devonshire before 1720. The composition is
based on a lost work of Annibale Carracci (1560–1609) and
until Ricci's signature was revealed by cleaning in 1947 the
painting was always believed to be by Carracci, despite the
great differences in style and date between the two artists.
The colouring of the picture and the fresh handling of paint
are, in fact, typical of Ricci.

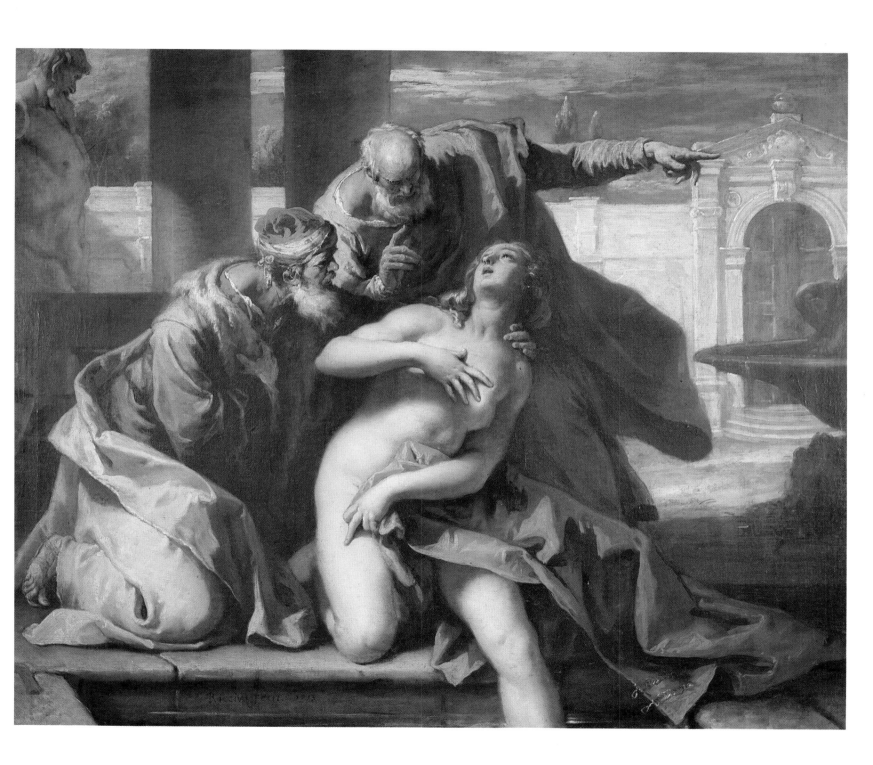

Canaletto (1697–1768)
The Riva degli Schiavoni, Venice, looking East

Oil on copper, 44.1 × 59.7 cm

In the foreground to the left is the Lion of St Mark in front of
the Doge's Palace. Together with another view of Venice at
Chatsworth by Canaletto painted on copper, called *The
Entrance to the Grand Canal, from the Piazzetta*, the picture was
probably painted in the late 1720s, but there is no record of
how or when these paintings entered the Devonshire
collection. Both are characterized by an exceptionally strong
light which brings every object into sharp relief.

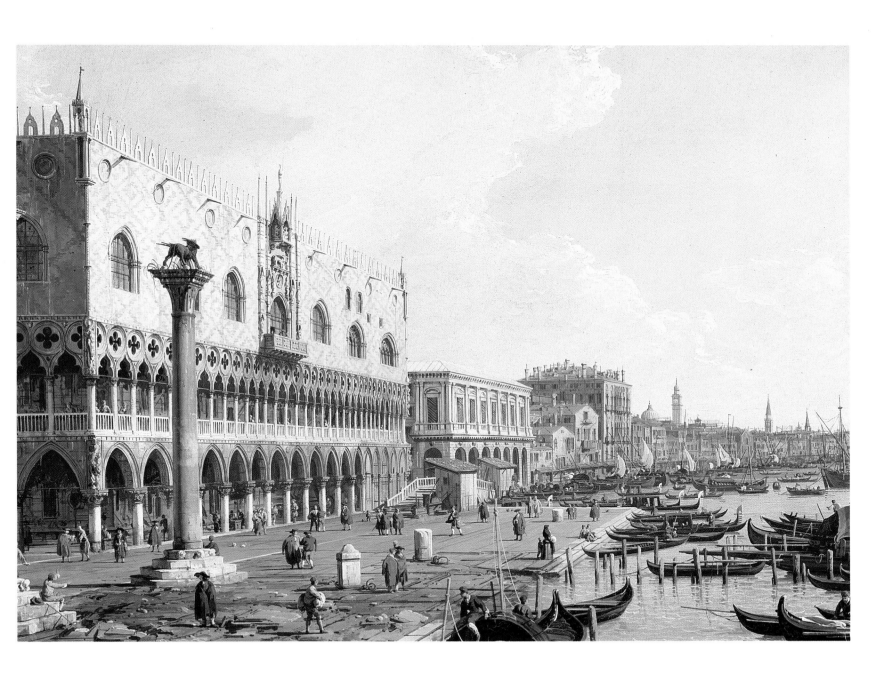

Nicolas Poussin (1594–1665)
The Shepherds in Arcadia

Oil on canvas, 101 × 82 cm

The picture was painted about 1630 and was almost certainly
acquired by the second or the third Duke of Devonshire, as it
is recorded as being at Devonshire House in London by 1761.
It was originally in the collection of one of Poussin's patrons
in Rome, Cardinal Camillo Massimi. The painting is often
called *Et in Arcadia Ego*, from the inscription which the
shepherds decipher on the tomb of another shepherd. He, too,
had lived in the ideally happy country of Arcadia but had
been struck down by death, which is not to be avoided 'even
in Arcadia'.
A later version of the same subject is in the Louvre.

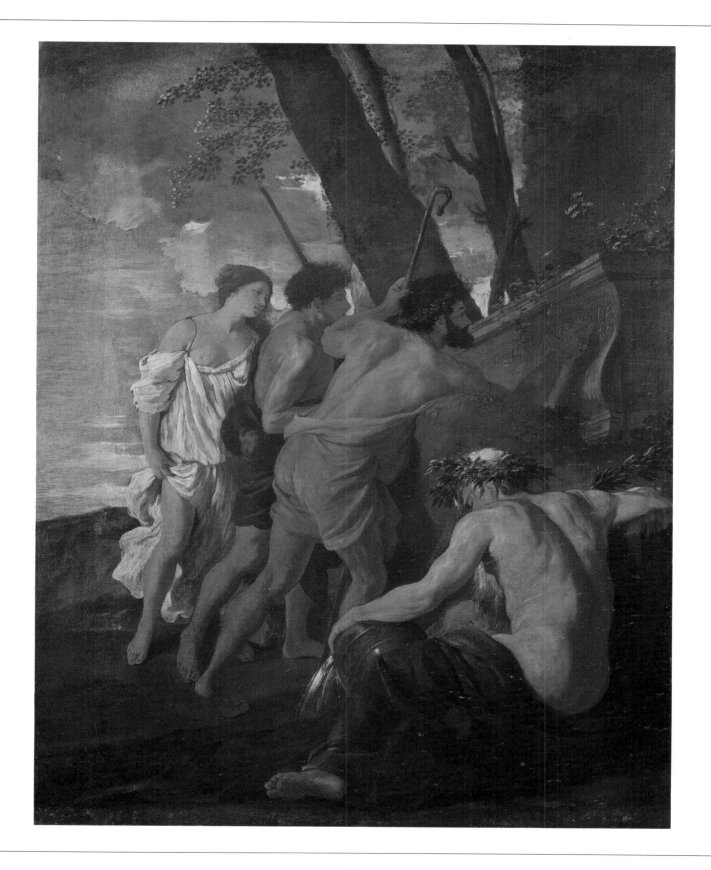

Claude Gellée, called Lorrain (1600–1682)
A Landscape with Mercury and Battus

Oil on canvas, 74 × 110.5 cm

The picture was painted in 1663 for an unidentified patron in
Antwerp, and was at Devonshire House by 1761, having
probably been acquired earlier by the second Duke of
Devonshire. In the list of present owners at the end of the
Liber Veritatis, the album of drawings that Claude compiled of
all his paintings, the second Duke wrote 'mine' against the
entry for this painting. The *Liber Veritatis* was formerly in the
second Duke's collection of drawings, and is now in the
British Museum.
Battus was a shepherd who broke his promise to Mercury not
to reveal that Mercury had stolen the cattle of Apollo. As a
punishment Mercury turned him into a touchstone.

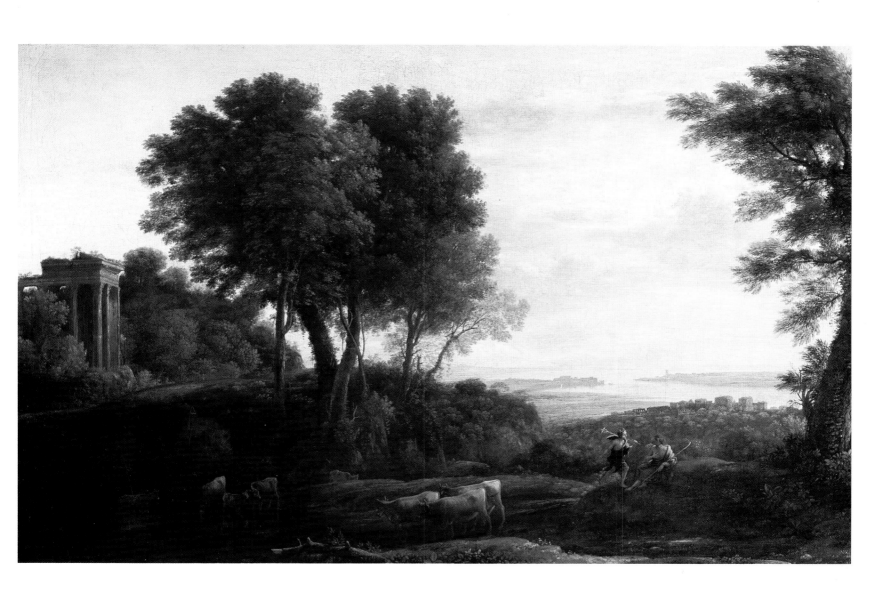

Velasquez (1599–1660)
A Portrait of a Lady in a Mantilla

Oil on canvas, 98 × 48 cm

The portrait was in the collection of the third Earl of
Burlington and is dated about 1640. Its tall narrow shape is
unusual and the canvas has almost certainly been cut down. A
drawing at Chatsworth in an album which contains sketches
by Lady Burlington and her daughters, seems to show the
portrait in its original form, with the lady depicted full-length,
standing in a landscape with a view of a town in the
background. The same sitter, who is unidentified, appears in a
slightly earlier portrait by Velasquez in the Wallace
Collection, London.
The traditional attribution to Velasquez has been challenged,
but received strong support when the picture was shown at a
major exhibition of the artist's work in Madrid in 1960.

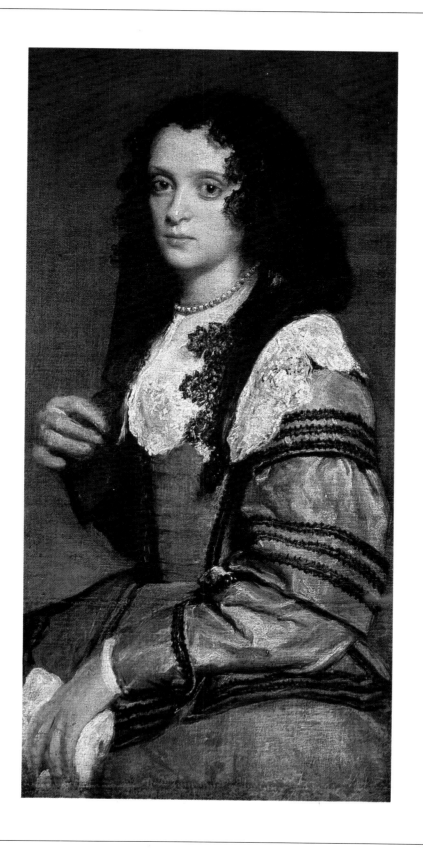

Bartolomé Esteban Murillo (1617–1682)
The Holy Family

Oil on canvas, 96.5 × 68.5 cm

The picture is not included under the artist's name in any
early inventories, but two unascribed versions of the subject
are recorded at Devonshire House in 1761. This may be one
of them, which suggests it was bought earlier by the second
or the third Duke of Devonshire. It is dated about 1670–75
and is one of Murillo's most intimate and domestic treatments
of the subject. The Virgin's gesture of uncovering the Christ
Child may symbolize His revelation to humanity, and the
wooden block which Joseph is cutting may likewise stand for
the wood of the Cross.

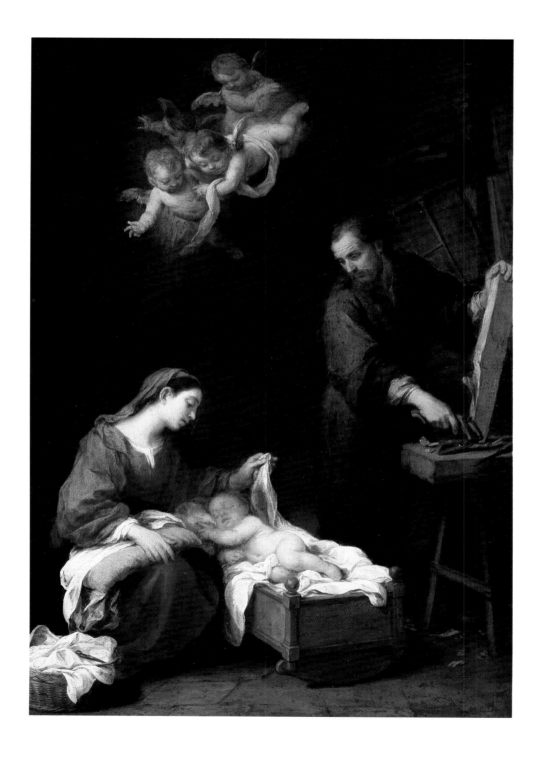

Frans Hals (1582/3–1666)
A Portrait of a Man

Oil on canvas laid down on panel, 107 × 85 cm

The portrait is dated 1622 and the sitter's age, given in an
inscription, is thirty-six. He has not been identified for certain,
but may be Isaac Abrahamsz Massa of Haarlem, whose
portrait Hals painted again at least twice, in 1626 and
about 1635.
Before the collection of the third Earl of Burlington became
part of the Devonshire collection in 1753, there was a portrait
by Hals in each, but it is not known which was which. The
other portrait, which is earlier in date, is of a woman.

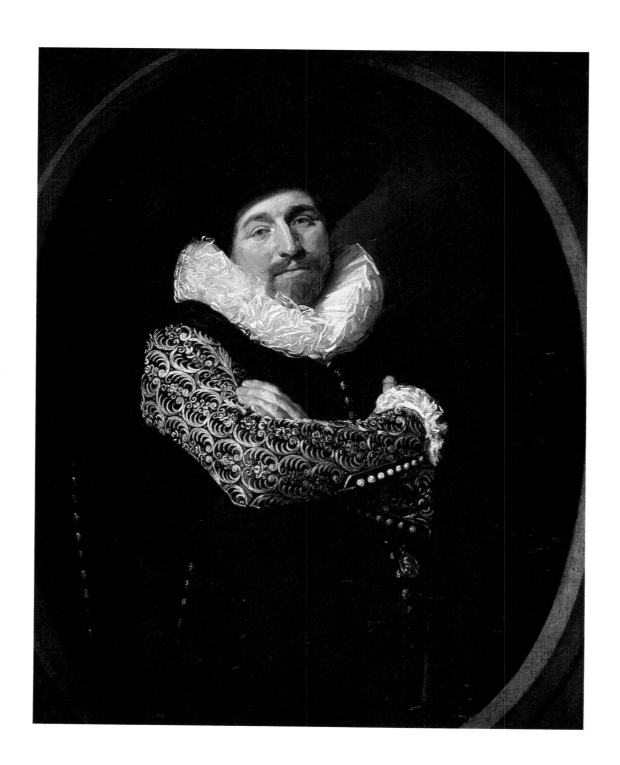

Cornelis de Vos (1584–1651)
A Portrait of a Little Girl

Oil on canvas, 103 × 77 cm

The portrait was in the collection of the third Earl of
Burlington and was believed at that time to be a Spanish
picture, by Velasquez. It is, however, a very charming and
characteristic work of de Vos, who worked in Antwerp,
occasionally assisting Rubens, and who specialized in
portrait painting.
The child may well be one of the artist's own daughters.

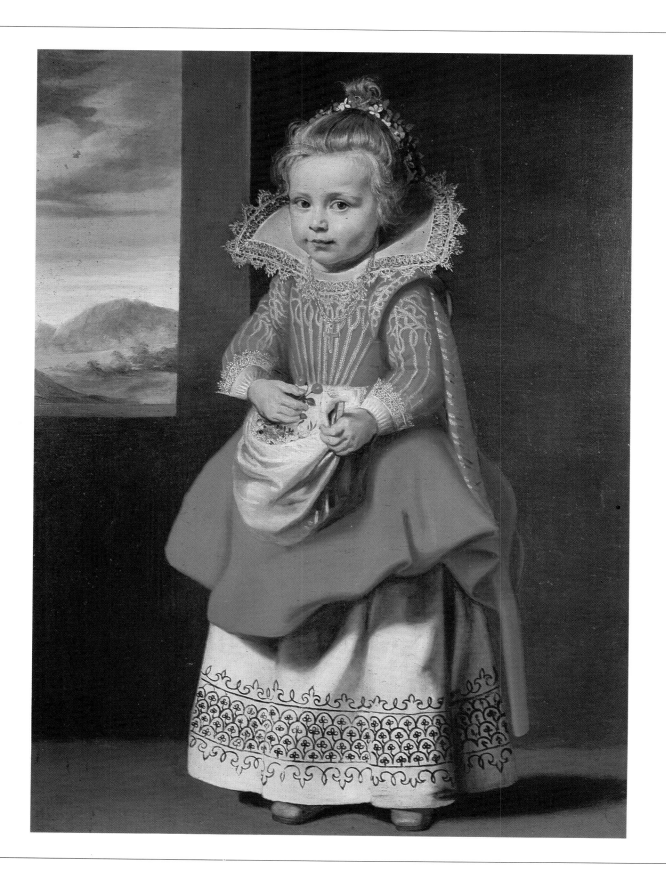

Rembrandt van Rijn (1606–1669)
King Uzziah Stricken with Leprosy

Oil on panel, 101 × 79 cm

The painting has a barely visible signature and date, which is probably 1639, and was bought by the third Duke of Devonshire in 1742. The subject is still not established beyond doubt but appears to show the moment when Uzziah, one of the warrior kings of Israel, was stricken by God with leprosy for burning incense in the Temple of Jerusalem, which was a sacrifice only the priests were ordained to perform. The disease is seen breaking out on his forehead, and the Temple is identified by the brass serpent that appears in the background.

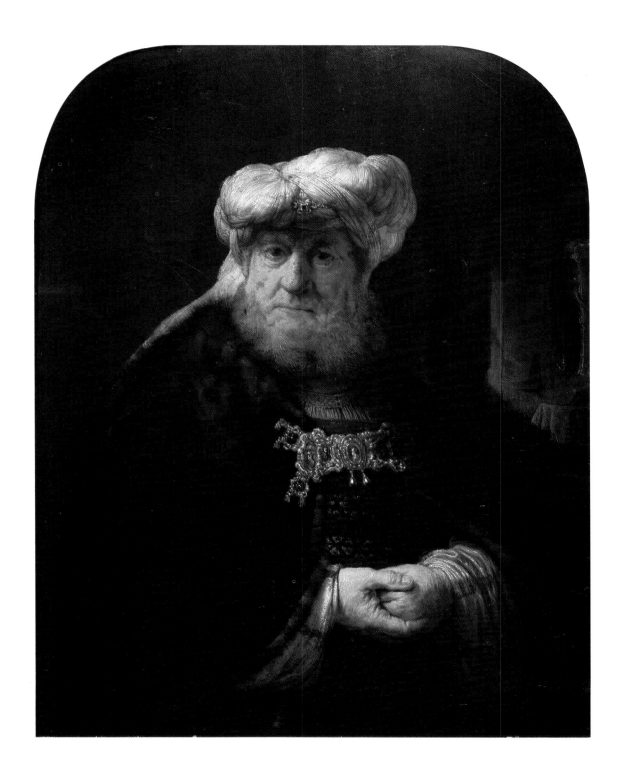

Nicolaes Berchem (1620–1683)
An Evening Landscape with a Stream, Cattle and Ruins

Oil on panel, 74 × 113 cm

The picture is signed, under the frame, and is from the
collection of the third Earl of Burlington. The ruins in the
background are the Castle of Brederode, near Haarlem.
Berchem was a native of Haarlem but formed his style in Italy,
where he was influenced especially by the classical landscapes
of Claude Lorrain (see page 35). Although the picture has
elements in common with ideal or classical landscapes, it
remains more realistic, in the Dutch tradition.

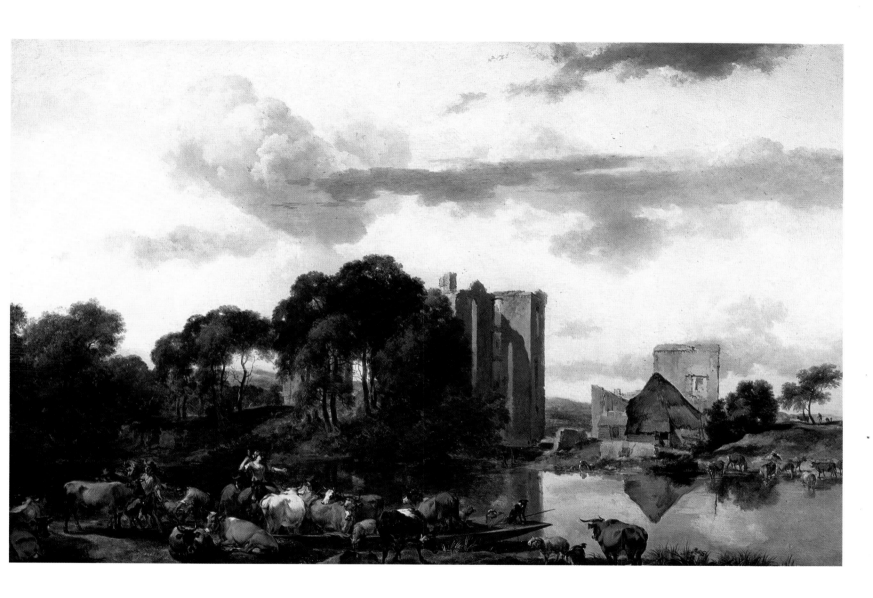

Attributed to Thomas Wyck (1616–1677)
A View of London from Southwark

Oil on canvas, 59.5 × 87.5 cm

The picture was probably painted about 1650 and is from the
collection of the third Earl of Burlington. Since the eighteenth
century it has been attributed to Wyck, a Dutch painter who
worked in England, but this remains uncertain. The view is
certainly of London before the Great Fire of 1666 but much of
the detail appears to derive from an engraving of 1638 by
Matthaeus Merian rather than from direct observation. In the
foreground is Southwark Cathedral; behind it is old London
Bridge (still built over with houses); and on the far (north)
bank is the Tower of London with its four turrets and old
St Paul's to the left.

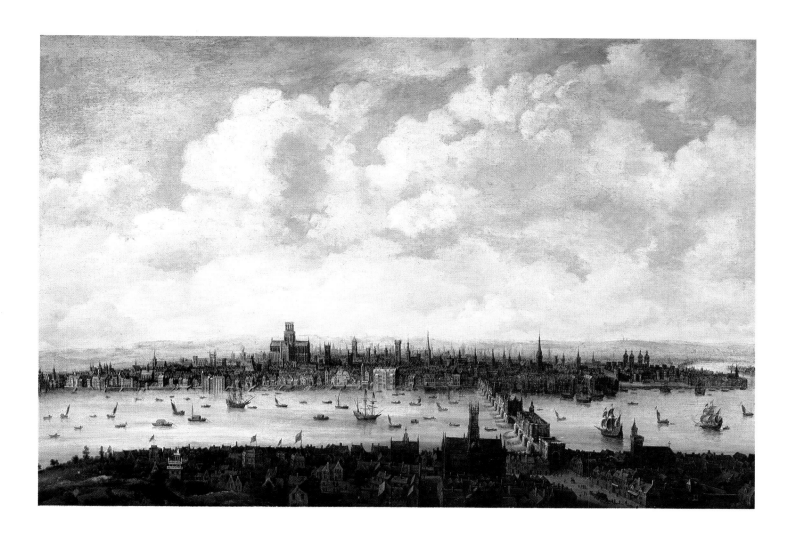

Sir Anthony Van Dyck (1599–1641)
A Portrait of Arthur Goodwin MP

Oil on canvas, 215 × 128 cm

The picture is inscribed 'Arthur Goodwin father of Jane his
sole daughter and heyre 2nd wife of Philip now Ld. Wharton,
1639, about the age of 40' and 'p.Sr. Ant.Vandike'. It was in
the collection of Sir Robert Walpole and was given after
Walpole's death to his friend the third Duke of Devonshire.
Before then, as the inscription suggests, it was in the
collection of the Wharton family. Arthur Goodwin MP
(?1593–1643) was the member for Buckinghamshire in the
Long Parliament of 1640, and parliamentary commander-in-
chief in Buckinghamshire in the Civil War.

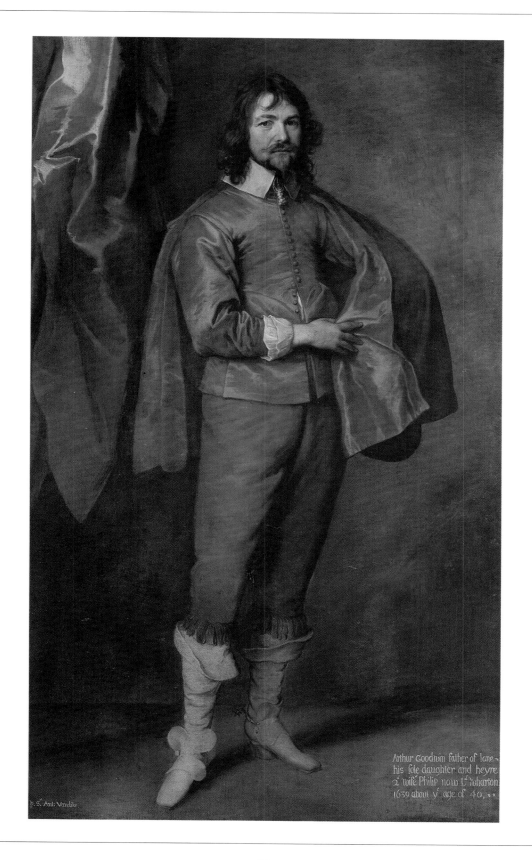

Sir Joshua Reynolds (1723–1792)
**A Portrait of Georgiana, Duchess of Devonshire, with
her Daughter, Georgiana Dorothy, later
Countess of Carlisle**

Oil on canvas, 111 × 142 cm

The portrait was painted in 1784 when the Duchess was in
mourning for her father, and was exhibited at the Royal
Academy in 1786. Georgiana (1757–1806) was the daughter
of the first Earl Spencer and married William Cavendish, fifth
Duke of Devonshire in 1774 at the age of seventeen. She
quickly became a queen of society and fashion in an era
renowned for its elegance, and has since been the subject of
several biographies. There is a sketch by Reynolds at
Chatsworth painted twenty-five years earlier, in 1759, which
shows Georgiana herself as a baby with her mother Countess
Spencer, and another portrait of her by him painted in 1780.
A fourth portrait by Reynolds at Chatsworth is of Georgiana's
closest friend and eventual successor, Lady Elizabeth Foster
(see page 55).

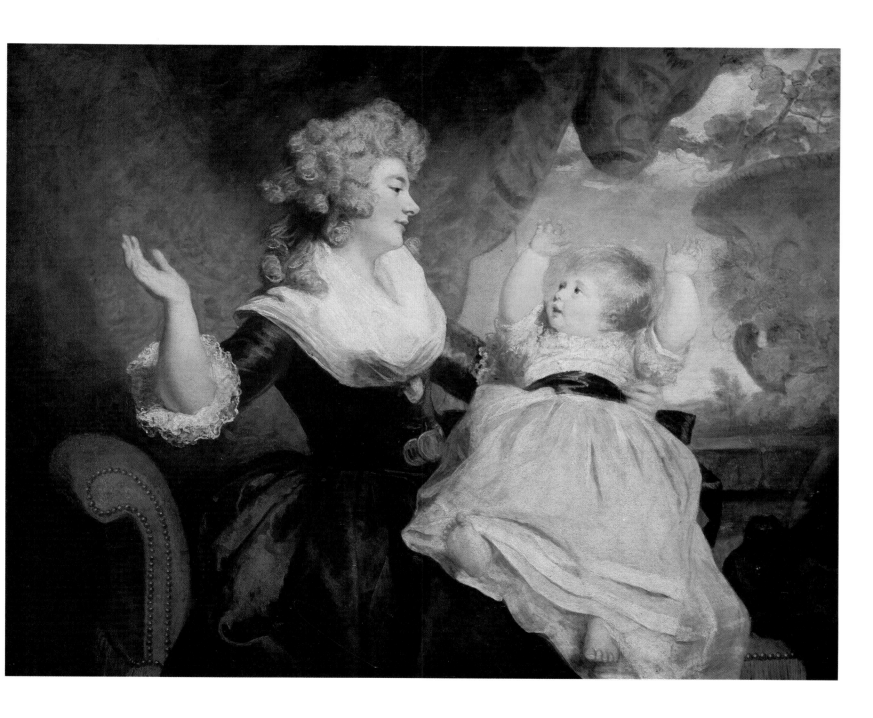

Sir Joshua Reynolds (1723–1792)
**A Portrait of Lady Elizabeth Foster,
later Duchess of Devonshire**

Oil on canvas, 74 × 62 cm

The portrait was painted in 1787 and exhibited at the Royal
Academy the following year. Lady Elizabeth (1759–1824) was
the daughter of Frederick Hervey, Bishop of Derry and fourth
Earl of Bristol. She made an unhappy marriage to an Irish
politician, John Foster, and after separating from him was
befriended by Georgiana, Duchess of Devonshire (see page
53), who gave her financial support and before long provided
her with a home at Devonshire House. The ensuing love affair
between Lady Elizabeth and the fifth Duke of Devonshire,
Georgiana's husband, was never broken off and produced a
daughter and a son. Georgiana, who, odd though it may
seem, remained Elizabeth's closest friend, died in 1806, and in
1809 the Duke married Elizabeth.

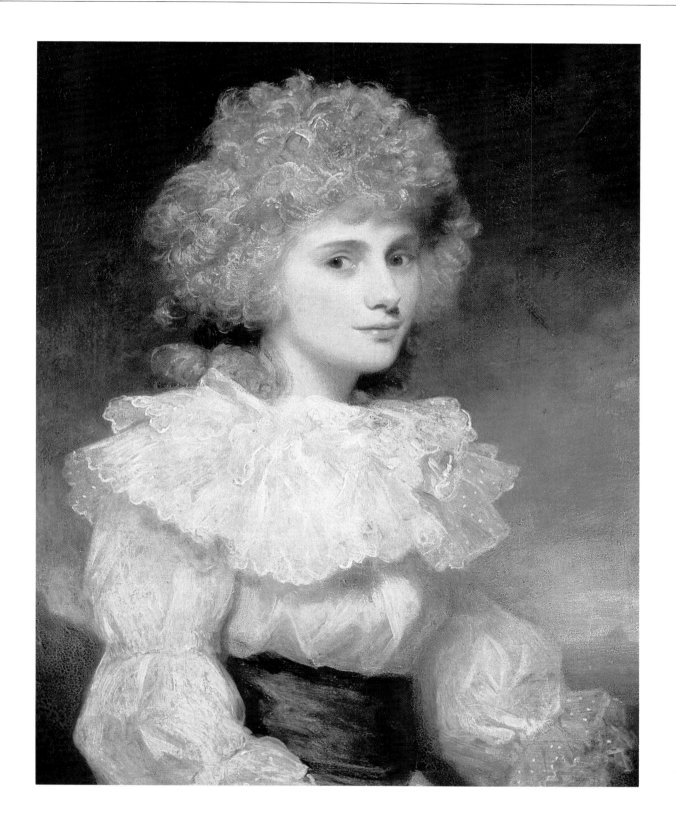

Sir Edwin Landseer (1802–1873)
Trial by Jury, or Laying Down the Law

Oil on canvas, 121 × 131 cm

The picture was commissioned by the sixth Duke of
Devonshire and was completed by 1842. It is a satire on the
legal profession, painted at a time when pressure for legal
reform was strong. The poodle probably represents Lord
Lyndhurst, the Lord Chancellor, who here presides as judge.
Other lawyers, officials and jurors are represented by a variety
of breeds of dogs, with the sixth Duke's own pet Blenheim
spaniel, Bony, specially included as a 'cub-reporter' to the left
of the judge's chair. Landseer began his career specializing in
dogs and in this picture achieved a *tour de force* on the theme.

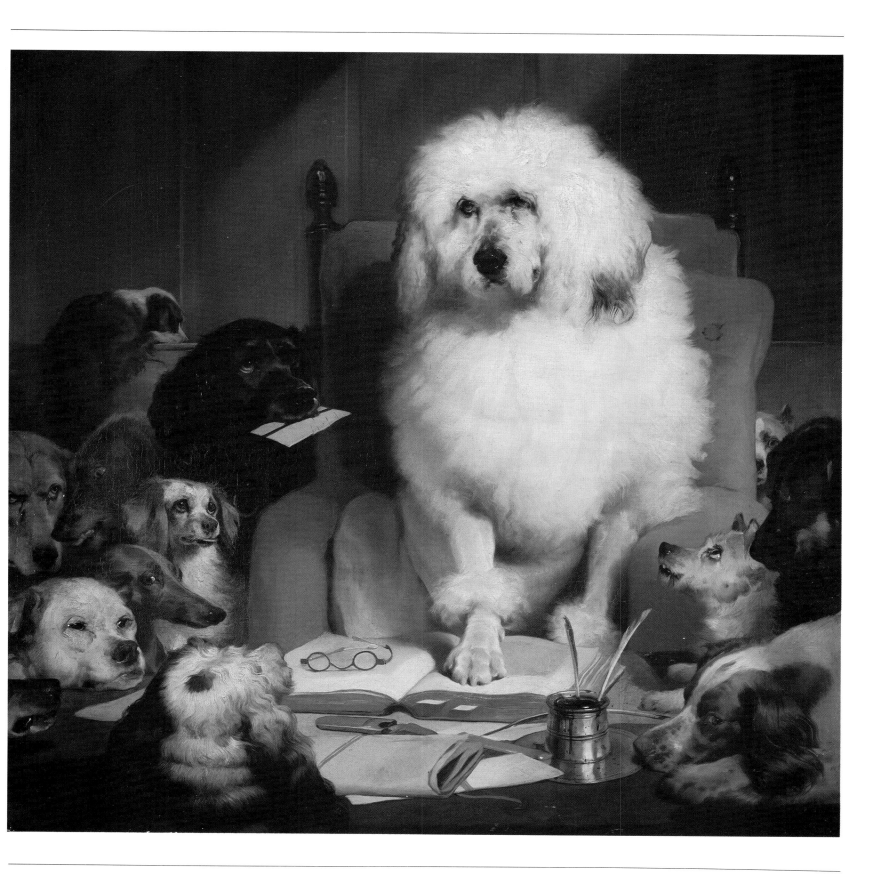

John Singer Sargent (1856–1925)
A Portrait of the Acheson Sisters

Oil on canvas, 275 × 198 cm

The picture is signed and dated 1902. Alexandra, Theodosia and Mary Acheson were the daughters of Archibald Brabazon Sparrow Acheson, fourth Earl of Gosford, and his wife Louisa, who in turn was the daughter of the seventh Duke of Manchester and his wife Louise. Following the Duke of Manchester's death in 1890, Louise married Spencer Compton Cavendish, eighth Duke of Devonshire, and so became known as 'the Double Duchess'. This portrait of her grand-daughters was almost certainly commissioned by her, which accounts for its presence at Chatsworth.

Sargent was reckoned the greatest portrait painter of the age, 'the Van Dyck of our times', and rose to an unrivalled position in English artistic life. In this enormous painting, he consciously echoed the poses and the grandeur of the full-length portraits of Reynolds of over a century earlier.

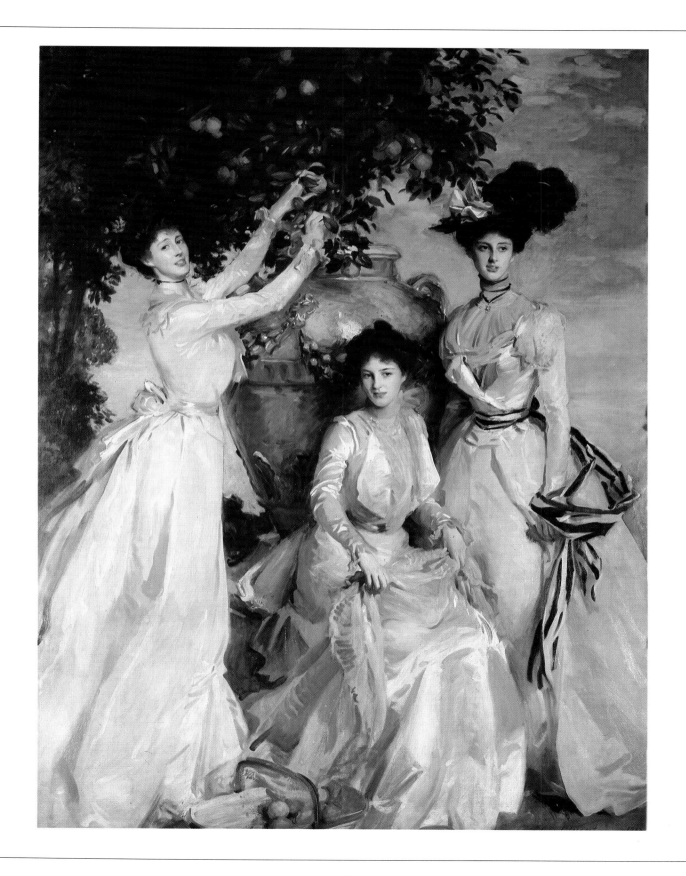

Lucian Freud (b. 1922)
Large Interior, London W9

Oil on canvas, 90.2 × 90.2 cm

The picture was painted in 1973 and bought by the present
Duke of Devonshire in 1974. The seated woman is the
artist's mother.
There are several paintings by Lucian Freud at Chatsworth,
nearly all of members of the present Duke's family, and
painted over the past three decades. They are not portraits in
the traditional sense but reflect what Freud has said is his
central theme: 'My work is purely autobiographical . . . I work
from the people that interest me . . . I use them to invent my
pictures with.'
He has also spoken of his 'horror of the idyllic', providing a
clue to the disturbing effect of *Large Interior, London W9*.

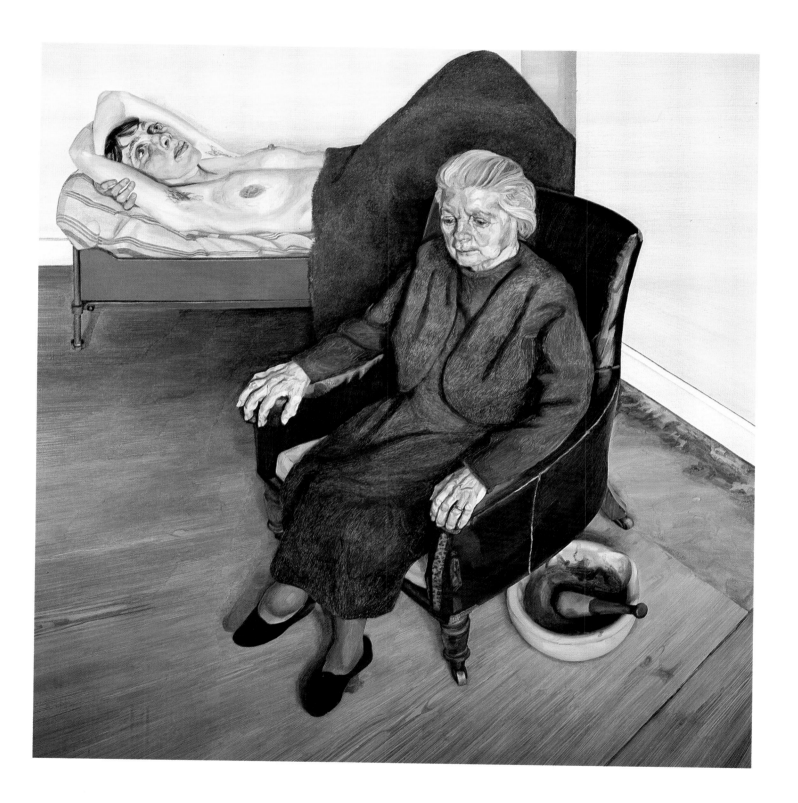

SCULPTURE

There are fine marble statues and elaborate carvings in stone and wood at Chatsworth that are really part of the fabric of the house, and which date from the time the first Duke of Devonshire was rebuilding it between 1686 and 1707, when entries for them appear in his accounts. None of his successors or relations in the eighteenth century, however, appears to have taken any interest in collecting statuary for its own sake, apart from the third Earl of Burlington who had a small collection of Roman busts in his villa at Chiswick.

This changed dramatically with the visit in the winter of 1818–19 of the sixth Duke of Devonshire to Paris and Rome. Several years later he wrote that 'at Rome the love of marble possesses one like a new sense'. The collection of neo-classical sculpture that he formed between 1818 and 1832, when his Sculpture Gallery at Chatsworth was completed, is unique in England and almost without parallel in Europe. Rome became the centre of the style after its greatest exponent, Antonio Canova (1757–1822) moved there in 1781, eventually attracting other sculptors from all over Europe to set up their workshops in the city. The sixth Duke acquired six works by Canova and gave a variety of commissions to at least twenty other sculptors, all of whom lived and worked in Rome.

The Sculpture Gallery itself, designed in a severe neo-classical style by the sixth Duke's architect Sir Jeffry Wyatville, was built during the years the collection was being formed. It has a floor and walls of plain gritstone (the local sandstone) in preference to marble, to avoid reflected light, and has top lighting from skylights to provide soft, even illumination without cast shadows. Galleries like this at Chatsworth and other large country houses set the pattern for the design of public museums later in the century.

Despite deciding not to collect ancient marbles because the best time for collecting them had passed, the sixth Duke also bought some remarkable examples of Egyptian, Greek and Roman statues. With his death, however, interest in sculpture again ceased for some generations until the present Duke of Devonshire began again to buy or commission portrait busts of his family and friends, including the examples by Sir Jacob Epstein and Angela Conner in the following selection.

Egyptian, eighteenth dynasty (1570–1304 BC)
A Statue of Sekhmet, Lion Goddess of War and Strife

Granite, 183 cm high

The statue, together with another of Sekhmet, comes from the
temple of Mut at Karnak in Thebes, and was bought by the
sixth Duke of Devonshire before 1845. He records in his
Handbook to Chatsworth, privately printed that year, that
they were 'sent home by a famous traveller and purchased by
me in the New Road'. He originally set them up in the area of
the present Rose Garden at Chatsworth, from where they
were moved in the 1920s to the Old Conservatory Garden,
and finally, in 1991, to the Chapel Passage inside the house.
King Amenhotep III of Egypt (1397–1360 BC) built a temple
at Karnak in Thebes dedicated to the vulture goddess Mut,
wife of Amon, king of the gods. In earlier times, Mut was
symbolized by the lion goddess Sekhmet (which means 'The
Powerful') and 574 statues of her in this guise were carved in
granite for the temple. Most are now in museums, but some
remain in the temple ruins.

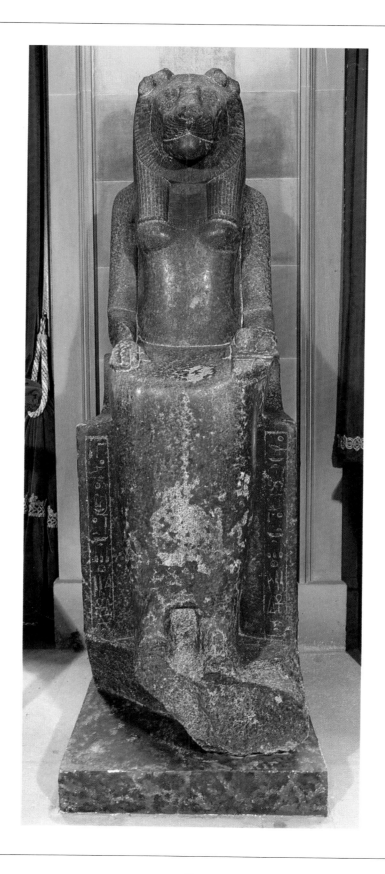

Hellenistic or early Roman, second century BC–first century AD
A Colossal Foot Wearing a Sandal

Marble, 102 cm long

The foot was bought by the sixth Duke of Devonshire in
1839 from Carlo Finelli, a sculptor in Rome, for 348 scudi.
Although the Duke believed it to be ancient, for most of this
century it has been considered to be a nineteenth-century
forgery. However its authenticity was established in 1983
when a connection was made between it and the matching
right foot, which had lain unnoticed in the basement of the
State Museum in East Berlin.
The two feet probably originally formed part of a colossal cult
statue of a goddess about eleven metres high, made mostly of
painted cloth and wood. It is likely that only the face, hands
and feet were carved in marble.

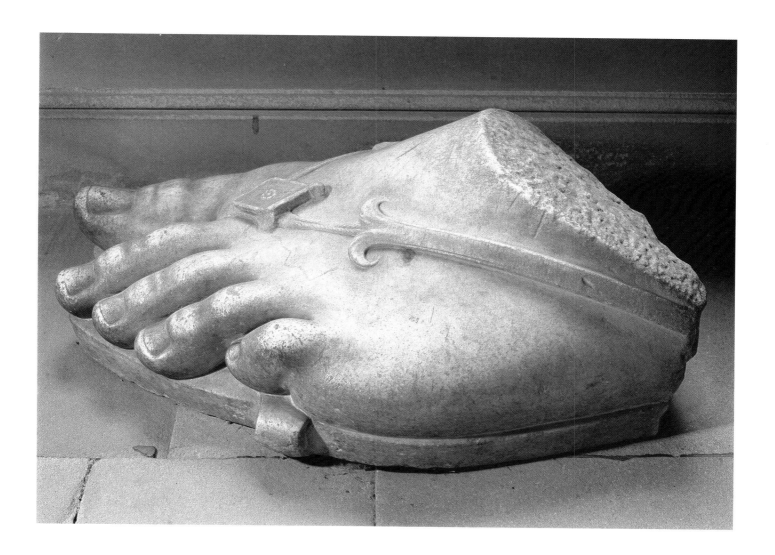

Roman, Flavian period, 81–96 AD
A Portrait Group of a Mother and Daughter

Marble, 159 cm high

The statue was originally found at Apt-en-Provence at some
time shortly before 1724, the year its discovery was
published. It was bought by the sixth Duke of Devonshire in
1822 for £105 at the sale of the contents of Wanstead House
in Essex, and placed by him in the North Entrance Hall at
Chatsworth where it remains.
The statue is in an extraordinarily good state of preservation,
and is a very rare example of a seated portrait of a
Roman lady.

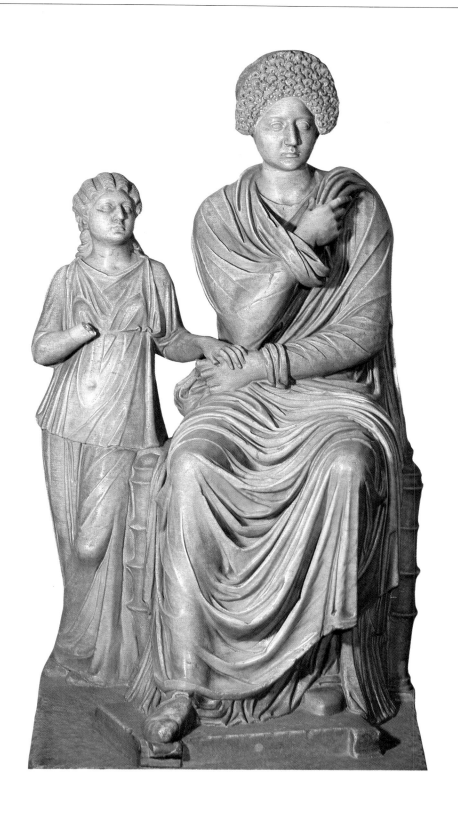

Roman, third century AD, second decade
A Half-figure of a Man Holding a Scroll

Marble, 76 cm high

Several Roman busts are recorded at Chiswick House in the
collection of the third Earl of Burlington in the eighteenth
century, and this may be one of them. It is entirely ancient
and unrestored, except for the ends of the scroll in the left
hand, and belongs to a rare class peculiar to the third century
in which the half-figure is represented together with the arms.
Also characteristic of that period is the slightly troubled
expression on the face.

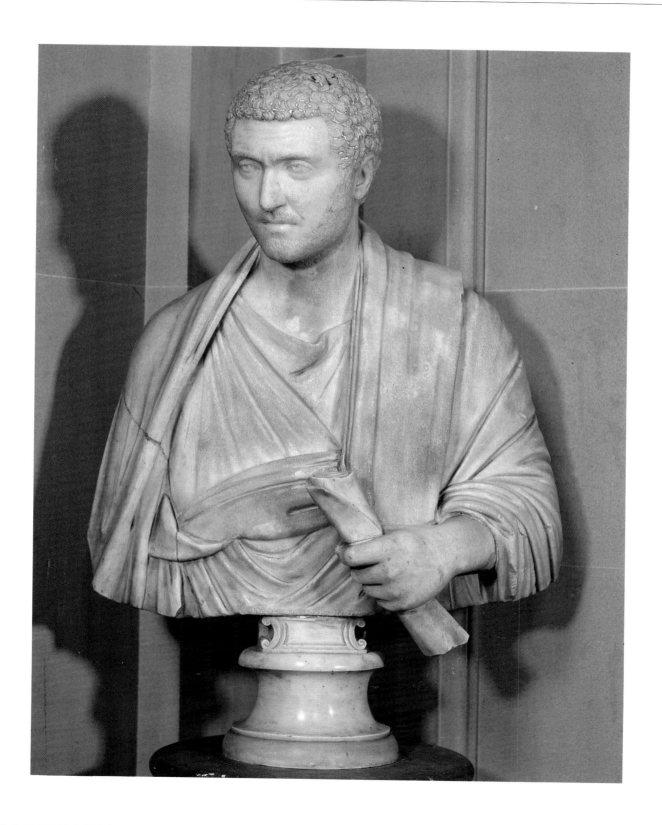

English, early seventeenth century
A Relief Carving of Diana Bathing

Marble, 161 × 91.5 cm

The relief is the centrepiece of a fountain set in the south wall
of the Grotto at Chatsworth, beneath the Great Stairs, which
is fitted with a black marble basin and has a frame of dolphins,
crabs and other shellfish carved in Roche Abbey stone by
Samuel Watson (see page 74).
The first Duke of Devonshire's building accounts record that
£16 was paid 'at London for ye figure of Diana' in November
1692. There are episodes in the story of the moon goddess,
Diana, in which she and her nymphs are surprised while
bathing by intruders on the scene. In this relief, however, it
appears as if we, the spectators, are the ones who surprise her
with our gaze.
The traveller Celia Fiennes recorded when she visited
Chatsworth in 1697 that the purpose of the Grotto was 'to
supply all ye house with water, besides severall ffanceyes to
make diversion'.

Gabriel Cibber (1630–1700) and Samuel Watson (1663–1715)
The Altarpiece of the Chapel at Chatsworth

Alabaster and Ashford black marble

The altarpiece in the Chapel at Chatsworth was carved for
William Cavendish, first Duke of Devonshire, as part of his
complete rebuilding of the house between 1686 and 1707. It
was designed by Cibber, who carved the statues of Faith and
Justice above the broken pediment, while the shield, festoons,
swags, winged cherubs and other adornments were carved by
Watson. The whole was complete by 1691, and the painting
of *Doubting Thomas* by Antonio Verrio was set up in 1693.
The wall and ceiling paintings of the Chapel itself are by
Louis Laguerre.
The Chapel was the first room to engage the first Duke's
interest when he began rebuilding Chatsworth, and the most
important room on the ground floor. It is clear he wanted the
altarpiece to be as magnificent as possible, as well as the
painted and carved decoration of the Chapel as a whole.
Today it remains the least altered room in the house and one
of the most impressive.

English, late seventeenth century, after Giambologna
(1529–1608)
A Statue of Samson Slaying the Philistine

Lead, 180 cm high

The original marble statue of this group by Giambologna is
now in the Victoria and Albert Museum in London, and first
came to England in 1623. A number of lead copies of it were
made in the seventeenth and eighteenth centuries, when it
was wrongly known as *Cain and Abel*. There was definitely a
version at Chatsworth in the first Duke of Devonshire's time
as his accounts for 1691 record that one was bought in
London for £50. However, there was also one in the garden
of Chiswick House by the 1720s, belonging to the third Earl
of Burlington, and it is apparently this version which is now
in the Rose Garden at Chatsworth, moved there with other
garden statues from Chiswick in the 1920s.

Lead statues were a prominent feature of the first Duke of
Devonshire's garden, and were originally painted. A letter
written by his London steward in 1698 records that: 'I saw the
ship sette saile for Stockwith werein is 22 cases with leaden
figures and several other leaden things for Chattsworth.'

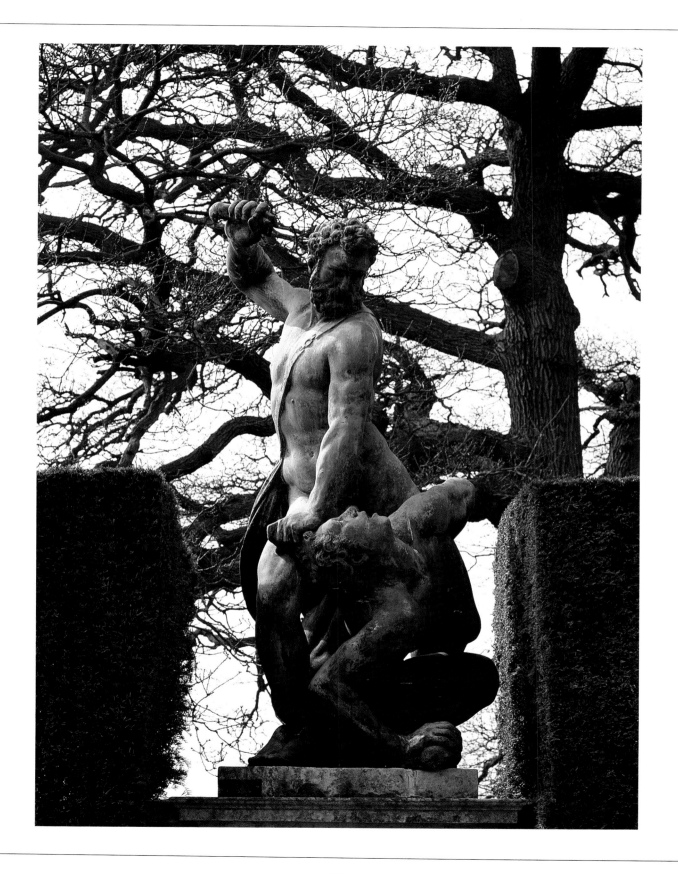

Antonio Canova (1757–1822)
A Colossal Bust of Napoleon

Marble, 91.5 cm high

The bust remained in Canova's own bedroom at his house in
Rome until his death in 1822 and was afterwards bought by
the Dowager Marchioness of Abercorn, a friend of the sixth
Duke of Devonshire. She left it in her will to him. The sixth
Duke's Sculpture Gallery at Chatsworth ultimately included
no less than five busts and statues of members of the
Bonaparte family (see also pages 81 and 83).
The Duke considered that this bust was the only authentic
one of Napoleon by Canova's own hand. It was made from
his model for the colossal statue presented to the Duke of
Wellington that is now at Apsley House in London.

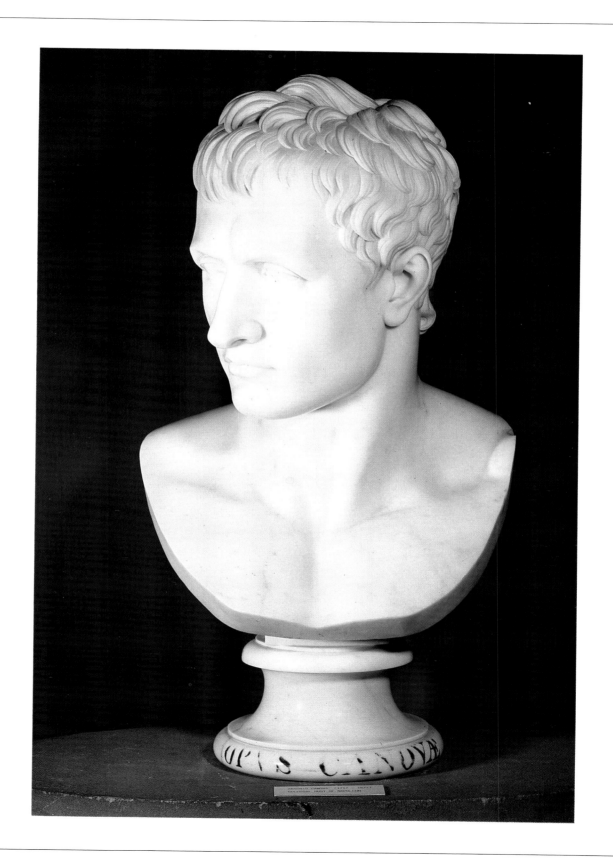

Antonio Canova (1757–1822)
A Statue of Napoleon's Mother,
Marie Letizia Ramolino Bonaparte

Marble, 145 cm high

The statue was made in 1804–08 and bought by the sixth
Duke of Devonshire in December 1818. This was the Duke's
first purchase for the new Sculpture Gallery he intended
building at Chatsworth, the first designs for which were
submitted to him by his architect Wyatville in October of
the same year.

Napoleon's mother, known as 'Madame Mère de l'Empereur'
(c. 1749–1836), rebuked the Duke for buying her statue when
she met him some years after the purchase. In 1824 he wrote
in a letter to a relative: 'I am growing particular with Madame
Mère. She scolds long and loud about the statue which she
says they had no right to sell nor I to buy. It is being copied
now for Jerome, and it is interesting for me to see how very
like the old lady it is. She has a very stately walk and her
whole appearance is miraculous for a woman of 80.'

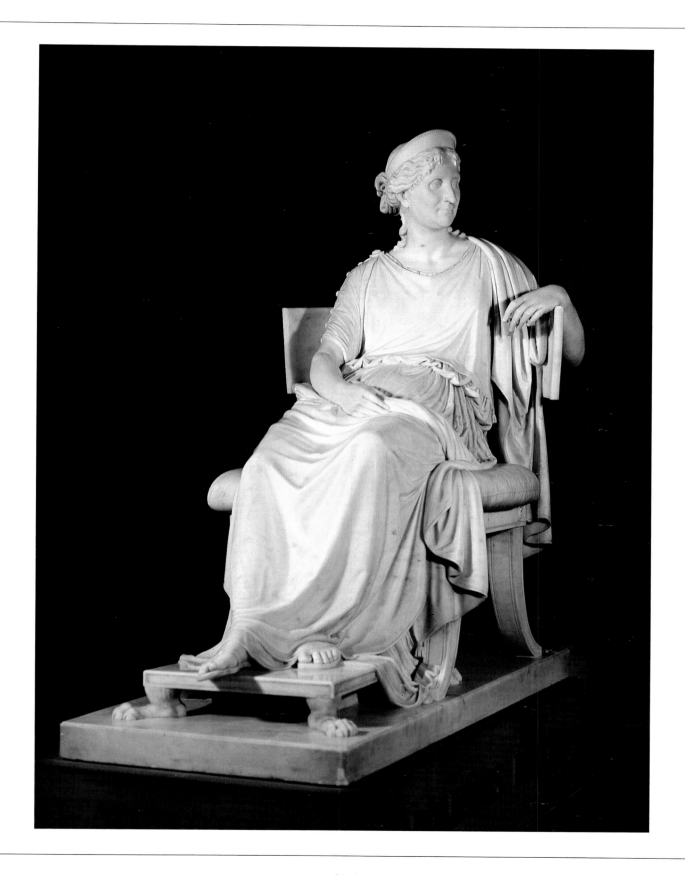

Thomas Campbell (1790–1858)
A Statue of Princess Pauline Borghese

Marble, 142 cm high

The statue was commissioned by the sixth Duke of
Devonshire in 1824 but not completed and delivered until
1840, at a total cost of £500. In a letter of 1836, when the
plaster model was at last ready and in England, Campbell
wrote in a letter to the Duke that: 'It is a work [upon which] I
have bestowed more anxious pains than any one I ever
undertook . . . I cannot express how sorry I am for the delay
which has occurred.' The final statue in marble was placed in
the Sculpture Gallery at Chatsworth as a pendant to Canova's
seated statue of Madame Mère (see page 81).
Princess Pauline Borghese (1780–1825) was the favourite
sister of Napoleon. As a noted beauty she had many admirers
in Rome after she retired there in 1815, with the rest of the
Bonaparte family, following the Emperor's defeat at Waterloo.
The sixth Duke met her in Rome in 1824 and enjoyed a brief
flirtation with her, describing her in his diary as 'full of whims
and childishness but now and then very entertaining about
her family, and *bellissima*'.

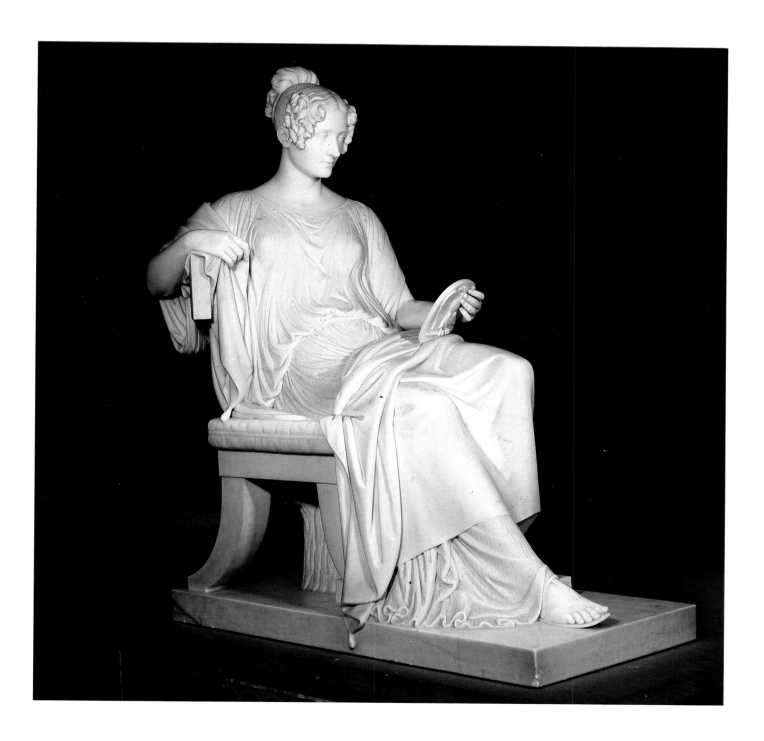

Antonio Canova (1757–1822)
Endymion

Marble, 183 cm long

The sculpture was commissioned by the sixth Duke of
Devonshire in 1819 and bought by him in 1822 for £1,500. It
became his greatest treasure. Canova was himself pleased with
the work and especially delighted with the block of marble
from which he carved it, saying it was the finest quality he
had ever seen.
The subject was a favourite one of artists and poets, who saw
in it a symbol of the timelessness of beauty. Endymion asked
Jupiter for the gift of immortality and eternal youth, but in
return for granting his wish the god sent him to
sleep for ever.

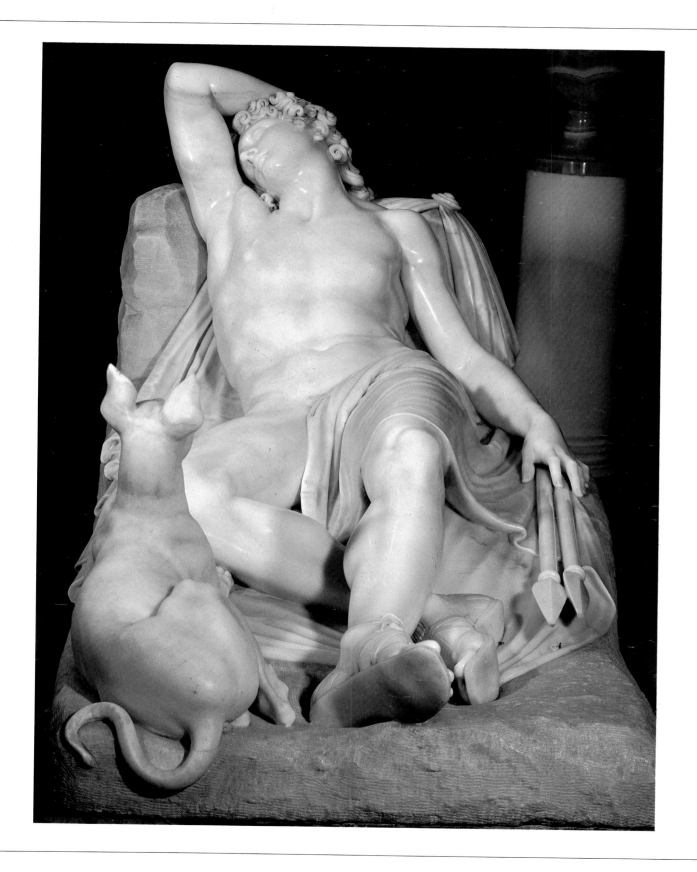

Rudolf Schadow (1786–1822)
A Statue of a Spinning Girl

Marble, 127 cm high

The statue is signed and dated 1819, the year in which it was ordered by the sixth Duke of Devonshire. It had originally been modelled before 1816 for an unknown English gentleman, and had become famous. Schadow, who was the pupil in Rome of the Danish sculptor Bertel Thorwaldsen, repeated it many times.

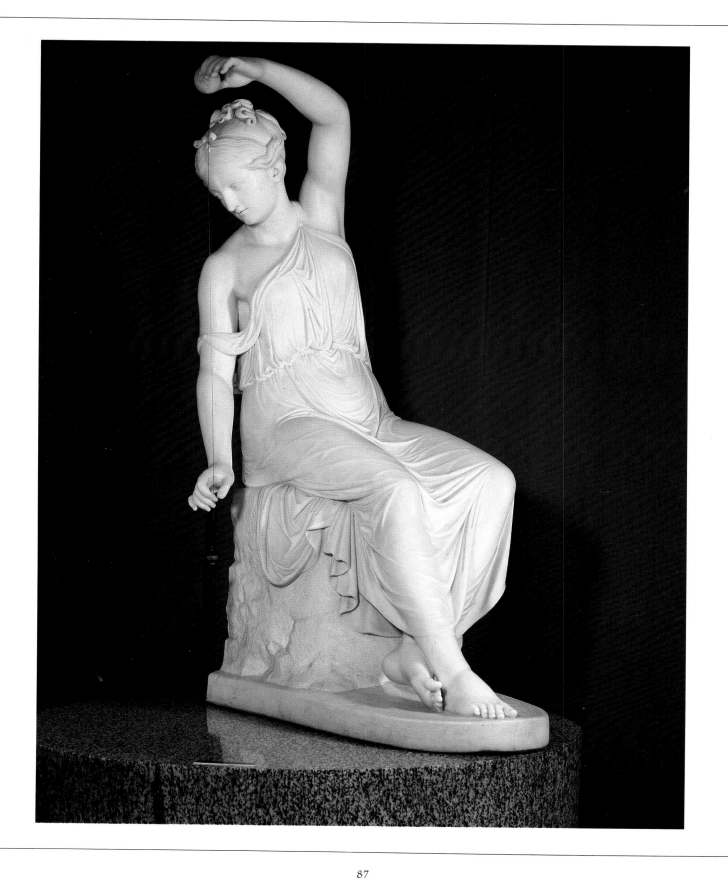

Sir Jacob Epstein (1880–1959)
A Portrait Bust of Lady Sophia Cavendish, as an Infant

Bronze, 45.7 cm high

The bust was modelled by Epstein in 1959, when Lady Sophia
was two years old, and was the last but one work he
completed before his death that year. Lady Sophia is married
to Mr Alastair Morrison and is the younger daughter of the
present Duke and Duchess of Devonshire.

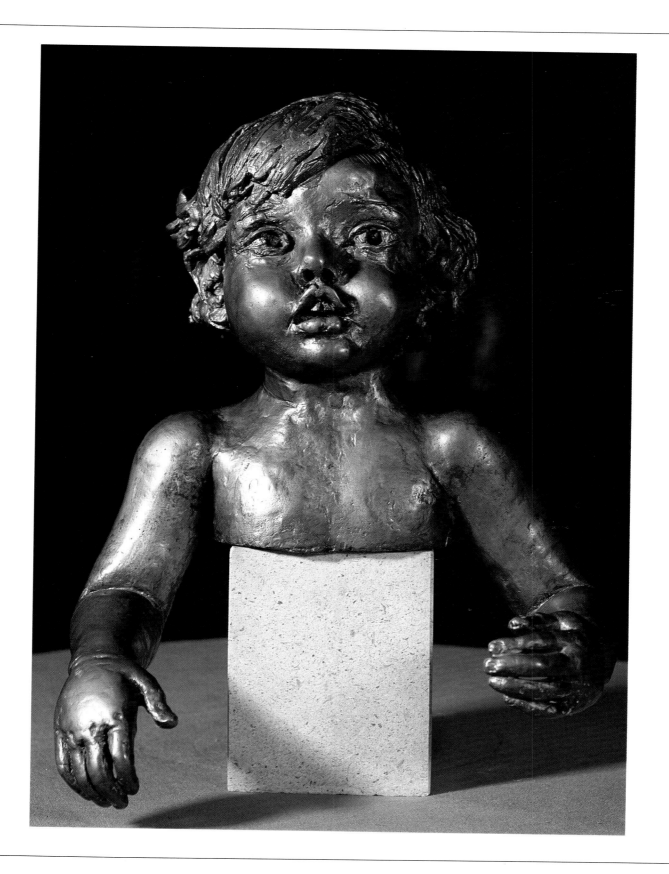

Angela Conner
A Portrait Head of Lucian Freud

Bronze, 51 cm high

The head was made in 1974. There are several portrait heads
by Angela Conner at Chatsworth, all of which are of friends
or relatives of the present Duke of Devonshire and were
bought or commissioned by him. The artist herself works
mainly as a painter in London and New York. (For details of
Lucian Freud see page 60.)

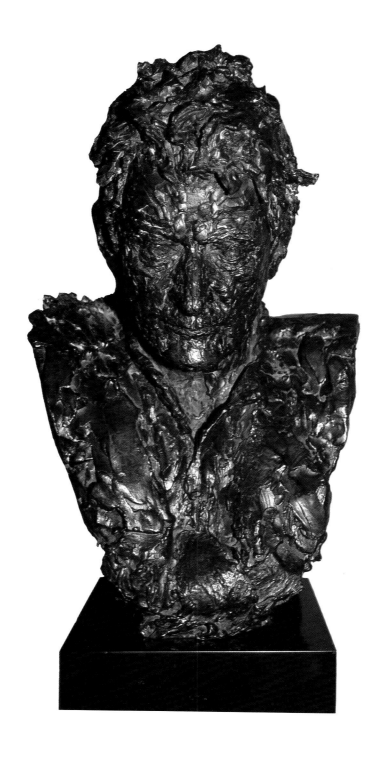

DRAWINGS

The art collection at Chatsworth is best known internationally for its Old Master drawings, groups of which are lent each year to exhibitions at home and abroad. Unlike the paintings, the drawings collection is well-balanced, and there is no great period or phase of art in Europe from the Renaissance until the end of the seventeenth century that is not represented, and hardly a great name missing. As an historic family collection it is unrivalled in this country or in Europe.

Old Master drawings were rarely made for their own sake but for various stages in the preparation of paintings, sculpture, or other works of art. The tradition of saving and collecting them seems to go back no further than Giorgio Vasari, the Florentine painter and biographer, in the mid-sixteenth century, and was continued by other painter-collectors like Rubens and Sir Peter Lely. The dispersal of the collections of Charles I and the Earl of Arundel, the first great English connoisseur, made the period of the Commonwealth and the Restoration a particularly fruitful one for Lely and his assistant Lankrink; and it was in turn the sales of their collections at the end of the seventeenth century that precipitated the golden age of the English 'amateur'. William Cavendish, second Duke of Devonshire, was, before he inherited the title, a prominent bidder at these sales, and by the time of his death in 1729 he had made one of the finest collections both of drawings and prints in the country, a collection extended by his son the third Duke. An early biographer of the second Duke wrote that: 'he was serious and learned in his purpose, not fashionable or ostentatious'.

The Italian artists of the fifteenth century, the High Renaissance, and the succeeding Mannerist and Baroque periods are represented in strength, together with German and Flemish artists of the sixteenth century and Dutch and French artists of the seventeenth. There are especially strong groups by Raphael and his school, by Rubens, Van Dyck and Rembrandt.

The drawings collection of the third Earl of Burlington, which was added to these riches in 1753, was formed solely for architectural purposes and almost entirely devoted to the two architects Burlington most admired, Andrea Palladio and Inigo Jones. However, it included a unique series by Jones of more than 400 designs for the costume and scenery of Court masques, which now provide the only visual evidence for these splendidly elaborate but otherwise ephemeral entertainments.

There are small groups of water-colours and pastel portraits at Chatsworth, framed and hung, including some outstanding examples by Jean Etienne Liotard (1702–89). To these the present Duke of Devonshire added in 1977 two highly finished pictures in water-colour and gouache by Samuel Palmer (1805–81). In contrast to the earlier tradition of drawing and water-colour, they are fully the equivalent of oil paintings and are displayed in elaborately gilt frames accordingly.

Leonardo da Vinci (1452–1519)
Leda and the Swan

Pen and brown ink and brown wash over black chalk on
paper, 16 × 13.9 cm

The drawing is inscribed in an old hand 'Leonardo da Vinci',
and is one of a number of studies the artist made for this
subject, which shows Leda with Jupiter in the form of a swan
and the eggs that resulted from their union. The children
hatching from the eggs are two pairs of twins, Castor and
Pollux and Helen and Clytemnestra.

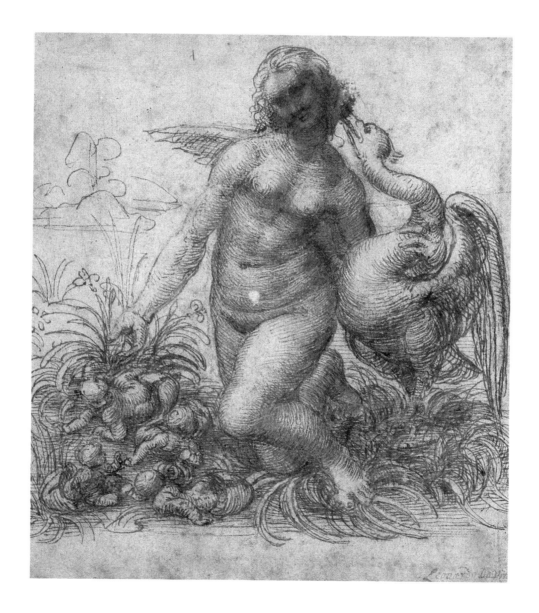

Raffaello Sanzio, called Raphael (1483–1520)
A Study of Three Nude Men in Attitudes of Terror

Black chalk on paper, 23.7 × 36.8 cm

The drawing comes from the Flinck collection (for details see page 114). It is a study for a composition of *Christ Rising from the Tomb*, on which Raphael was engaged at some time near the end of his life but which was never carried out as a painting.

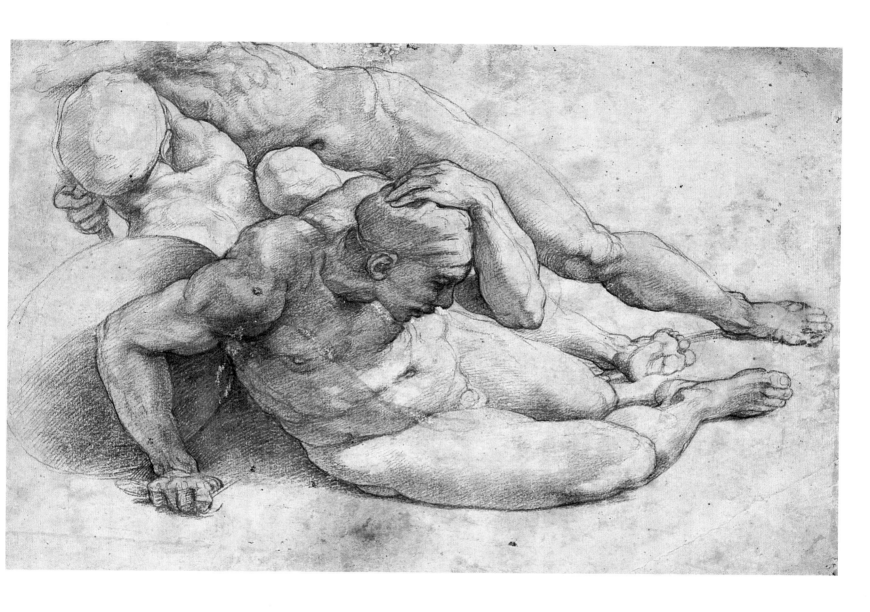

Attributed to Raffaello Sanzio, called Raphael (1483–1520)
A Cartoon for the Head of Pope Leo X

Black chalk on paper with the lines indented, 48 × 29.9 cm

The drawing has the collector's mark of the second Duke of
Devonshire, and has an inscription on the back in the hand of
Padre Sebastiano Resta (1634–1714), who formed a large and
famous collection of drawings for the Bishop of Arezzo,
Giovanni Matteo Marchetti. Its attribution to Raphael is by
no means certain, as there are equally strong arguments in
favour of its being by Giulio Romano (1485–1546), Raphael's
chief assistant in the painting of the Vatican frescoes.
Giulio completed the frescoes in the Vatican of the Sala di
Costantino, unfinished at Raphael's death, in which this
cartoon corresponds with the head of Pope Clement I. The
features, however, are those of Pope Leo X (1475–1521), for
whom the frescoes were painted.

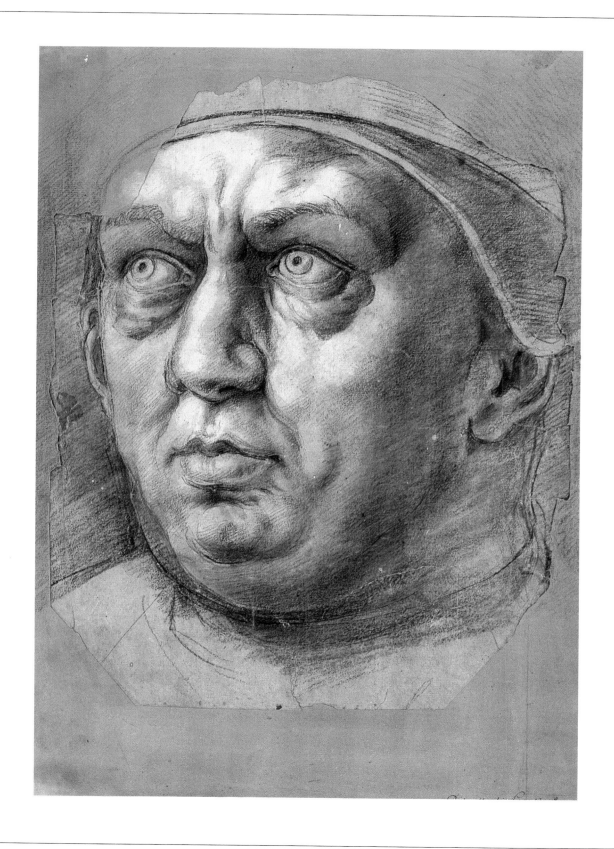

Francesco Mazzuoli, called Parmigianino (1503–1540)
A Design for part of the Vaulting of a Ceiling

Pen and brown ink and water-colour on paper, 23.3 × 17 cm

The drawing has an unknown collector's mark. It is one of the
more elaborate among a large group of studies Parmigianino
made for the decoration of the vaulting of the church of Sta
Maria della Steccata in Parma, on which he was engaged
between 1531 and 1539.

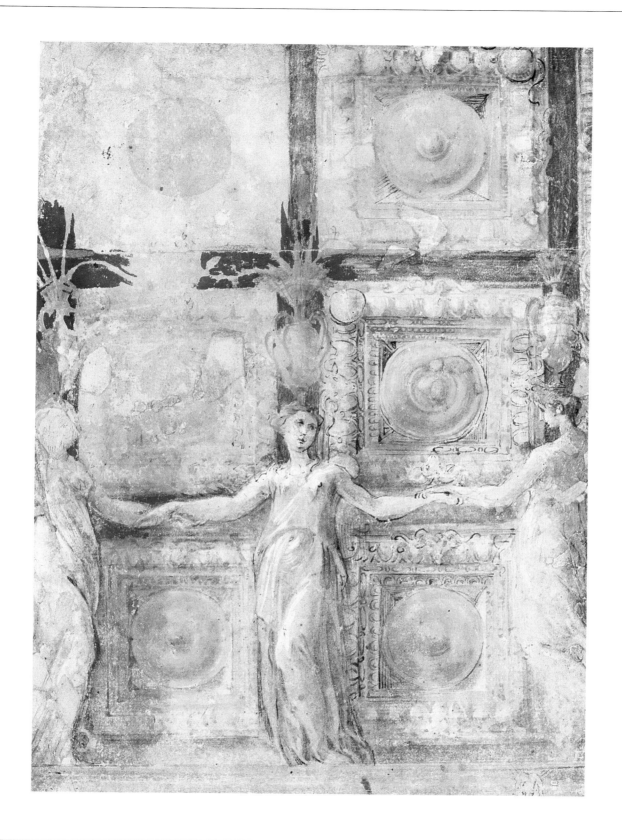

Federico Barocci (1526–1612)
The Assumption of the Virgin

Pen and brown ink and brown wash, heightened with white
over black chalk on grey paper, 52.2 × 36.7 cm

The drawing has the collectors' marks of Sir Peter Lely, his
assistant Prosper Henry Lankrink, and the second Duke of
Devonshire. It is a complete composition sketch for the great
altarpiece that was still unfinished at Barocci's death and
which is now in the National Gallery in Urbino.

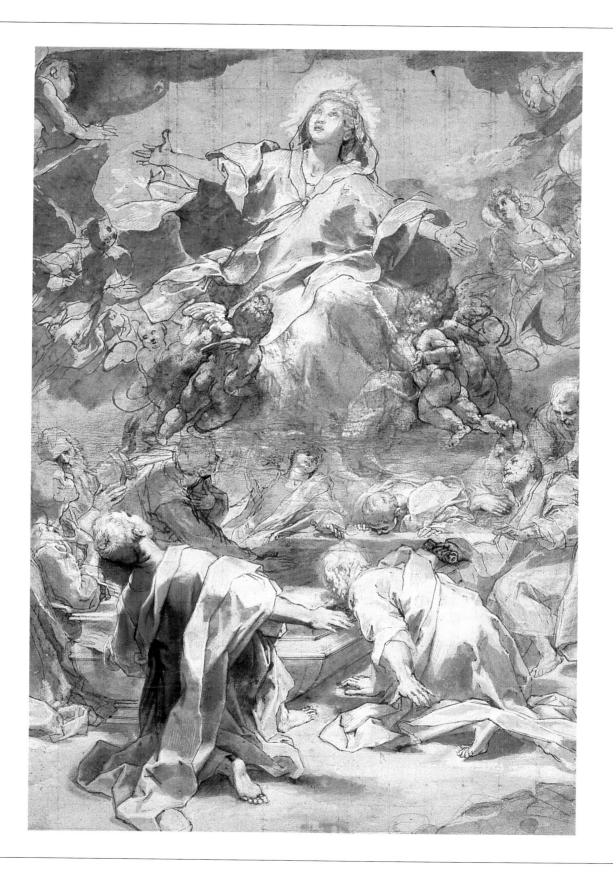

Albrecht Dürer (1471–1528)
A Women's Public Bath

Pen and brown ink on paper, 28.5 × 21.5 cm

The drawing is signed and dated 1516 and has the collector's
mark of the second Duke of Devonshire. Many years earlier,
in 1496, Dürer had already made a drawing of a women's
public bath, and there is also a well known woodcut by him of
about 1497 of a men's public bath.

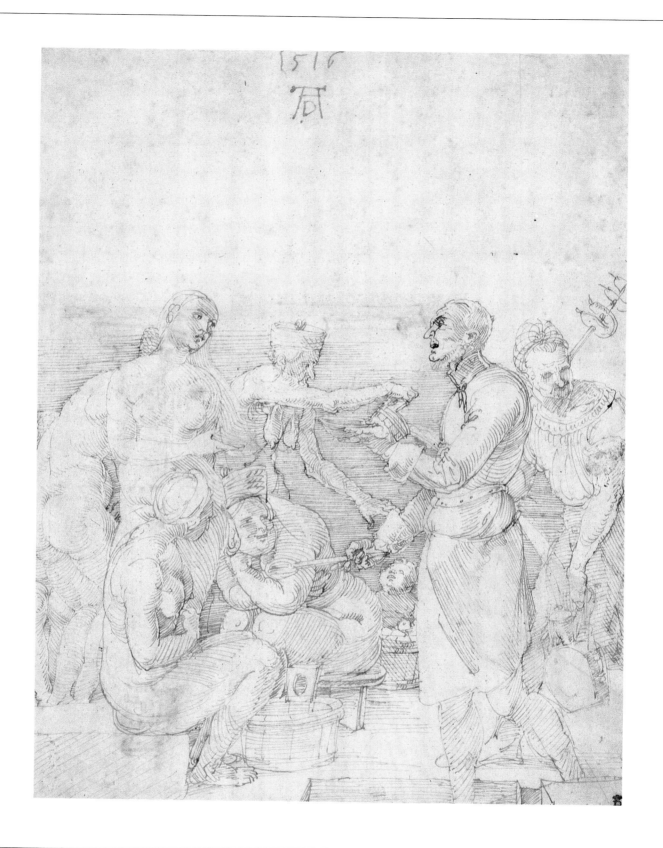

Albrecht Dürer (1471–1528)
The Virgin and Child with the Infant St John

Pen and brown ink on paper, 28.6 × 20.5 cm

The drawing has the collector's mark of the second Duke of
Devonshire, and is signed with the artist's monogram,
although this may have been added by another hand at a later
date. The style and type of the Virgin is closely related to
Dürer's woodcut of 1518 called *The Virgin with Many Angels*
and almost certainly of the same date.

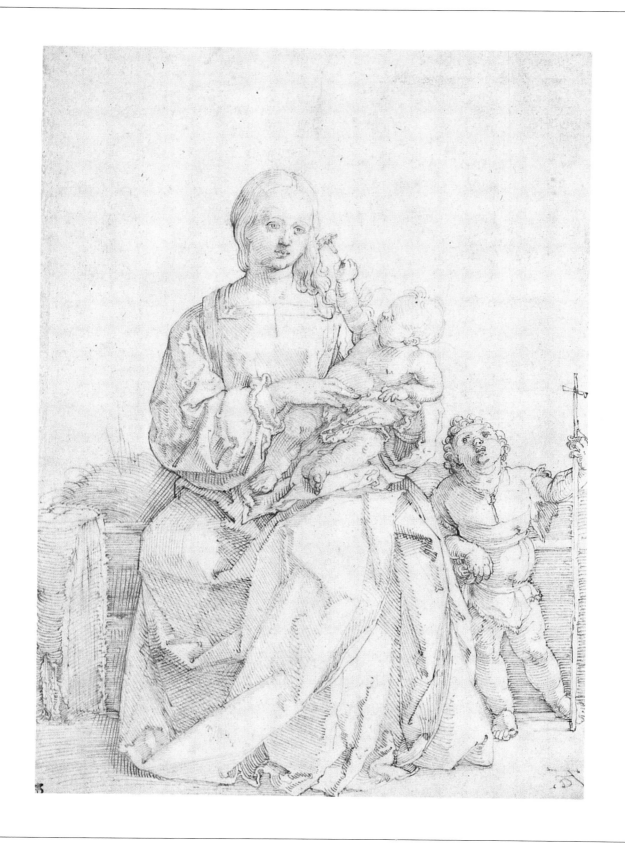

Jan Gossaert, called Mabuse (c. 1478–1533/36)
Adam and Eve

Pen and black ink heightened with white on paper with a
blue-grey prepared surface, 34.8 × 23.9 cm

The drawing has the collector's mark of N. A. Flinck (for
details see page 114). It is one of a series of drawings by
Mabuse of this subject and is dated about 1520.

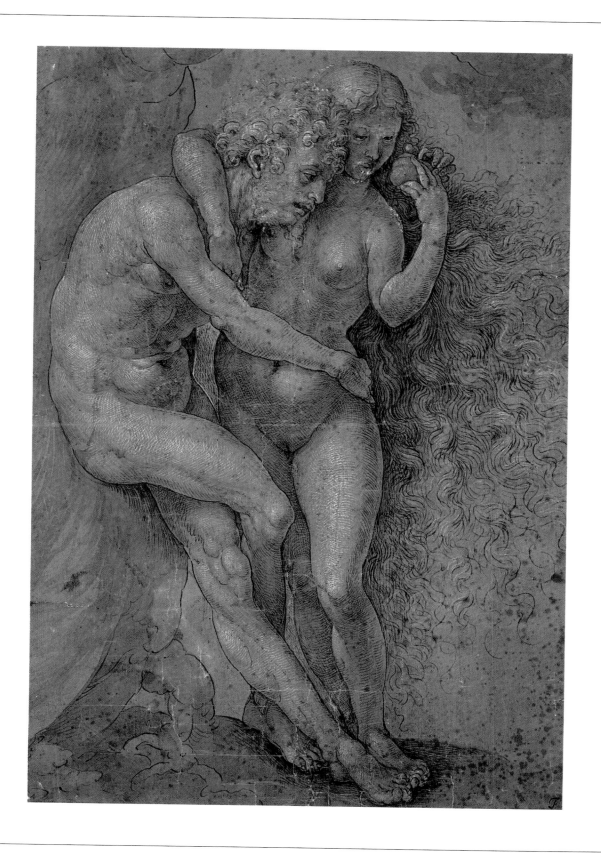

Sir Peter Paul Rubens (1577–1640)
A Study of a Tree-Trunk and Brambles

Red and black chalk, pen and brown ink and some water-
colour on paper, 35.2 × 29.8 cm

The drawing has an inscription in the bottom right-hand
corner in Rubens' hand which is translated as 'fallen leaves and
in some places green grasses peep through'. The study is
related to a drawing in the Louvre which was used by Rubens
in the painting of *A Boar Hunt* at Dresden, which dates from
about 1615–20.

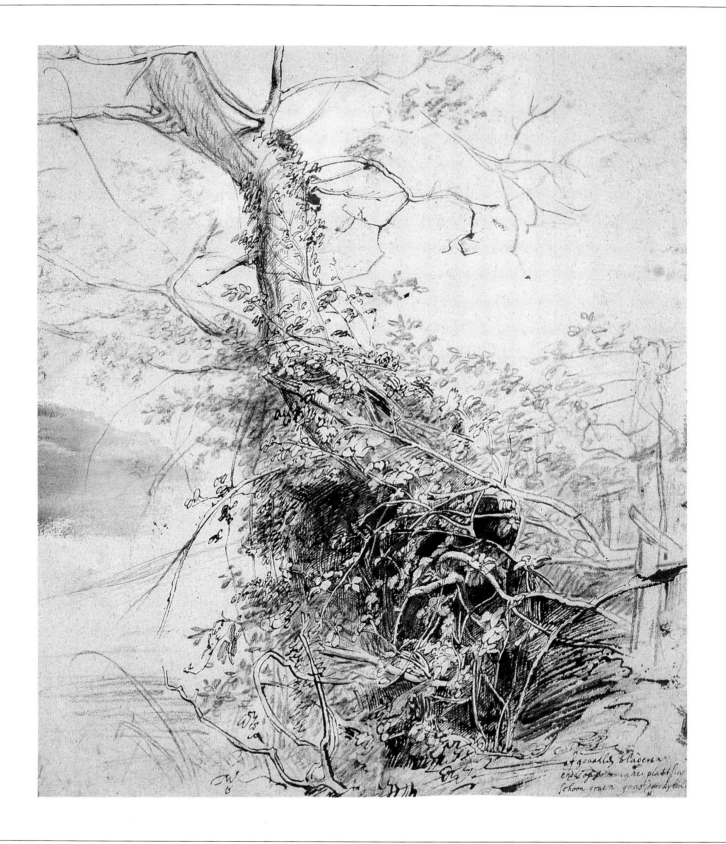

Sir Anthony Van Dyck (1599–1641)
A Study of the Head and Forequarters of a Horse

Black and white chalk on paper, 33.7 × 31.4 cm

The drawing is a study for Van Dyck's early painting of *St Martin Dividing his Cloak with a Beggar*, in particular the version in the parish church of Saventhem in Belgium. Another version of this painting is in the Royal Collection at Windsor.

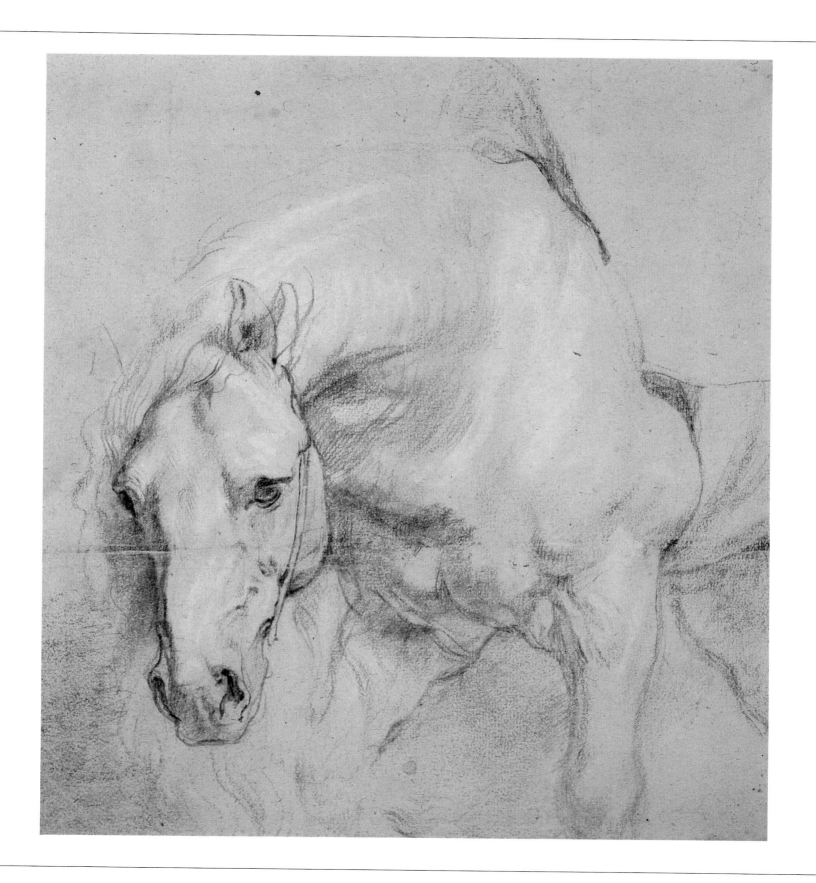

Rembrandt van Rijn (1606–1669)
An Actor in his Dressing Room

Pen and brown ink on paper, 18.3 × 15 cm

The drawing has the collector's mark of Nicolaes Anthoni
Flinck (1646–1723), who was the son of Rembrandt's pupil
Govaert Flinck. The major part of the Flinck collection of
drawings was bought by the second Duke of Devonshire in
1723, and other drawings from it were bought by the third
Duke in 1754.
Though the drawing is traditionally called *St Augustine in his
Study,* the subject is now believed to be an actor in his
dressing-room about to perform the part of Bishop Gozewije
in a tragedy entitled *Gijshecht van Aemstel* by the Dutch poet
Joos van den Vondel. The play was written in 1637 and first
produced in 1638, and the drawing was probably made at that
time. Rembrandt is known to have been in touch with Vondel
and may well have attended rehearsals of the play and visited
the actors in their dressing-rooms. Other drawings by
Rembrandt show individual actors and scenes from the play.

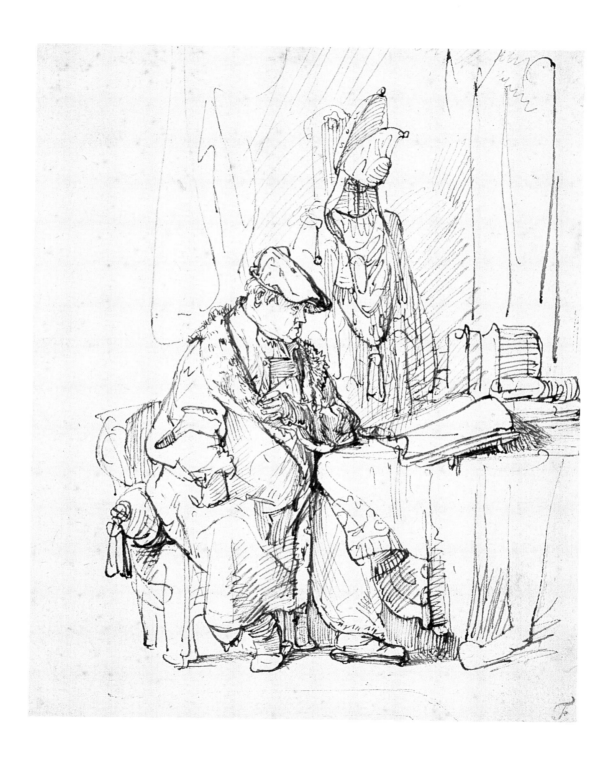

Rembrandt van Rijn (1606–1669)
**A View on the Bullewijk, looking towards the
Ouderkerk, Amsterdam, with a Rowing Boat**

Pen and brown ink and brown wash touched with white on
paper, 13.3 × 20 cm

The drawing has the collector's mark of N. A. Flinck (for
details see page 114), and is probably dated about 1650.
There are several landscape drawings by Rembrandt at
Chatsworth which, like this one, record views he saw while he
was out sketching in and around Amsterdam.

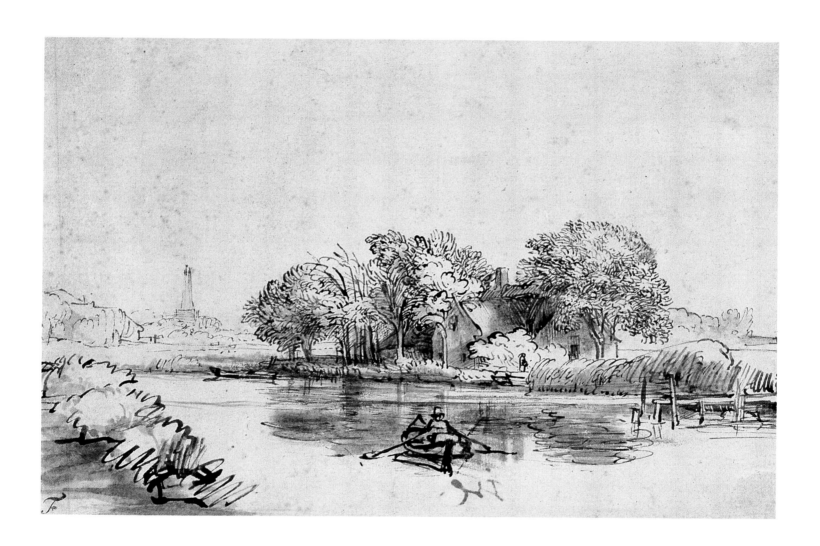

Rembrandt van Rijn (1606–1669)
A Thatched Cottage by a Large Tree

Pen and two shades of brown ink on paper, 17.5 × 26.7 cm

The drawing, which is the largest of Rembrandt's drawings at
Chatsworth, has the collector's mark of N. A. Flinck (for
details see page 114), and is probably dated about 1652.
The series of landscape drawings by Rembrandt at
Chatsworth, from which this and the preceding drawing come,
is without doubt a highlight of the collection, but they may
have been acquired almost by accident. If the great collection
of prints made by the second and third Dukes of Devonshire
at the same time is an accurate indication of their tastes, they
appear to have shown little interest in Rembrandt, for very
few of his etchings are included. It may be, therefore, that this
series of his drawings came into their hands only because it
formed part of the Flinck collection, which was prized above
all for the works of the great Italian masters it contained.
Rembrandt came to be appreciated generally in England only
towards the middle of the eighteenth century.

Claude Gellée, called Le Lorrain (1600–1682)
A Wooded Landscape with Jupiter and Callisto

Pen and brown ink and brown and grey wash heightened
with white over black chalk on paper, 25.7 × 33.5 cm

The drawing is signed and inscribed 'CLAUDIO INVFEC' and has
the collector's mark of the second Duke of Devonshire. It
shows the nymph Callisto in the foreground with Jupiter
disguised as Diana.

Inigo Jones (1573–1652)
A Costume Design for a Fiery Spirit Torchbearer

Pen and brown ink with watercolour on paper, 29 × 16 cm

The drawing is one of more than 400 designs by Inigo Jones
at Chatsworth for Court masques, all of which came from the
collection of the third Earl of Burlington. It is for *The Lords'
Masque* by Thomas Campion, which was staged at the
Banqueting House at Whitehall on 14 February 1613 in
honour of the marriage of James I's eldest daughter Elizabeth
to Frederick, Elector Palatine of the Rhine. The text refers to
'Sixteene Pages, like fierie spirits, all their attires being alike
composed of flames, with fierie Wings and Bases, bearing in
either hand a Torch of Virgine Waxe'.

Inigo Jones (1573–1652)
A Design for an Elephant Pageant

Pen and brown ink and brown wash on paper, 29 × 20.6 cm

The drawing is included in the collection of more than 400
designs by Inigo Jones at Chatsworth for Court masques, and
belonged to the third Earl of Burlington (see page 122). It was
probably a design for the elephant pageant of Richard
Preston, Lord Dingwall (died 1628), Gentleman of the King's
Privy Chamber and instructor in arms to Prince Henry,
James I's eldest son.
The pageant formed part of an Accession Day Tilt which took
place on 24 March 1610, and which was especially elaborate
in order to impress the Duke of Brunswick who was present
on that occasion. From contemporary descriptions it is clear
that the entrance of Lord Dingwall caused a sensation. He
arrived in a pageant 'which was an Elephant with a castle on
the back . . . it was as long a coming till the running was well
entered into, and was then as long a creeping about the Tilt-
Yard, all which while the running was intermitted'.

Jean Etienne Liotard (1702–1789)
A Portrait of Mrs Garrick

Pastel colours on paper, 62 × 47.5 cm

Eva Marie Veigel (1724–1822), known by her stage name as
Violette, was a celebrated Viennese ballet-dancer who in 1749
married David Garrick, the famous actor. Both were friends of
the third Earl and Countess of Burlington and later of the
fourth Duke of Devonshire. Liotard was a Swiss pastellist who
worked throughout the Continent and who had great success
in England, which he visited from 1753 to 1755 and from
1772 to 1774.

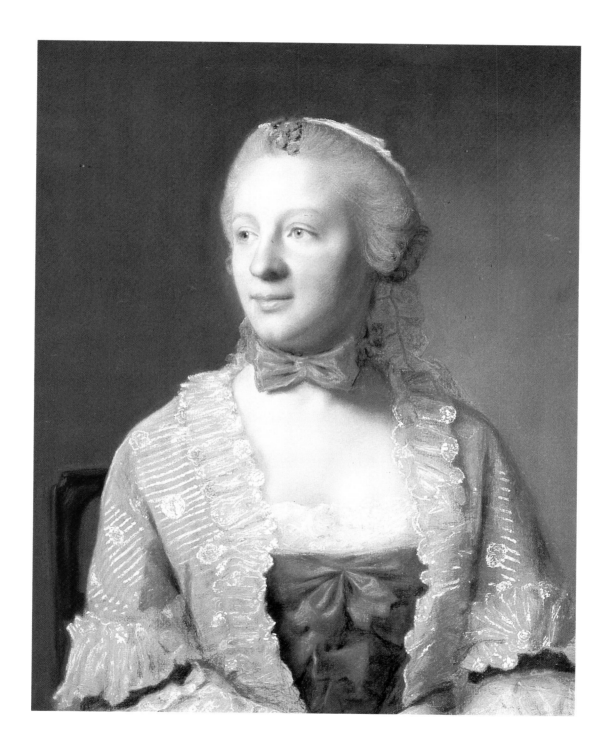

Samuel Palmer (1805–1881)
The Bellman

Water-colour and body-colour on paper, 51 × 70 cm

The drawing was originally commissioned by Palmer's friend
C. R. Valpy and was bought by the present Duke of
Devonshire in 1977. It is an illustration to Milton's poem 'Il
Penseroso', which includes the lines 'And the Bellman's
drowsy charm, To bless the doors from Nightly harm'. The
pair to it, which is called *Morning*, is also at Chatsworth and
illustrates another passage from the same poem. *Morning* was
painted in 1869 but *The Bellman* was not painted until 1881,
the year of Palmer's death.

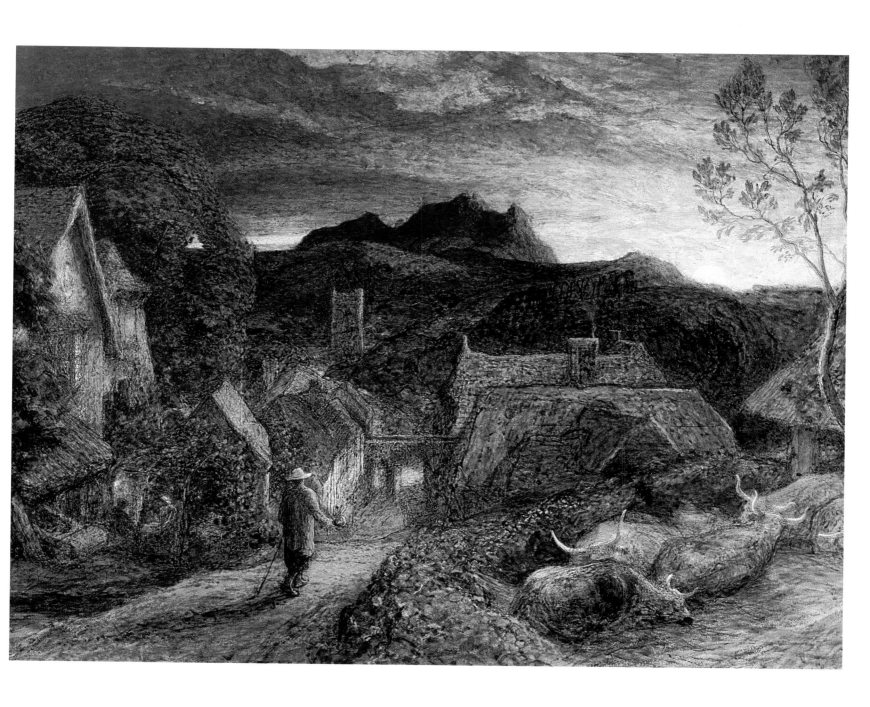

GOLD AND SILVER

The collection is especially famous for the pieces made by refugee Huguenot goldsmiths in London, who were protected by William III against French persecution and patronized by the first Duke of Devonshire, one of the King's closest supporters. Like the new house at Chatsworth itself, which the first Duke rebuilt in palatial style, magnificent show plate such as his chandelier, perfume-burner, wine-coolers and 'pilgrim' bottles made manifest his high standing and power in the land, no less than it embodied his wealth.

The Huguenot style was more boldly decorative than the Dutch style favoured in England before the French refugees arrived, and surfaces were often much enriched with cast and applied work. It was still less elaborate, however, than the style carried to a pitch of refinement by contemporary goldsmiths in Paris. An outstanding and extremely rare example is the sumptuous toilet service bearing the arms of William and Mary, by Pierre Prévost, which was presumably given to the first Duke by Mary herself.

Because gold and silver plate was, for all its decoration, an important form of wealth, it usually reveals more clearly than other possessions the pattern of inheritance from one generation to another. Rich additions to the mainstream were brought by heiresses on marriage or bequest, such as the Savile Cup and Cover which is the earliest English piece in the collection. Charlotte Boyle, from whose maternal ancestors this cup descended, was by far the most important of these heiresses, but the silver-vaults at Chatsworth provide ample evidence of others.

Almost the equal in quality and extent of the Huguenot pieces is the Regency silver, by Paul Storr, Robert Garrard and others, bought or commissioned by the sixth Duke of Devonshire. Today some of these makers' finest pieces are displayed in the sixth Duke's Great Dining Room in the north wing of the house, completed in 1832, which together with the dining-room at Devonshire House provided their original setting.

English, c. 1650
The Savile Cup and Cover

Silver-gilt, 34.9 cm high by 26.9 cm diameter

The cup has no date letter but has the mark, a hound *séjant*, of
an unidentified London goldsmith reckoned to be the most
outstanding of the mid-seventeenth century. He was
patronized by royal and high-church circles and his work
survives for the twenty years from 1646 to 1666 at
Gloucester Cathedral, Winchester and Wadham Colleges,
Fulham Palace and elsewhere. Often the pieces he made show
Dutch influences in style, characteristic of the period.
The embossed arms on one side are those of Savile, later
Halifax, and on the other of Coventry. The owl on the top of
the cover is the crest of the Savile family, (see also page 223).
Sir William Savile married Anne, daughter of Thomas, Lord
Coventry and their son William became Marquess of Halifax
in 1668. He was the grandfather of Dorothy Savile, wife of
the third Earl of Burlington.

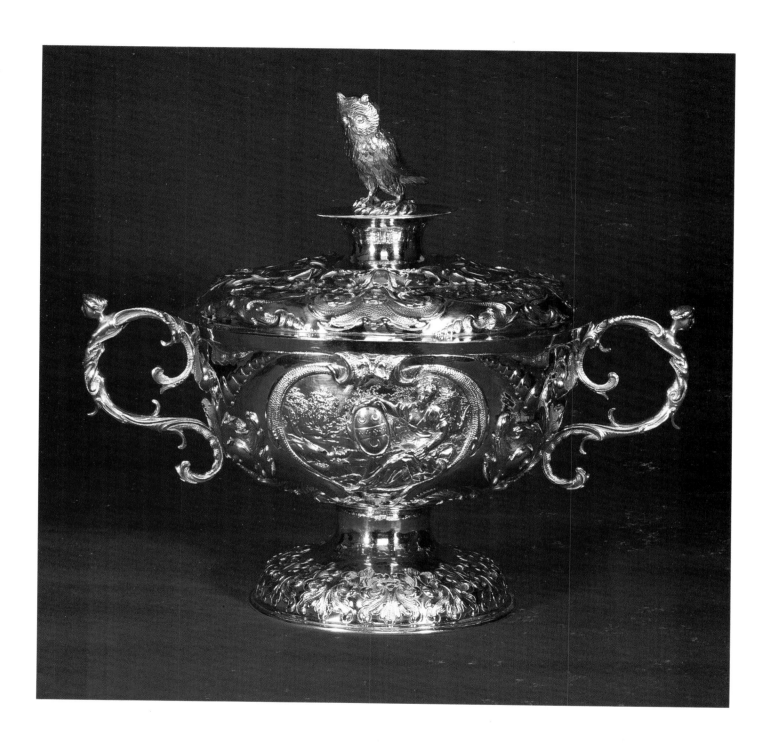

Italian, late seventeenth century
A Rose-Water Dish

Silver, 80 cm diameter

The dish has the mark of Rome, but the maker and date are
not known, and there is no record of when it was acquired. It
is embossed with a fully pictorial scene of Perseus
confounding his enemies by showing them the head of
Medusa, the Gorgon, which had the power of turning men to
stone. The setting is that of the wedding feast of Perseus and
Andromeda, which was interrupted by Phineus and his mob
of followers. Phineus was Andromeda's disappointed suitor.

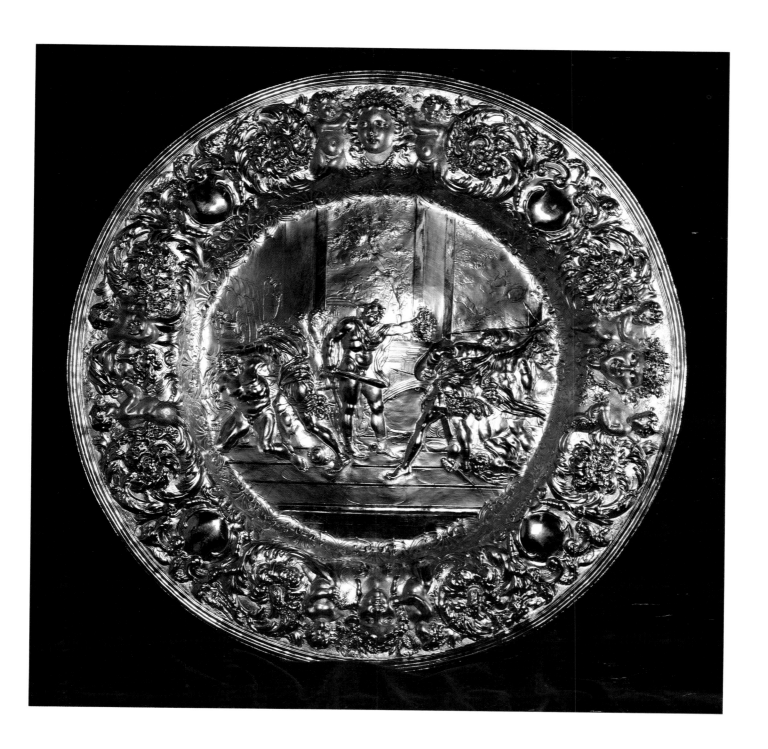

Pierre Prévost (b. 1640)
A selection from a Toilet Service

Silver-gilt. The complete service has twenty-three pieces: a mirror, a pair of candlesticks, a pair of powder flasks, a ewer and basin, a pair of caskets, a small bowl and cover, a mug, a pair of oval salvers, a circular salver, a jewel casket, a pair of octagonal boxes, a pair of circular boxes, two small oval boxes and a snuffer tray and snuffers.

The maker's mark, where legible, is that of Pierre Prévost, who became a master goldsmith in 1672 and worked in Paris until 1716. The service is reckoned to be the most important surviving toilet service in Western Europe and was probably acquired by purchase or gift for the marriage in 1677 of William, Prince of Orange, to the Princess Mary. The pieces are all richly decorated with embossed flowers and foliage and embellished with the applied arms and monogram of William and Mary. The service must therefore have belonged to Queen Mary, who presumably made a gift of it to the first Duke of Devonshire, who had helped secure the English throne for herself and King William at the Glorious Revolution of 1688.

Surviving examples of French silver of the period of Louis XIV are extremely rare, as nearly all pieces were melted down by order of Louis himself to raise money for his wars. Only three marked toilet services, including this one, escaped this fate, having been taken out of France by their foreign owners.

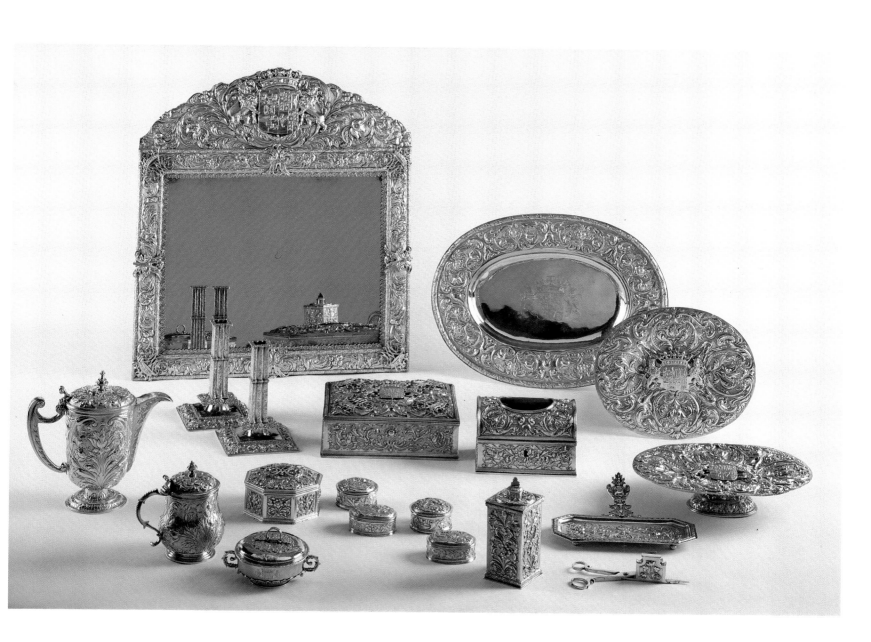

Adam Loots (active late seventeenth century)
A pair of Pilgrim Bottles

Silver-gilt, 46.9 cm high
The bottles are marked AL, probably for Adam Loots, The
Hague, 1688, and are engraved with the arms of the first
Duke of Devonshire within the Garter. Loots was goldsmith
to Prince William of Orange, later King William III, who
probably gave them to the first Duke, one of his
closest supporters.
'Pilgrim' bottles are called after the traditional leather water-
bottle of the medieval pilgrims from which they are presumed
to derive. Large silver flasks of this shape survive from the
sixteenth century in French and English examples, in the
Louvre and the Kremlin and in the collections of a few noble
English families. This pair is believed to be the only surviving
Dutch example.

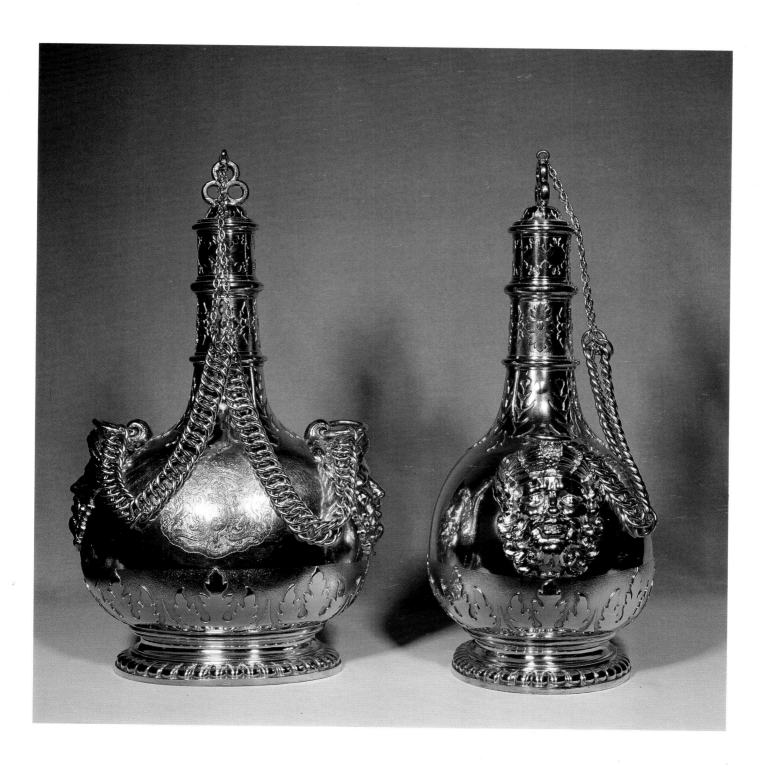

English, c. 1690
A Perfume-Burner

Silver, 87.6 cm high

The maker's mark, P.R. in a shield, is very possibly that of the
Huguenot Philip Rollos who was known to have been in
England by 1691, although he was not made a Freeman of the
Goldsmith's Company until 1697. Perfume-burners, which
were probably once common in brass and copper, have
survived in silver only in a few great family collections. This
is the largest and heaviest recorded.

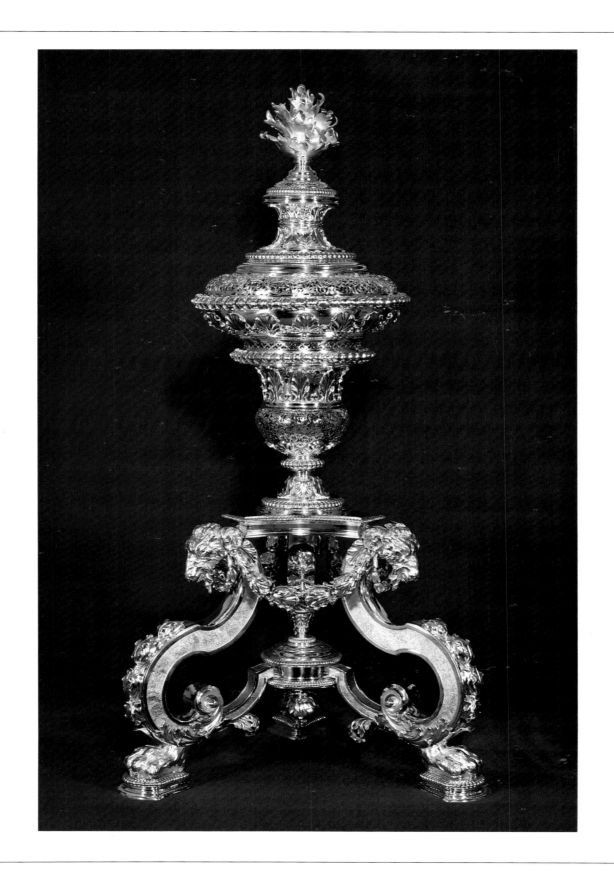

English, late seventeenth century
A Chandelier

Silver, 97 cm wide

The chandelier has ten lights, and on the upper part of each of
the scrolled branches sits a winged *putto* holding a shield with
an earl's coronet (with ball finials). The central *putto* on top,
however, holds aloft a duke's coronet (with strawberry
leaves), and it is traditionally believed from this that the
chandelier was made to commemorate the fourth Earl of
Devonshire's elevation to the dukedom as first Duke of
Devonshire in 1694.
The piece is unmarked and was long thought to be Dutch,
possibly a gift from King William and Queen Mary. However,
it is now generally considered for reasons of style to be by an
English maker.

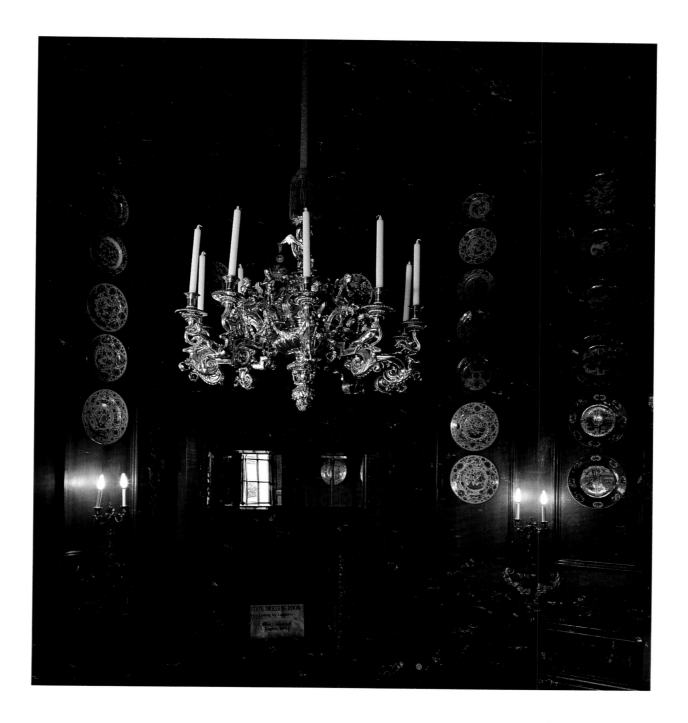

David Willaume (1658–1741)
A pair of Wine-Coolers

Silver-gilt, 24.7 cm high

The wine-coolers have the mark of David Willaume, London,
1698–99, and are engraved with the arms of the first Duke of
Devonshire. They are probably the earliest surviving single
ice-pails. Willaume was born at Metz and was a leading
Huguenot goldsmith in London. He was working there by
about 1686 and became a Freeman of the Goldsmiths'
Company in 1693.
The 'cut-card' style of decoration round the sides of the pails
was popular at this period, and consists of soldering patterns
cut from flat sheets of silver to the surface of the vessel.

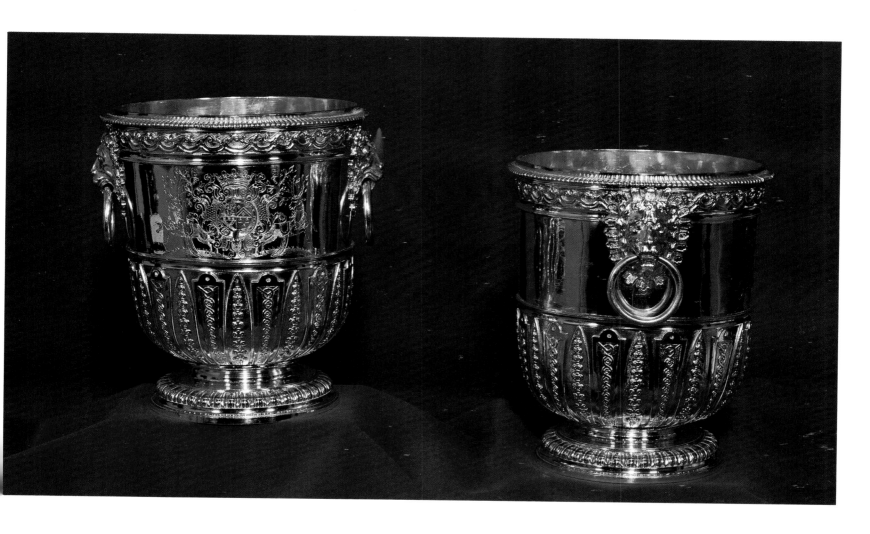

Pierre Platel (active 1699–1719)
A Ewer and Basin

Gold, the basin oval, 27.3 cm wide, the ewer 17.8 cm high

The pieces have the mark of Pierre Platel, London, 1701, and
are engraved with the arms of the first Duke of Devonshire
within the Garter. Platel was a French Huguenot from Lille,
who arrived in England with his brother Claude as a page in
the train of William III in 1688. He was made a Freeman of
the Goldsmiths' Company in 1699 and was later patronized
by George, Prince of Wales (afterwards George II) for whom
he provided a complete service of plate. This solid gold
helmet-shaped ewer and basin, however, is reckoned to be his
masterpiece. One of Platel's apprentices was Paul de Lamerie
(see page 152).

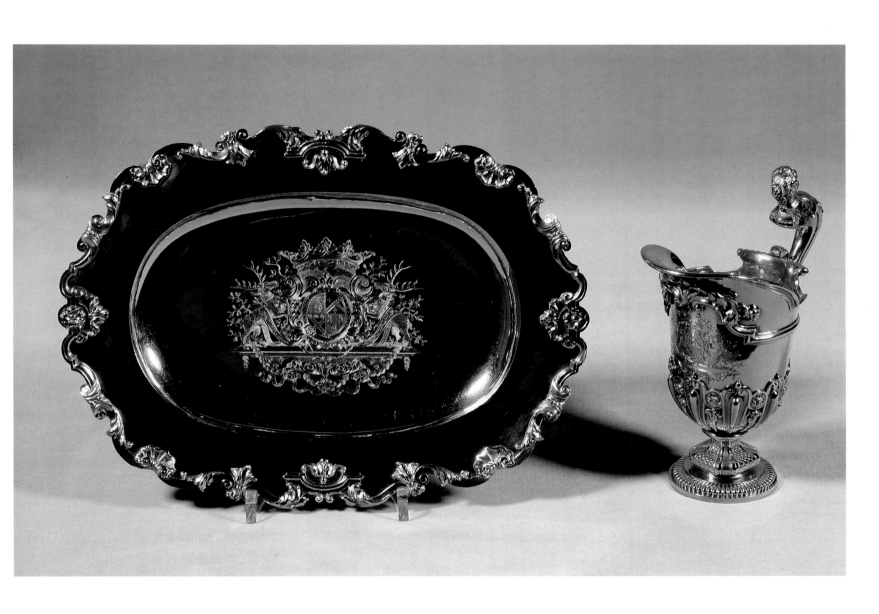

English, early eighteenth century
Two Exchequer Seal Salvers

Silver-gilt, each 31.7 cm diameter

One salver is engraved with the Exchequer Seal of William III
and the other with that of Queen Anne. Both are engraved
with the Boyle arms and the first is signed S.G. for Simon
Gribelin (1661–1733), the leading Huguenot engraver of plate
in London at this period.

From at least the reign of Elizabeth I it became the custom for
the holders of the great seals of the Kingdom to retain the
seal itself on the death of the sovereign or if a new seal was
to come into use, and to make a commemorative cup and
salver from the silver of which it was made. Henry Boyle,
third son of Lord Clifford of Londesborough, held the office of
Chancellor of the Exchequer from 1701 to 1708. This meant
that he not only received the seal made obsolete by the death
of William III in 1702 but also the one discarded after the Act
of Union with Scotland in 1707, which was passed while
Anne was on the throne. Henry Boyle was a relative of the
third Earl of Burlington, to whom the seals presumably
descended.

Paul Crespin (1694–1770)
An Inkstand

Silver-gilt, 25 cm wide

The inkstand has the mark of Paul Crespin, London, 1739–40,
and was bought by the sixth Duke of Devonshire in 1822 at
the sale of the contents of Wanstead House in Essex. The
working of it into shells of different shapes is typical of the
Rococo style associated with Crespin, who was a silversmith
from a refugee Huguenot family that had settled in London
about 1687.

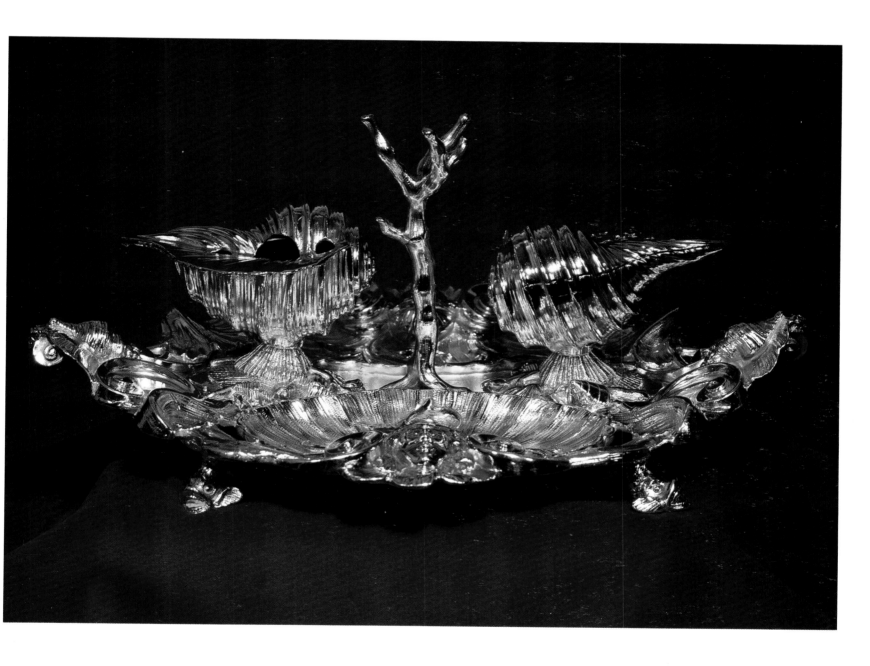

Paul de Lamerie (1688–1751)
A Bread Basket

Silver, 38 cm wide

The basket has the mark of Paul de Lamerie, London, 1732–33, and is engraved with the Devonshire arms incorporating those of Burlington, which cannot have been added until after the marriage in 1748 of William Cavendish, later fourth Duke of Devonshire, to Charlotte Boyle, the Burlington heiress. De Lamerie began as an apprentice in the workshop of Pierre Platel (see page 146) and became the best-known English silversmith of his day, a period during which the elaborate Rococo style flourished. This particular style of basket was his invention and there are several others by him of about the same date.

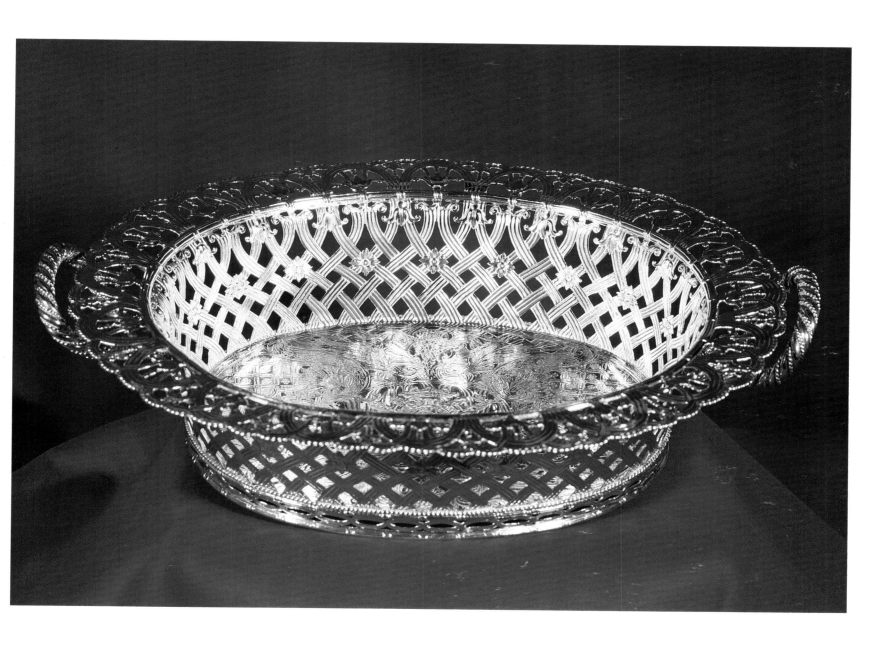

Richard Glynne (1696–1755)
A Universal Ring Dial

Silver, 25 cm high

Also known as an astrolabe, or heliochronometer, the
instrument was used in navigation to determine the elevation
of the sun above the horizon, and to read off the latitude and
time of day from the calibrated scales. It has a circular base
geared to rotate within a peripheral year calendar, a glazed
magnetic compass, and two spirit-levels set at right angles to
each other. The upper part has a twenty-four-hour chapter
ring and a plate pierced and engraved with the Devonshire
arms. There is no record of when the instrument was acquired.
Richard Glynne had his workshop in Fleet Street, London,
where other makers of scientific instruments were based in the
eighteenth century.

Paul Storr (1771–1844)
A pair of Candelabra

Silver, 101.6 cm high

The candelabra have the mark of Paul Storr, London, 1813–14, and were bought by the sixth Duke of Devonshire. Examples of this great size were made for use at banquets, and similar pieces were supplied to the Prince Regent (later George IV) and leading families of the period. The ten lights of each rise on scrolling branches above three figures of Apollo, and the bases are decorated with applied shields showing the Devonshire arms between figures of stags, which are the arms' usual heraldic supporters.
Paul Storr was the leading silversmith of the Regency period and at the time these candelabra were made was in partnership with Rundell and Bridge, the royal goldsmiths.

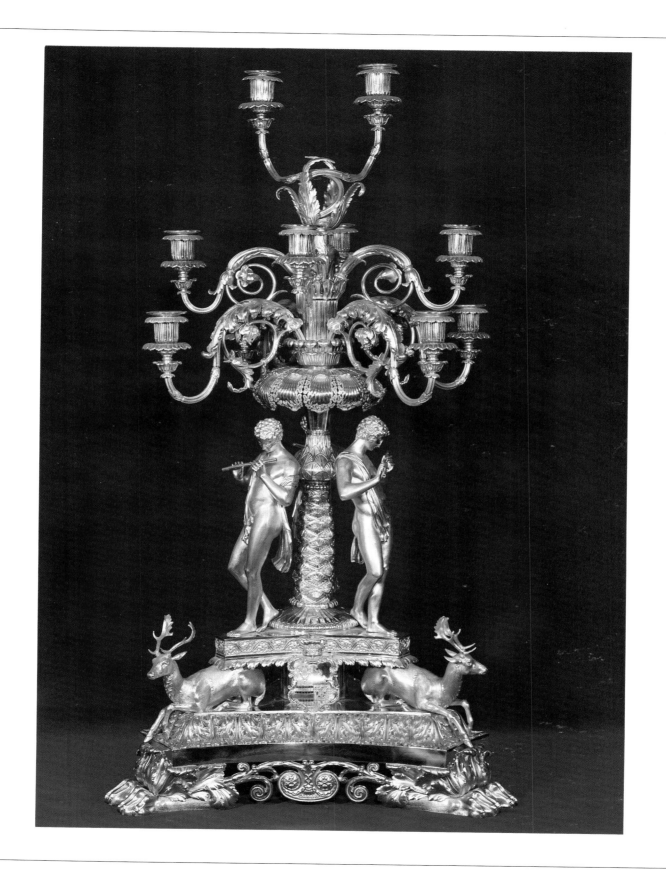

CERAMICS, JEWELLERY AND
OBJETS DE VERTU

Virtually no specific references to porcelain or pottery at Chatsworth appear in the surviving account books and inventories of the day, giving a clue to the largely functional origins of what has grown to become a large and miscellaneous collection. Rarities like the so-called Medici Cruet are very much the exception, but there are examples of services, part-services and individual pieces by most English factories, including Derby, Chelsea, Coalport, Worcester, Pinxton, Rockingham and Minton, as well as by European factories like Sèvres, Meissen, Dresden and Vincennes.

There are nevertheless more extensive groups of Oriental and Delft wares which date mainly from the period towards the end of the seventeenth century when the first Duke of Devonshire was rebuilding and furnishing his house. These are now a principal feature of the State Rooms and galleries on the top floor. Later, when true porcelain was being produced both in England and Europe, it was possible for much of the household's needs to be provided locally from the factory established at Derby in 1756. The 'Bolton Abbey' service made there for the sixth Duke of Devonshire is the best known of these commissions.

Although there are wonderful examples at Chatsworth of jewellery in the conventional sense of the word, including the diamond tiara and the diamond-set watch and châtelaine selected here, the term also covers the second Duke of Devonshire's famous collection of carved and engraved gem-stones from classical and Renaissance times. These were published in an illustrated catalogue in the second Duke's own lifetime. The materials used — agates, chalcedonies, rubies, emeralds and sapphires — were rare, and the art of carving them with miniature sculpture in relief or intaglio made them even more so.

The astonishing Devonshire Parure, commissioned by the sixth Duke of Devonshire in 1856, brought together both forms of jewellery in a single ensemble, incorporating many of the rarest and finest gems from the second Duke's collection in a group of seven pieces which are designed to be worn.

Objets de vertu is the term used to embrace other family treasures, usually precious personal items like snuff-boxes, but also including otherwise unclassifiable pieces like the extraordinary Kniphausen Hawk.

Italian, c. 1580
'The Medici Cruet'

White soft-paste porcelain painted in blue, 17.3 cm high

Most of the porcelain at Chatsworth was bought or commissioned for use rather than collected for its beauty or rarity, but the so-called 'Medici Cruet' is an exception, even though there is no record of who acquired it.

It is an oil and vinegar bottle, shell-shaped, with a double spout, and is painted with stylized scrolling foliage in the Oriental style. The Medici porcelain factory in Florence was the first European factory to produce soft-paste porcelain of which examples survive, and only fifty-nine pieces, including this one, are known to exist.

Hard-paste or true porcelain, made from white china-clay, was not made in Europe until the early eighteenth century (at Meissen) but it was preceded by a number of imitations in soft-paste, all aiming to discover the Chinese secret. Medici porcelain was the first European attempt, and was made from a mixture of ingredients which resulted in a greyish or yellowish white.

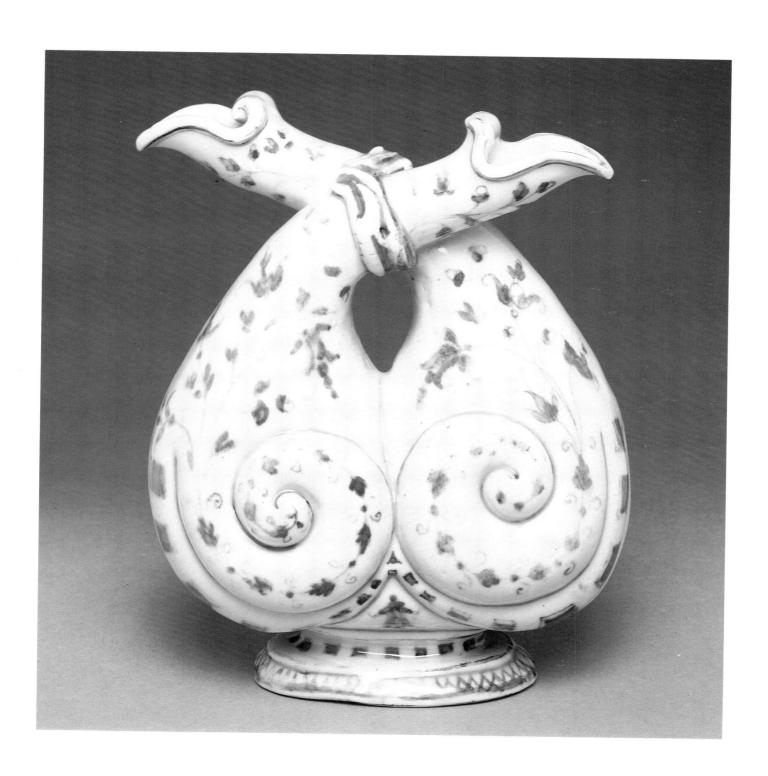

Adriaen Koeks (d. 1701)
A Tulip Vase

Tin-glazed earthenware, 117 cm high

The vase, which has a square base supporting seven separate
tiers, was made in Delft and is marked AK for Adriaen Koeks.
The base is painted with the Virtues of *Prudence, Hope, Justice*
and *Charity*, with supports formed as human busts and snakes.
Each tier in the stack has four separate nozzles, modelled as
grotesque masks, to take single blooms.
There are several tulip vases and other pieces of Delftware at
Chatsworth (see also page 165), which like this one were
probably bought by the first Duke of Devonshire, following
the fashion set by Queen Mary after she came to the throne
of England with William III in 1688. Mary bought many vases
and other fanciful Delftware for Hampton Court, the Palace
which William rebuilt and enlarged.
There are very few contemporary pictures of tulip vases in
use, but there are enough to show that these vases were
intended for the display of a variety of cut flowers, not
just tulips.

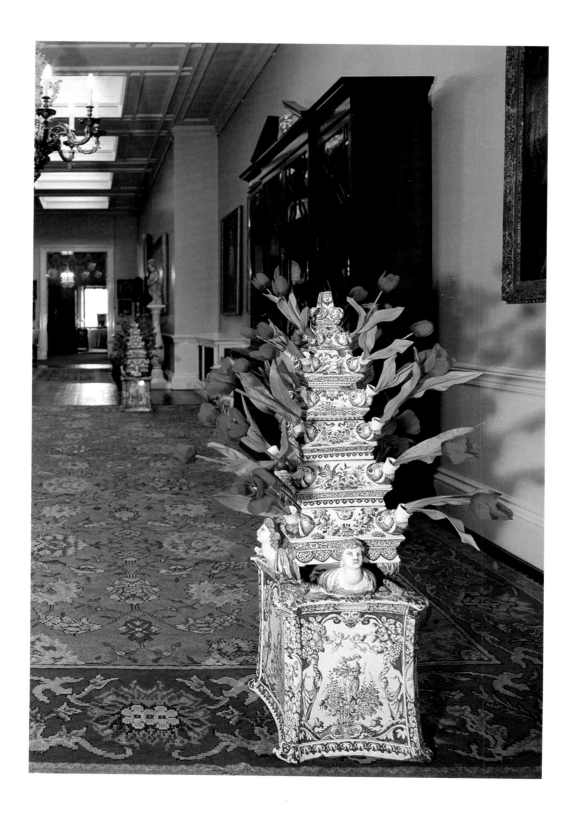

Adriaen Koeks (d. 1701)
A Tulip Vase

Tin-glazed earthenware, 104 cm high

The vase, which separates into the base, the body and two
tiers of nozzles, is marked AK for Adriaen Koeks. Its baluster
shape is unlike any of the other tulip vases at Chatsworth (see
page 163), and it is also the best preserved of the group.

Chinese, K'ang Hsi period (1662–1772)
A Pair of *Famille Verte* Vases

White porcelain painted in enamel colours, 30.5 cm high

Most of the larger Oriental ware at Chatsworth, including
vases like these, and dishes, bowls and jars, is of the K'ang Hsi
period and therefore likely to have been bought by the first
Duke of Devonshire, both for use and decoration, during the
period he was rebuilding the house. At that time it was the
only true porcelain available and was imported into Europe in
great quantities. Like other great houses towards the end of
the seventeenth century, Chatsworth originally had a room
wainscoted with colourful lacquer panels in the Oriental style,
doubtless a setting for the display of fine or curious pieces of
Oriental porcelain.

The so-called *famille verte* palette, based on a brilliant apple-
green, became especially popular during the reign of the
Emperor K'ang Hsi. The vertical panels of these vases are
painted with butterflies, birds and flowers.

Japanese, eighteenth century
A pair of Dragon-headed Carp, Leaping from Waves

White porcelain painted in blue and red, 32 cm high

The carp, which have iron-red six character marks, are
displayed with other Oriental porcelain in the Oak Room at
Chatsworth, which was reconstructed in curious fashion in the
1830s by the sixth Duke of Devonshire using carvings from a
German monastery. Much of the pottery and porcelain shown
there today is of the eighteenth and nineteenth century and
may have been bought by him.

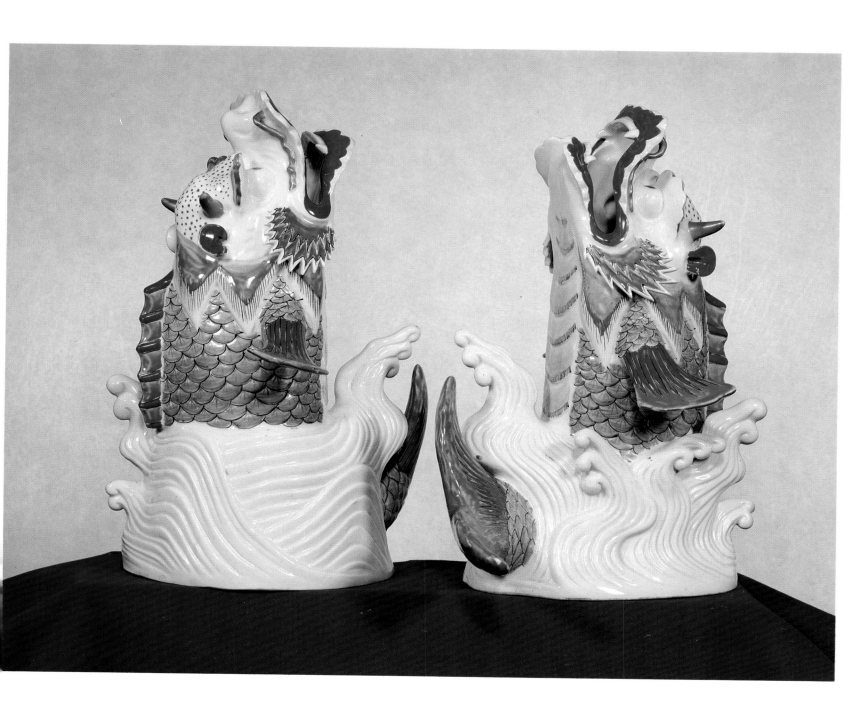

German, Berlin, c. 1780
A selection of pieces from a Dinner Service

White porcelain, each piece painted in colours

The service was bought at auction by the present Duke of
Devonshire in 1948 when it was sold by his wife's father,
Lord Redesdale. It originally belonged to Warren Hastings,
Governor-General of India, who sold it to John, first Baron
Redesdale in 1795 (see introduction, page 19).
The entire service is very large, comprising more than 200
pieces, each painted with birds perched on branches,
butterflies or moths. The Berlin factory where it was made
was bought in 1763 by Frederick the Great of Prussia and
then entered its most famous period. It has continued as a
royal and later a state-owned factory until the present day.

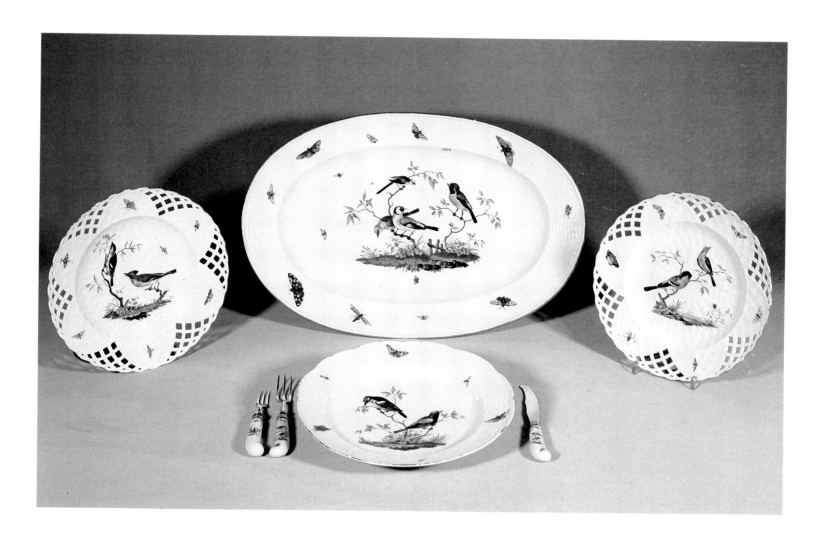

English, Derby c. 1815
A selection of plates from a Dessert Service

Bone china, painted on a deep blue ground with gilt borders,
each plate 24.7 cm diameter
The service was made by the Derby porcelain factory and is
traditionally known as the Bolton Abbey Service after the
house in Yorkshire where for many years it was kept. It
includes altogether thirty-six plates painted, like the ones in
this selection, with views of houses belonging to the sixth
Duke of Devonshire, for whom the service was made. The
views illustrated are (left to right, from the top) Lismore
Castle in County Waterford, Ireland; Hardwick Hall and
Chatsworth in Derbyshire; Bolton Abbey in Yorkshire; and
Chiswick House in Middlesex.
The paintings on the plates themselves and the preparatory
designs for them in water-colour, which are also in the
collection at Chatsworth, are by Robert Brewer (1775–1857)
who with his brother John continued the practice begun at
Derby by Zacchariah Boreman in the 1780s of decorating
porcelain with landscapes of local views.

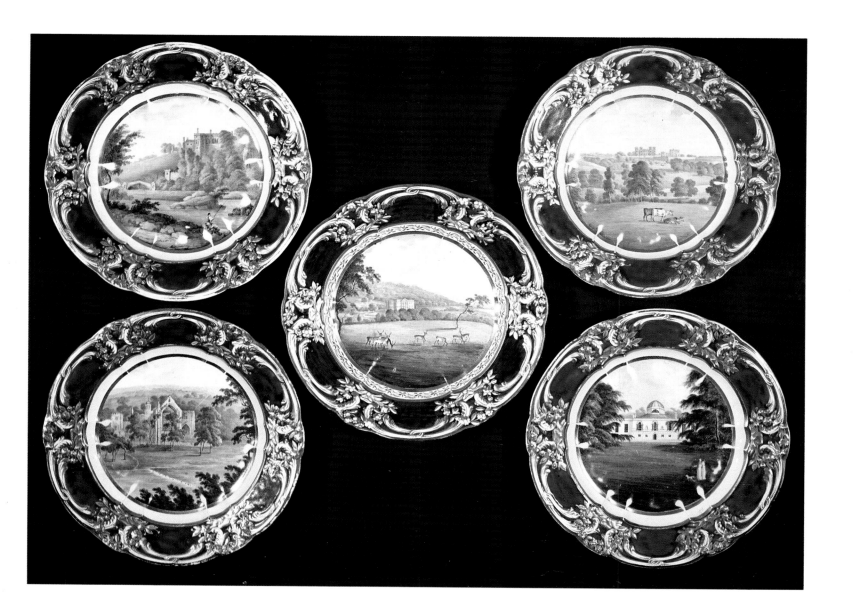

German, 1697
The Kniphausen Hawk

Silver and silver-gilt, decorated with painted enamel, the body
and base set with precious and semi-precious stones,
36.5 cm high

The hawk, which should strictly be called an eagle, was made
in 1697 for Count Georg Wilhelm von Kniphausen of Nienort
Castle in eastern Holland. It is an unlikely but highly elaborate
commemorative drinking-vessel, containing a silver-gilt beaker
engraved with a long inscription which ends: 'This cup was
dedicated as a symbol in the year 1697 in memory. Since cups
adorned with chrysoliths and studded with gems — cups
shaped like the armour-bearing bird of Jove — resemble the
sign of the Nienort family, the Count rightly dedicated such a
cup to his castle.' The head can be taken off and the beaker
unscrewed from inside the body, although there is also a tube
in the eagle's mouth to allow liquid to be poured from it.
The Kniphausen Hawk, which is typical in style of the
ostentatious gem-studded plate made in Germany towards the
end of the seventeenth century, disappeared from Nienort in
the eighteenth century, but reappeared in London at the Great
Exhibition of 1851 on loan from the sixth Duke of
Devonshire. A letter written in 1819 to the sixth Duke by a
Mr Chad records the payment of £105 for an 'eagle', and this
almost certainly means the so-called 'hawk'. Mr Chad wrote
from Brussels and dealt through a dealer in The Hague. It is
just possible the Duke bought it for historical reasons, as there
are distant connections between the Kniphausen and
Devonshire families, but more likely that he thought it a great
curiosity.

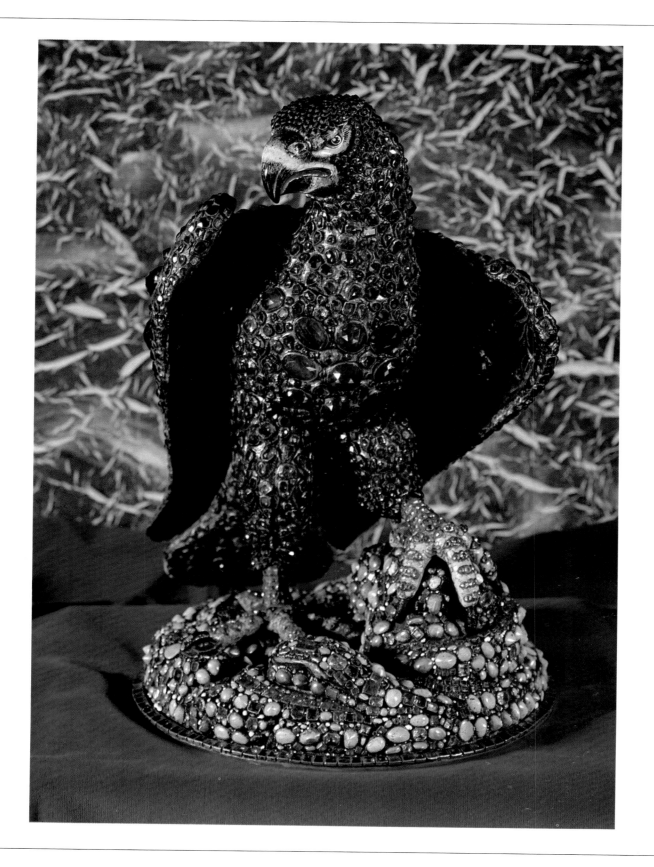

A selection of Snuff-boxes

The boxes are, from left to right, top row:
An oval gold box by G. R. Morel, the cover set with an agate cameo portrait of Livia signed 'Girometti, Paris', early nineteenth century; an octagonal enamel and gold box by Henrik Wigstrom for Fabergé, St Petersburg, the cover and base with views of Chatsworth, c. 1900; and an oval gold box attributed to Simon-Achille Léger, the cover with a miniature portrait of Georgiana, Duchess of Devonshire, signed 'Counis 1825', Paris c. 1838.
Middle row:
A rectangular gold box by G. R. Morel, the cover set with a late-sixteenth-century oval agate cameo of *The Judgement of Paris*, Paris c. 1838; a rectangular gold box with panels of Florentine mosaics of coloured vases on a dark grey jasper ground, Italian, early nineteenth century; a rectangular gold and enamel box with an unidentified maker's mark, B.O., the cover and sides set with panels of coloured jasper, c. 1840; an octagonal gold box by J. C. Neuber, inlaid with banded red and green agates, German, c. 1760; and a rectangular, engine-turned gold box, the cover with a Roman mosaic after a painting of the sixth Duke of Devonshire's spaniel Tawney, Italian, c. 1820.
Bottom row:
A circular gold box chased and engraved by A. J. Strachan, the lid set with a cornelian intaglio portrait of George IV, London, 1821; a circular gold box by John Northam, the cover with a medallion of Tsar Nicholas I by V. A. Lerske, London, 1827; and an oblong gold-mounted box of amethystine quartz, the cover carved with a stag hunt, Dresden c. 1760.

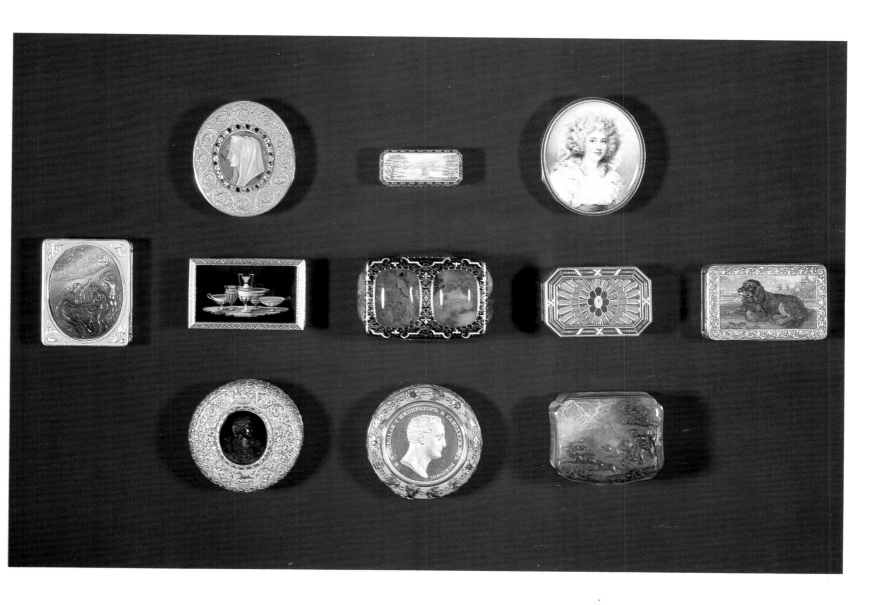

English, early nineteenth century
A Watch and Châtelaine

Gold and silver, diamond-set throughout, the watch
4.1 cm diameter

The châtelaine has two chalcedony seals, a watch key, two
oval plaques enclosing brown hair and two diamond-set
tassels. Cupid appears on both seals, in one holding a letter
with the inscription *'Lisez et Croyez'* ('Read and Believe Me')
and in the other with a lovers' knot and the inscription
'Denouera qui Pourra' ('Untie it who Can'). The Devonshire
crest of a snake and the cipher GHC, diamond-set in each
panel of hair, are repeated in a similar panel on the back of the
watch. It is possible that the piece belonged to Lady Elizabeth
Cavendish (1760–1835), the wife of Lord George Cavendish,
the brother of the fifth Duke of Devonshire. This would
explain the cipher, which could be that of George Henry
Cavendish, Lady Elizabeth's son, who was drowned at sea in
1809.
A châtelaine is the traditional emblem of the mistress of the
house, originally designed to carry keys, scissors and other
objects of utility, but here transformed into a decorative
means of wearing a watch and seals.

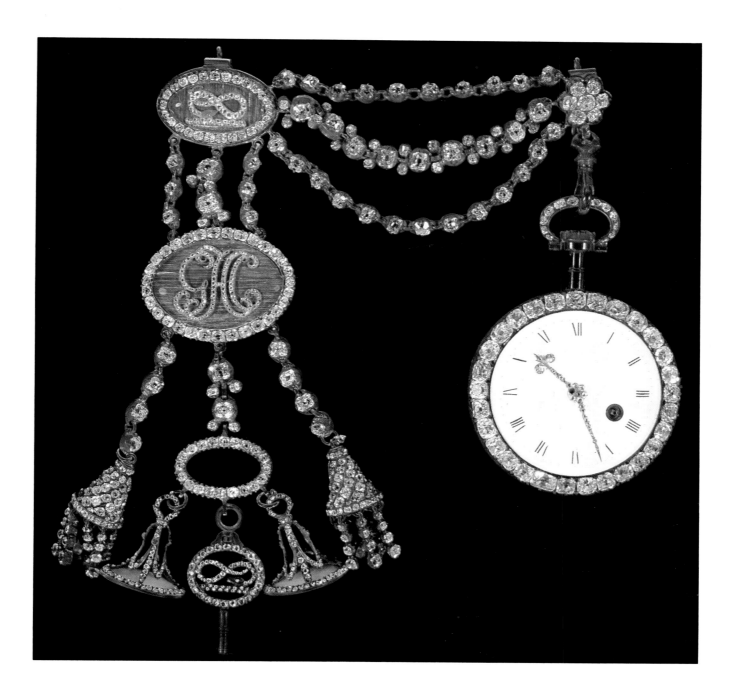

C. F. Hancock (d. 1891)
A selection from the Devonshire Parure

The parure consists of seven pieces of jewellery made by
Hancock, a pupil of Paul Storr (see page 156), for Countess
Granville to wear in Moscow at the coronation of Tsar
Alexander II in 1856. She would have selected which pieces
to wear according to the importance of the occasion, but it
would not have been possible to have worn all together.
There are four separate head ornaments consisting of a
coronet, a diadem, a bandeau and a comb, as well as a
necklace, a bracelet and a stomacher.
Lady Granville was the wife of the second Earl Granville
(1815–1891), the nephew of the sixth Duke of Devonshire.
When Lord Granville was invited to lead the British embassy
to Moscow for the coronation of 1856 the Duke promised to
lend him the Devonshire plate, diamonds and gems for his
mission. The Duke himself had represented his country at the
coronation of Tsar Nicholas I in 1826, and had impressed
everyone present then with the lavishness of his display and
entertainments. Hancock was commissioned to design the
parure to incorporate eighty-eight of the most precious
classical and Renaissance gems in the Devonshire collection
(see also page 216), together with 320 diamonds. He set the
gems in gold enriched with enamel colours and used the
diamonds as points of contrast in a conscious revival of the
Renaissance style. The diamonds were later removed to make
the Devonshire Tiara (see page 183) and are now replaced
with paste imitations.

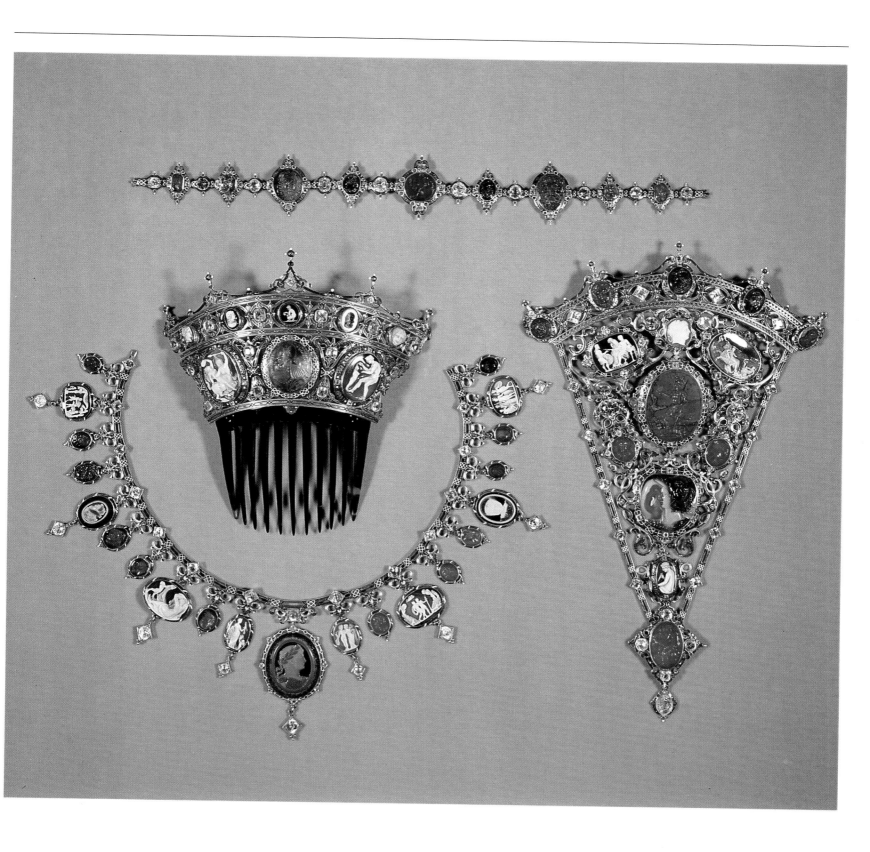

A. E. Skinner
A Diamond Tiara

The tiara was made by the jeweller, Skinner, in 1893 for
Louise, wife of the eighth Duke of Devonshire, the 'Double
Duchess' (see page 58). The principal motif is repeated twelve
times with fourteen in-between pieces resting on a two-row
bandeau, and it can be divided to make brooches out of the
individual parts. To make it hundreds of diamonds were
removed from the Devonshire Parure (see page 181) and from
other heirlooms, including the sixth Duke's Garter Star. They
totalled 1,041 stones, to which Skinner added
another 840.
The Double Duchess was a famous beauty in her youth and in
later years a formidable leader of society and fashion, known
especially for the magnificent jewellery she wore. Her
marriage in 1892 to the eighth Duke, when she was sixty and
he fifty-nine, brought both Devonshire House and Chatsworth
back to life again, following the period of reserve and
austerity characteristic of the seventh Duke.

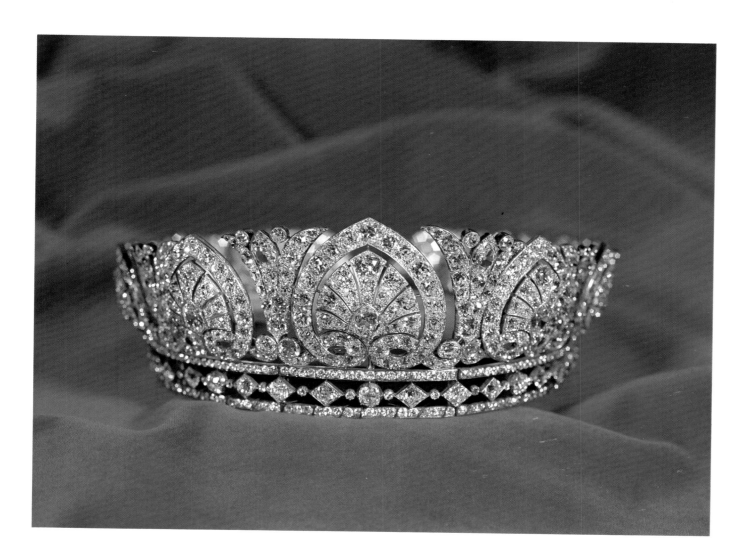

ILLUSTRATED BOOKS
AND MANUSCRIPTS

The Chatsworth Library first became famous in the early nineteenth century, when it was largely created by the sixth Duke of Devonshire; and despite the record-making sales from it, to pay death duties, that have taken place this century, it remains truly great. In addition to printed books and manuscripts of the past six centuries, it includes most of the autograph writings of Thomas Hobbes, the philosopher, and Henry Cavendish, the scientist, as well as important groups of political and family correspondence. Originally the Old Master drawings and prints also formed part of the library, where they were kept in splendid albums. Many of the albums of prints survive intact today.

The selection that follows is made up mostly of illuminated manuscripts collected by the sixth Duke, and the sumptuously illustrated flower books which the present Duke has bought in recent years. The two groups diverge widely in date but there is an intangible link between them that goes beyond the beautiful hand-colouring that they have in common. In the golden age of botanical illustration, when the spectacular books of Redouté, Thornton, Curtis and others were produced, what had previously been a largely scientific tradition was combined with new aspirations to luxury and artistic beauty. This was also the period when the young sixth Duke of Devonshire's enthusiasm for book-collecting was at its peak. He spared no expense to obtain volumes of special beauty or rarity, seeking out incunabula, manuscripts, fine bindings and books printed on vellum at all the important sales. He was pleased that the results of his 'bibliomania' were 'of real use to several men of letters', but made no pretence that his motive was anything other than the delight he took in collecting.

By contrast, his great-nephew and successor the seventh Duke was a serious and learned man who shunned the luxuries of the previous age. The great illustrated books on natural history which he collected, by Audubon, Gould, Elliot, and others, were again valued more as works of science than of art.

Flemish, c. 1465–68
Vengeance de Notre Seigneur

Illuminated manuscript on vellum, Volume I 137 leaves,
Volume II 167 leaves, 37.5 × 26 cm

The manuscript was bought by the sixth Duke of Devonshire
in 1812 at the sale of the library of the Duke of Roxburghe. It
originally belonged to Philip the Good, Duke of Burgundy
and afterwards to Chrétien de Lamoignon.
The text is an anonymous mystery play and purports to
narrate events of the first century AD. The story culminates in
the destruction of Jerusalem by the Romans, which is
interpreted as 'Our Lord's Vengeance' for the killing of Christ
by the Jews. It was written for Philip the Good by the scribe
Yvonnet le Jeune, and there are twenty miniature paintings by
Loyset Liedet, a miniaturist who worked in Bruges. The two
volumes were originally bound in one and the manuscript is
typical of the de luxe books that were made for the library of
the Dukes of Burgundy.
The scenes of ancient history are seen in contemporary terms
and reflect the domestic customs, costume and architecture of
Flanders in the fifteenth century.

E leur donray tresgrant finance.
Silz en scauent venir a chief.

Maistre alphons pmier medecin.
Se vostre mal nest par trop grief.
Incontment vous guarirons.

Vaspasien.
Approuchies si vous monstrerons.
Le mal qui si fort nous traueille.

Le .ij. medicin en
regardant son visaige.
Ha maistre alphons vecy merueille.

Flemish, c. 1470
Roman de Gillion de Trazegnies

Illuminated manuscript on vellum, 237 leaves, 37.5 × 26 cm

The manuscript was bought by the sixth Duke of Devonshire
in 1812 at the sale of the library of the Duke of Roxburghe. It
originally belonged to Louis de Gruuthuse of Bruges and
afterwards to King Louis XII of France.
The text is a romance that tells the adventures of an
imaginary crusading knight called Gillion de Trazegnies in the
Holy Land, first written in 1450 and dedicated then to Philip
the Good, Duke of Burgundy. The script is attributed to a
famous professional scribe, Daniel Aubert, and there are eight
miniature paintings, including some highly animated battle
scenes on both land and sea, which are attributed to Liévin
van Lathem.
Each miniature is decorated with an exceptionally rich and
colourfully embroidered border of flowers, birds, beasts and
droll figures.

nestoient demourez ne vieilz ne jeunez que tous ne
fussent venuz aux champs pour le grant miracle
quilz cuidoient certainement que mahom eust fait
sur la personne du souldan leur seigneur Et tant
exploicterent que ilz se retrouuerent sur la champa
gne ou la crimnelle bataille auoit este et illec trou
uerent leur maistre estandart gesant par terre ilz le
releuerent puis le baillerent a porter a vng roy sa
razin lequel estoit preudhome en sa loy et vaillant
en armes Atant se taist pour le present listoire
de messire gillion de trasignies de hertan et des babi
lonnois pour parler du roy ysore de damas et de ses
roys et admirauls qui estoient pres de leur mort

Comment messire gillion de trasignies et hertan ociret
et desconfirent le roy ysore de damas et son ost Et
comment le souldan fut reconquis sur ses ennemis

Flemish, c. 1500

**A Book of Hours, According to the
Use of Sarum (Salisbury)**

Illuminated manuscript on vellum, 187 leaves, 20.5 × 14 cm

The third Earl of Burlington recorded in a note inside the back
cover that the book was presented to him by General George
Wade, for whom the Earl designed a Palladian house in 1723.
Originally it was given by King Henry VII to his daughter
Queen Margaret of Scotland, and afterwards it belonged to
the Archbishop of St Andrews and Monsieur Le Pin, a
magistrate of Bruges.
The book is a prayer-book used for the private devotions of
Queen Margaret, the wife of James IV of Scotland. There are
inscriptions in the hand of Henry VII, Margaret's father, the
second of which reads: 'pray for your lovyng fader that gave
you thys book and I geve you att all tymes godds blessy'g
and myne. Henry Ky.'
The opening section is a calendar with border scenes of the
twelve months, followed by a series of miniatures of twelve
saints. The book concludes with *The Hours of the Virgin*, which
has a principal sequence of six full-page miniatures, beginning
with *The Annunciation* and ending with *The Flight into Egypt*.
The one illustrated here is *Mary and Joseph Adoring the Christ
Child*. The borders have flat opaque grounds painted in
trompe-l'oeil with flowers, birds and insects which seem to be
scattered on the surface of the page, a style typical of the
years around 1500. The illumination is attributed to an
anonymous Flemish miniaturist known as 'the Master of
the Prayer-books'.

eus in Ad primam.
adiutorium meum
intende. Domine ad
adiuuandum me
festina. Gloria. Ps.

eni creator spiritus mentes tuo
rum visita imple superna gra
cia que tu creasti pectora. Memento
salutis auctor quod nostri quondam
corporis exillibata virgine nascen
do formam sumpsens. Maria me
gracie mater misericordie tu nos ab
hoste protege in hora mortis suscip.
Gloria tibi domine qui natus es
de virgine cum patre et sancto spiri
tu in sempiterna secula. Amen. an.
O admirabile. Psalmus

eus in nomine tuo saluum
me fac et in virtute tua iudica

Flemish, c. 1510

A Book of Hours, According to the Use of Rome

Illuminated manuscript on vellum, 250 leaves, 13.7 × 9.9 cm

The book's provenance is not known, but it is likely to have
been acquired by the sixth Duke of Devonshire. There are
nineteen historiated initials or small miniatures, with marginal
scenes in the framed borders. The scene illustrated here is *The
Flight into Egypt* with a border of peasants harvesting grapes.
The illumination is of the Ghent/Bruges school and has some
links with the style of Simon Bening (1483/84–1561).

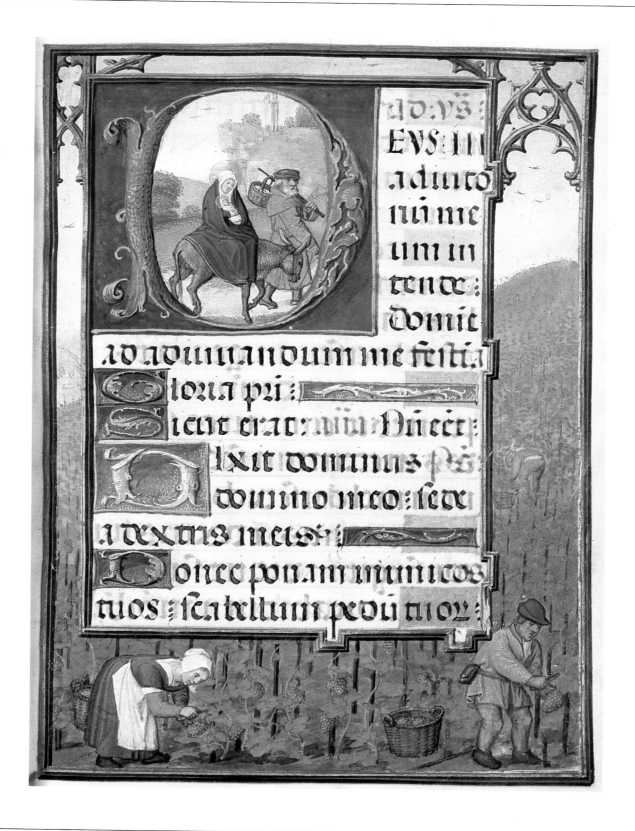

French, mid-eighteenth century
Les Plaisirs des Dames pendant la Journée

Illuminated manuscript on vellum, illustrated with 17
miniature paintings, 13.5 × 9.5 cm

The first two miniatures are whole-page allegories of *Music*
and *Painting*, and the remaining fifteen are set in decorated
oval borders with poems on the opposite page. Nearly all are
on the theme of love, illustrated by Cupid in a variety of
situations. On the title page appear the arms of the lady to
whom the book belonged, but she has not been identified.
There is no record of when the manuscript was acquired, but
it is almost certain to have been bought by the sixth
Duke of Devonshire.

Quand une belle eſt en-
dormie,
Pour lors Amour ſe plait à la
charmer,
Telle de jour contre lui peſte &
crie,
 Et n'oſe preſque le nõmer,
Qui la nuit dans ſa fantaiſie,
Trouve pourtant qu'il eſt bien
doux d'aimer.

Charles Perrault (1628–1703)
Contes des Fées

Four volumes, printed on vellum, illustrated with 19 drawings
in pen and wash, 17 × 10 cm

This edition of Perrault's fairy tales, a book which first
appeared in 1697 with the title *Histoires ou Contes du Temps
Passé*, was printed by Lamy at Paris in 1781. There is no
record of when it was acquired, but it is likely to have been
bought by the sixth Duke of Devonshire. A printed notice on
the first leaf of each volume states that 'this unique copy,
printed on vellum, decorated with 19 original drawings by the
most famous artists, was made for Madame Royale [Queen
Marie-Antoinette], to whom the work was dedicated'.
The stories include *Cinderella, Little Red Riding-Hood, Bluebeard*
etc, as well as the one illustrated here, *The Sleeping Beauty*.
Only two signatures are visible on the drawings throughout
the book, Martinet and Moitte, but there may be others
which are covered up by the borders.
François Nicolas Martinet (b. 1731) was a draughtsman and
engraver in Paris at this time, as also were a number of artists
named Moitte, who were members of one family.

La Belle au bois dormant.

LA BELLE
AU BOIS DORMANT,
CONTE.

Il y avoit une fois un Roi &
une Reine, qui étoient si fâchés
de n'avoir point d'enfans, si fâ-
chés, qu'on ne sauroit dire. Ils
allèrent à toutes les eaux du
monde : vœux, pélerinages,

Robert John Thornton (?1768–1837)
The Temple of Flora

Large folio with 30 coloured plates of flowers, 56 × 44 cm

The book was bought by the present Duke of Devonshire. It
was first issued in parts between 1799 and 1807 and its full
title, which refers to the Linnaean system of plant
classification, is *A New Illustration of the Sexual System of
Carolus von Linnaeus* (and) *The Temple of Flora, or Garden of
Nature*. The plates, which were engraved by various processes,
are mostly colour-printed and finished by hand.
The Temple of Flora is the most famous of all flower books, but
the great costs of its production led Thornton almost to
bankruptcy. His aim was to provide each flower with its
appropriate landscape setting, for which specialist artists were
engaged in addition to those who painted flowers.
He wrote an 'Explanation of the Picturesque plates' in which
he says of the *American Cowslip*, illustrated here, that 'a sea
view is given and a vessel bearing the flag of that country'.

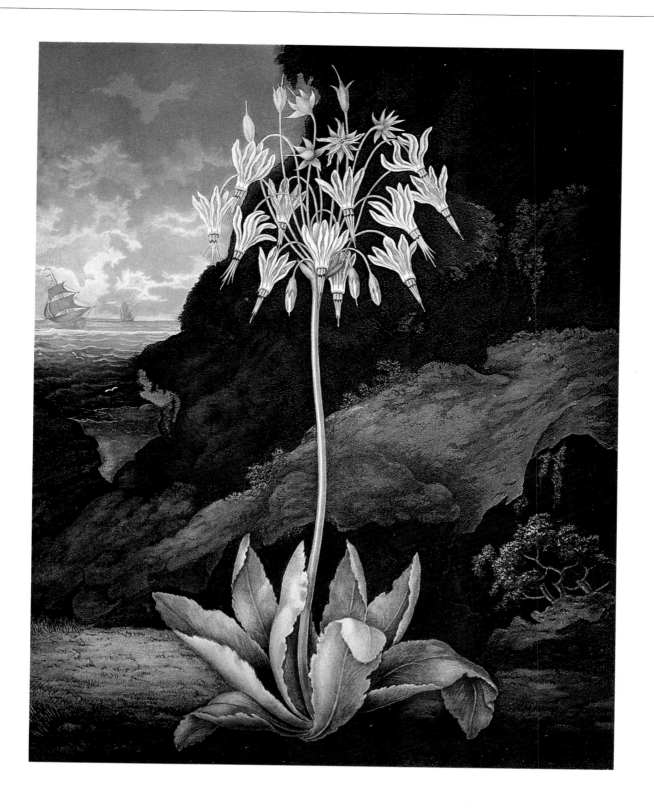

Pierre-Joseph Redouté (1759–1840)
Les Roses

Large folio in 3 volumes, with 169 coloured plates,
55 × 36 cm

The book was bought by the present Duke of Devonshire in
1968 and was formerly in the collection of G.M.T. Foljambe.
It is a large paper copy of the first edition and was printed at
Paris by Firmin-Didot, 1817–24. In this copy two separate
impressions of each plate are included, one printed in colour
and finished by hand, the other printed uncoloured on brown
paper. The one illustrated here is *Rosa sulfurea*, or *Rosa
hemisphaerica*.
Redouté was appointed botanical artist to the Empress
Josephine in 1798 when she acquired the garden of
Malmaison, near Paris. *Les Roses*, his most famous work, was
based upon the many varieties of roses which were grown
there, but was not completed and published until after
Josephine's death. It is one of a series of great flower books of
unprecedented luxury and beauty which her patronage and
that of other royal ladies of France enabled Redouté
to produce.

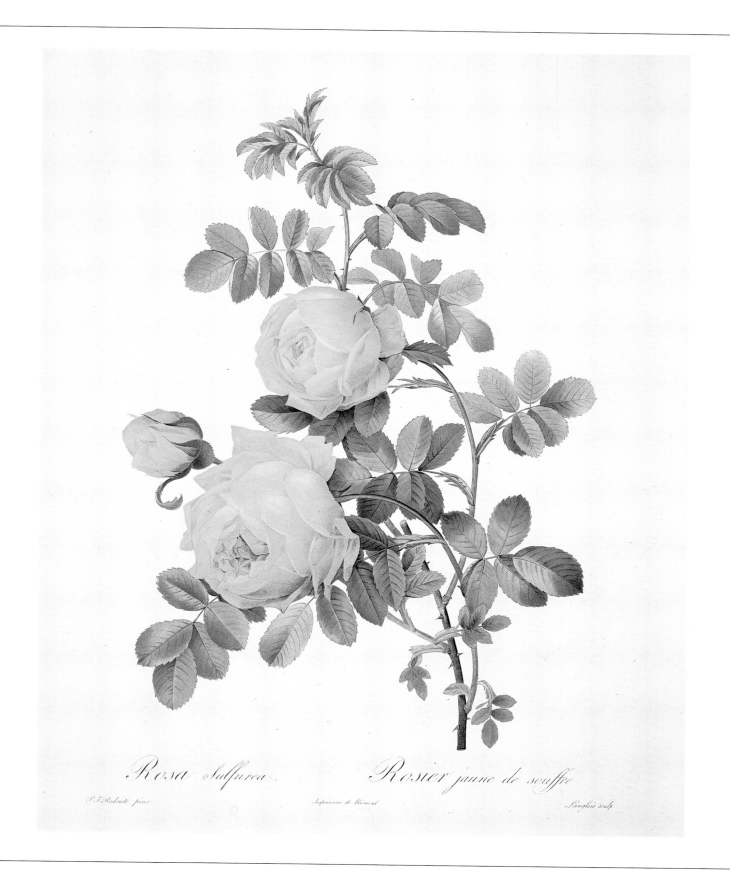

Rosa Sulfurea. *Rosier jaune de souffre.*

P.J. Redouté pinx. Imprimerie de Rémond Langlois sculp.

Samuel Curtis (1779–1860)
The Beauties of Flora

Title page and 10 coloured plates, unbound, 70 × 59 cm

The book was published at Gamston, Nottinghamshire, in 1820, and was bought by the present Duke of Devonshire in 1974. Curtis conceived it as a rival to Thornton's *Temple of Flora* (see page 199), the only other flower book that sets life-sized flowers in front of a landscape background. The project proved equally costly and led Curtis, like Thornton, into severe financial difficulty. The illustrations are hand-coloured stipple-engravings and aquatints after Clara Maria Pope (d. 1838) who was the wife of the artist Francis Wheatley. The one shown here is *Anemones*.
Samuel Curtis was the cousin of William Curtis, the founder of *The Botanical Magazine*.

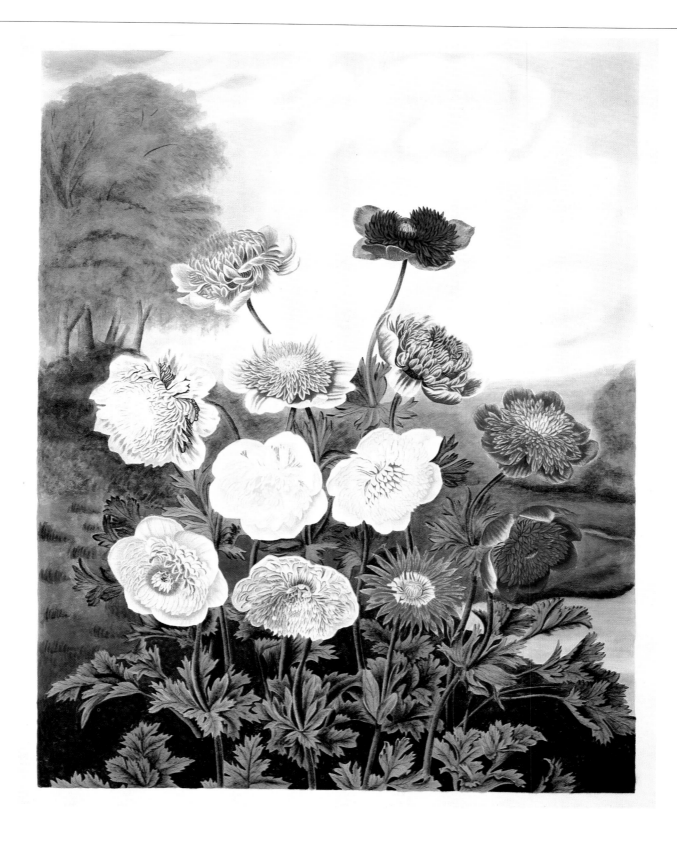

John James Audubon (1785–1851)
The Birds of America

Double Elephant folio in 4 volumes with 435 coloured plates,
975 × 66 cm

The book was originally issued in parts between 1827 and
1839, first in Edinburgh and afterwards in London. This copy
was bought by the seventh Duke of Devonshire. The bird
illustrated here is the *Snowy Heron* or *White Egret*.
Audubon's great work is one of the largest books ever printed
and certainly the most famous of all bird books. His aim was
to produce life-sized engravings, hand-coloured 'in the most
careful manner', of the 435 drawings of 1,065 birds in their
natural habitats which he had completed 'during a residence of
upwards of 25 years in the United States and its territories'.
Following its success he was able to return to America, his
native country, and complete the drawings for a second book,
The Viviparous Quadrupeds of North America.

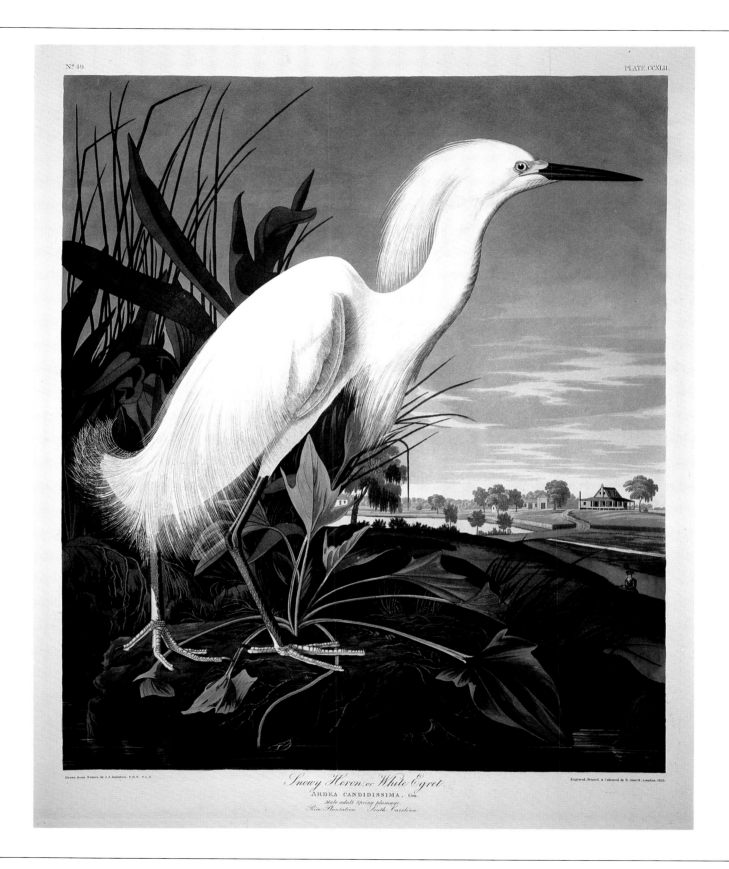

Drawn from Nature by J.J. Audubon. F.R.S. F.L.S.

Engraved, Printed, & Coloured by R. Havell. London. 1835.

Snowy Heron, or White Egret.

ARDEA CANDIDISSIMA, Gm.

Male adult Spring plumage.

Rice Plantation South Carolina.

John Gould (1804–1881)
The Birds of Great Britain

Large folio, 5 volumes, 367 coloured plates, 55 × 37 cm

The book was printed in London by Taylor and Francis and issued in parts between 1862 and 1873. It was bought by the seventh Duke of Devonshire. The plates are hand-coloured lithographs after drawings mostly by Josef Wolf (1820–1899) and the one illustrated here is *Scolopax rusticola* or *Woodcock*. The great series of illustrated books published by Gould, covering the birds of several continents, totals forty volumes in all and contains more than 3,000 plates. *The Birds of Great Britain* was the most sumptuous and costly of British bird books, and it was reported in 1874, when publication was complete, that 'no bird-book, it is whispered, has ever had such a financial success'.

SCOLOPAX RUSTICOLA, Linn.

Daniel Giraud Elliot (1835–1915)
Monograph of the Felidae, or Family of Cats

Large folio, with 43 coloured plates, 60 × 47.5 cm

The book was published in London in 1883 and was almost
certainly bought by the seventh Duke of Devonshire. The
plates are hand-coloured lithographs after drawings by Josef
Wolf (1820–1899; see also page 206), all of cats in their
natural habitats. The one illustrated here is *Felis scripta* or
Painted Cat.
Elliot was a wealthy American natural historian who wrote
and published several books, mostly on birds.

FELIS SCRIPTA.

FURNITURE, WOODCARVINGS, AND A TOY

The collection of furniture at Chatsworth, although of various periods and deriving from several houses besides Chatsworth itself, is consistently rich and formal in character, with relatively few pieces easy to imagine or accommodate other than in a house of similar grandeur. In the selection that follows the hall chairs designed by William Kent are an obvious example, architectural in form as well as function. The furniture, generally, of country houses up to the late eighteenth century was treated as part of a room's design or decoration – especially in the great apartments of state – and arranged according to elaborate conventions governing its use. Even with a change to greater comfort and convenience in the nineteenth century, and an increase in social informality, the very scale of the rooms and the furniture they required made it difficult to think of making casual rearrangements.

The name of William Kent is associated more than any other with the collection now at Chatsworth, as he not only furnished Devonshire House in Piccadilly (sold in 1920 and demolished four years later) for the third Duke of Devonshire, but also Chiswick Villa for the third Earl of Burlington, his principal patron and friend. Burlington first encouraged Kent to be a painter, with disappointing results, but later guided his development into a remarkable architect, landscape gardener, interior decorator and furniture designer. Kent's architectural principles were firmly Palladian, but he often showed in his furniture an exuberance more characteristic of the Baroque style which the Palladian movement had meant to sweep away.

The rosary of Henry VIII and the carving of a lace cravat by Grinling Gibbons are isolated examples at Chatsworth of virtuoso woodcarving of an extraordinarily intricate kind. Both are celebrated pieces and a contrast in every way to the model aeroplane, a rarity only recently rediscovered.

The pattern by which yesterday's trifles turn into treasures and are prized for their rarity is a familiar one, but at Chatsworth examples like the toy aeroplane are the exception. As most of the items in this book show, the works of art and fine craftsmanship that make up the collections were usually remarkable and costly pieces from the beginning, and have remained so for successive generations to admire.

Italian, Florentine, mid-seventeenth century
A Table Cabinet

Pietre dure, 106 cm wide

The cabinet, which is in a room called the China Closet adjoining the State Rooms at Chatsworth, has a front fitted with eighteen drawers surrounding a central cupboard, and is inlaid with an architectural caprice, decorative panels and borders of animals and hunting scenes. There is no record of when it was acquired.

Pietre dure, also known as Florentine mosaic, is a style of inlay using thin layers or flakes of different-coloured hard or semi-precious stones, like agate, jasper, lapis lazuli etc, to decorate surfaces with patterns or pictorial scenes. It is particularly associated with Florence, where a special workshop was set up in 1588 to produce table-tops, caskets and pictures as well as cabinets like the one illustrated here.

Attributed to Gerrit Jensen (active 1680–1715)
A Cabinet-on-Stand

Walnut and 'seaweed' marquetry, 119.5 cm wide

The cabinet is one of a pair at Chatsworth which were probably made about 1700 for the first Duke of Devonshire. Jensen, whose name was sometimes Anglicized to Johnson, is mentioned in the first Duke's building accounts as supplying glass and woodcarving for the decoration of the State Rooms of the house, but no bills for individual pieces like these cabinets, if they are by him, have survived. He was, however, the most skilled of the Anglo-Dutch cabinet-makers working for royal and noble patrons in England at the time of William and Mary, and this pair of cabinets, with their very intricate arabesque inlays, could be attributed to him on evidence of quality alone. The cupboard doors are inlaid inside and out with panels of strapwork and foliage, and enclose a cupboard and drawers inlaid in similar style.

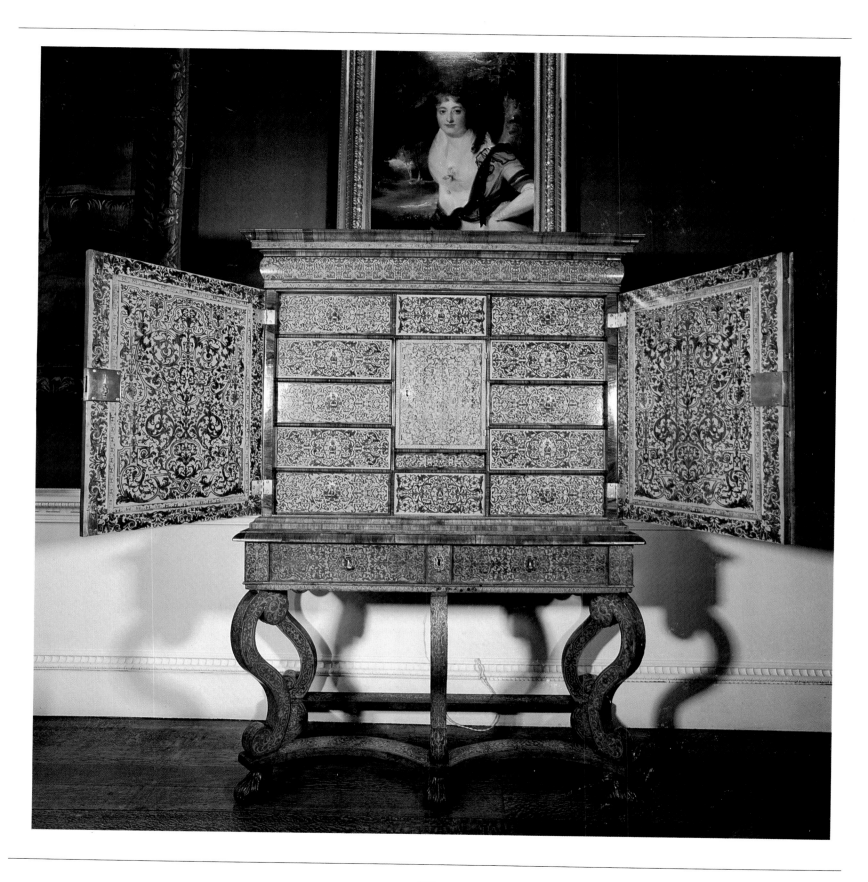

French, early eighteenth century
A Drop-front Coffer

Boulle, 70 cm wide

The coffer served the second Duke of Devonshire as a gem
cabinet, to hold his great collection of classical and
Renaissance gems, some of the finest of which are now
mounted in the Devonshire Parure (see page 181).
It is decorated in the Boulle *contre-partie* style of marquetry in
which a brass ground is inlaid with a tortoiseshell design,
using layers of both materials cut by fretwork to form
interlocking patterns. The technique is named after the French
craftsman who perfected it, André-Charles Boulle (1642–
1732), the most famous of Louis XIV's furniture-makers.

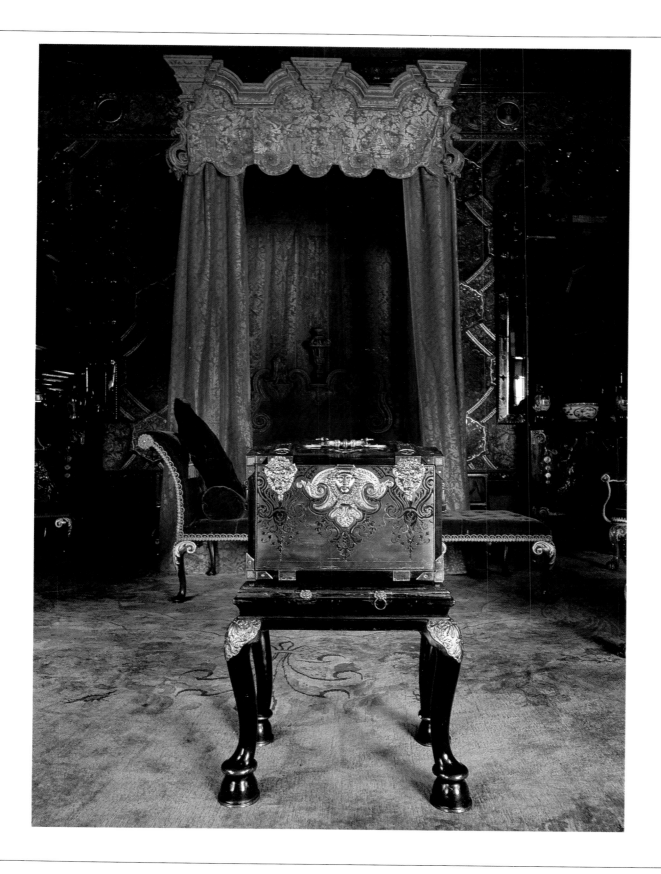

English, early eighteenth century
A Pier Glass

Giltwood and *verre églomisé*, 203 × 100.5 cm

The glass is one of a pair at Chatsworth and has a bevelled
plate set in a divided border of *verre églomisé* decorated with
strapwork and foliage on a brilliant red ground. The shaped
and scrolled cresting rises to a ducal coronet. No bills have
survived for the pair, but it is possible they were made for the
second Duke of Devonshire.

Verre églomisé is a kind of glass decorated on the back by
painting or gilding which is then protected by another sheet
of glass, or sometimes by a layer of metal foil or a coat of
varnish.

William Kent (1685–1748)
A Hall Settee and Chair

Mahogany and oak, the settee 100 × 125 cm, the chair
89.7 × 64 cm

The chair, which has a pediment-shaped back, is from a set of
seven at Chatsworth which, together with a related set of
sixteen with circular backs, was almost certainly made for the
third Earl of Burlington's villa at Chiswick, to the designs of
William Kent, in the early 1730s (see also page 222). The
settee appears to be slightly later in date and is one of a set of
six which came to Chatsworth from Devonshire House in
London. Whether this set was originally made for Devonshire
House or for Chiswick, however, is not certain, as Kent was
employed on the furnishing and decoration of both houses
and both eventually became the property of the fourth
Duke of Devonshire.
As hall furniture, they are severe, classical and architectural in
style, designed for grandeur, not comfort, to form part of the
interior decoration of a Palladian house.

John Boson (active 1727–1743)
Pier Glass and Table

Mirror frame of giltwood, 182 × 133 cm; table of mahogany,
parcel-gilt, 89.5 × 151 × 80 cm

This is one of a pair of pier glasses and tables made for
Dorothy Savile, Countess of Burlington (1699–1758),
probably to the designs of William Kent (1685–1748), to go
in the Summer Parlour at Chiswick House in Middlesex. The
owls that form part of the decoration of each piece refer to
the Savile family crest (see also page 133). Together with
other furniture they were later moved from Chiswick to
Chatsworth.
Lady Burlington wrote in a letter of 1735: 'I hope the Signior
[Kent's usual nickname] has remembered about my tables and
glasses,' presumably referring to these pieces. A bill for
'carving done for ye Honble Lady Burlington' was submitted
by John Boson and paid on 11 September 1735. It specifies
'two Rich Glas frames with folidge and other ornaments'
costing £15 and 'two Mahogany Tables with Tearms folidge
and other Ornaments' as well as 'modles for ye Brass work'
costing £20. Boson is likely to have carved other work to
Kent's designs, including parts of the famous state barge made
for Frederick Prince of Wales in 1737, which is now in the
National Maritime Museum, Greenwich. William Kent,
architect and designer, was a protégé of Lord and Lady
Burlington, and responsible for the interior decoration of the
Palladian villa Lord Burlington built at Chiswick.

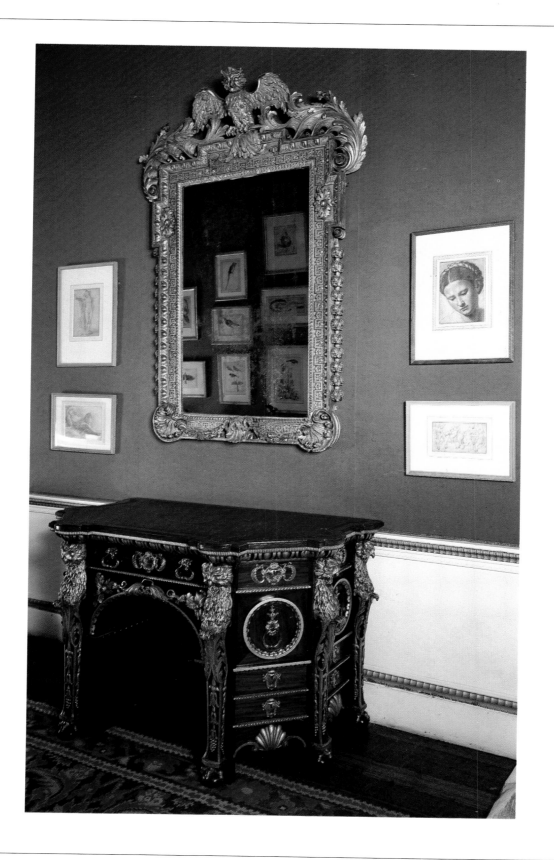

William Kent (1685–1748)
A Baby-Carriage

120 cm long

The carriage, which was intended to be pulled by a goat, was
made for the children of the third Duke of Devonshire, and is
traditionally believed to have been designed by William Kent.
The body is formed as a shell, and both the springs on which
it rests and the shafts for the goat are in the form of snakes.
This unlikely decoration for a baby-carriage derives from the
Devonshire family crest, which is a snake. Given the nature of
the commission, the shafts could also be a light-hearted if
learned allusion to the story of the infant Hercules, who in his
cradle was able to strangle two snakes sent by Juno to harm
him.

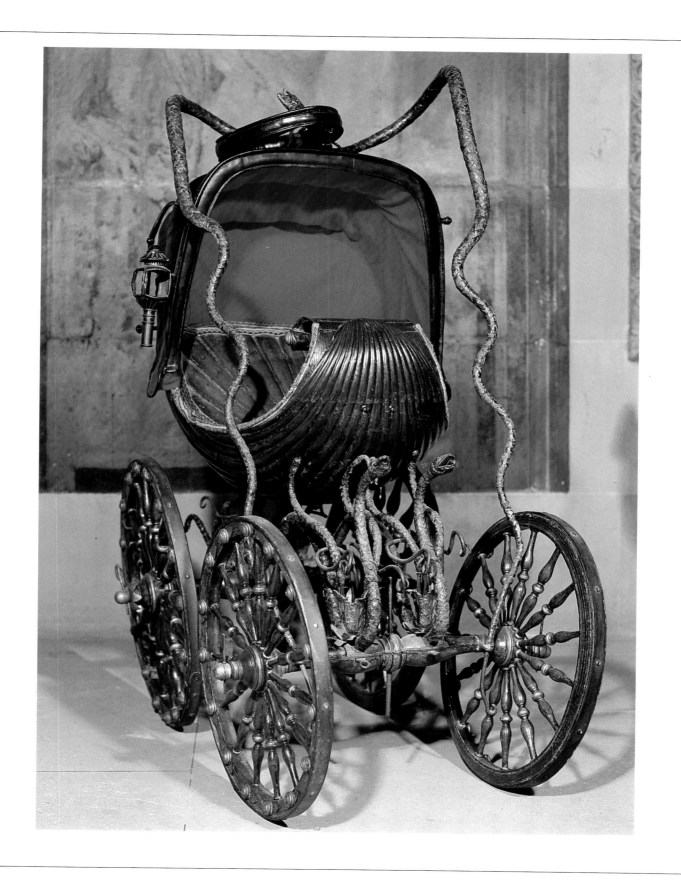

English, 1761
The Coronation Thrones and Footstools of
King George III and Queen Charlotte

The thrones, 174 cm high, the footstools 63.5 cm wide

The ceremony for which these thrones and stools were made
took place in Westminster Abbey on 22 September 1761.
Afterwards they were sent to Chatsworth as perquisites of
office of the fourth Duke of Devonshire, who served first
George II and then George III as Lord Chamberlain between
1757 and 1762. Both thrones and stools have been in the
State Drawing Room at Chatsworth ever since.

They were carved and gilded by the royal chair-maker
Katherine Naish and upholstered by the royal cabinet-makers
and upholsterers William Vile and John Cobb. The silk
covering is the original, recorded in the bill of the silk mercer
Thomas Hinchliff as '16.$\frac{1}{2}$ Yds of rich Brocade, Gold, Silver
and Colours a(t) £36.16.6', costing £112 12s 3d. Only the
gold fringes are now lacking.

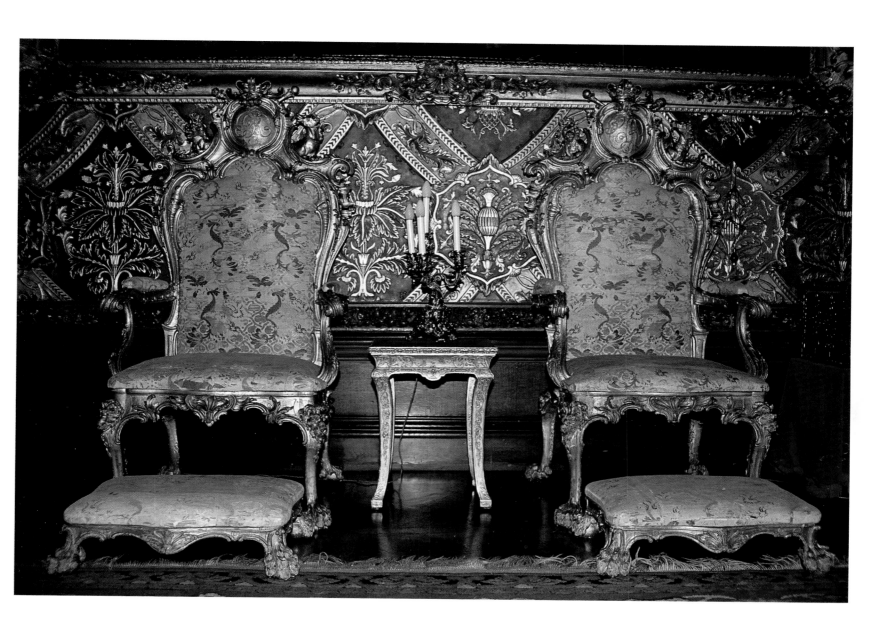

David Roentgen (1743–1807)
A Bureau à Cylindre

Mahogany, 135 cm wide

The bureau, which has a solid cylinder operated by a pull-out
writing slide, is provided with a round-back chair with a
swivelling seat, and small oval writing-table *en suite*. The
group is now in the State Drawing Room at Chatsworth and
was probably made about 1780, but there is no record of
when it was acquired.
David Roentgen, the most successful furniture-maker of the
eighteenth century, sold his furniture in Paris, Berlin and
Vienna and is often classed as French, although his workshops
were in Neuwied near Coblenz. He became especially known
for his ingenious mechanical devices, like the slide that
operates the cylinder of this desk. The accompanying writing-
table likewise has a spring-release drawer containing a leather
slide.

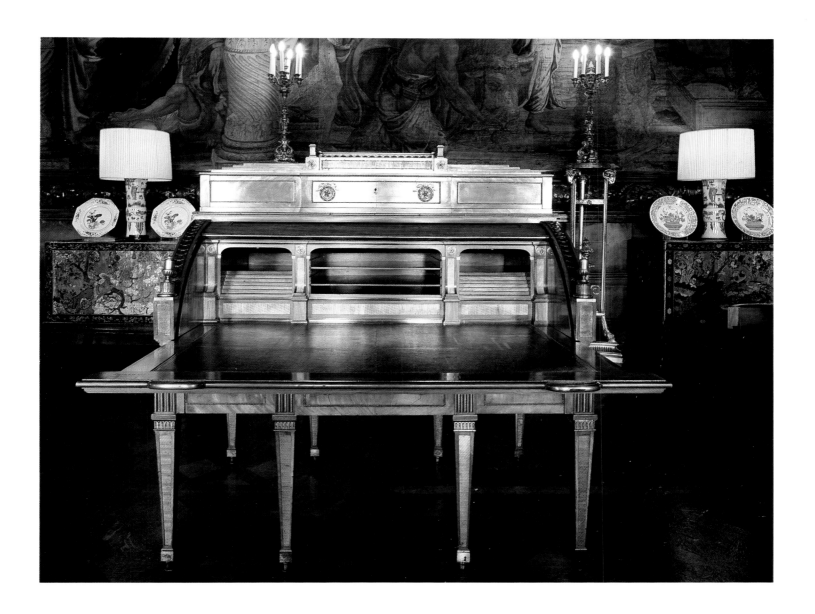

French or English, c. 1830
A 'Polonaise' Bed

Mahogany and parcel-gilt with chintz hangings, 127 cm wide

The bed is in the Queen of Scots Dressing Room, one of a
suite of rooms at Chatsworth named after a wing occasionally
occupied by Mary Queen of Scots when she was the prisoner
of the Earl of Shrewsbury, Bess of Hardwick's last husband.
The rooms were rebuilt by the first Duke of Devonshire in the
1690s and then reconstructed on a more domestic scale for
the sixth Duke in the 1830s when they were refurnished and
hung with hand-painted Chinese wallpaper.
Beds in the 'Polonaise' style, with domed canopies on inclined
supports and elaborate hangings, first became fashionable in
the 1760s and continued so throughout the Regency period.
There are three more in the house.

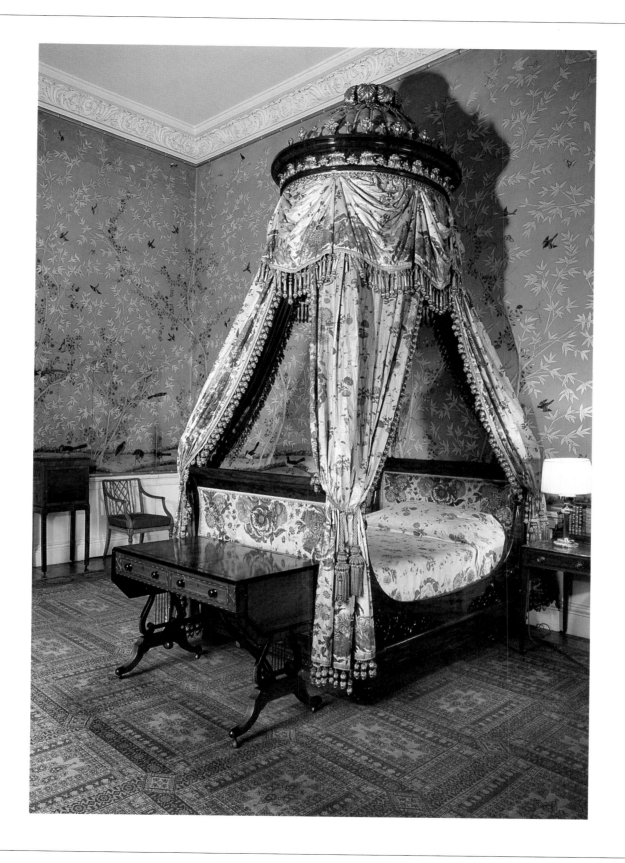

231

Flemish, early sixteenth century
A Rosary

Boxwood, 58 cm long

The rosary was bought by the sixth Duke of Devonshire from Rundell and Bridge (see page 156) for £200, and was originally owned by King Henry VIII. In the late seventeenth century it belonged to the Jesuit Père de La Chaise (1624–1709), confessor to Louis XIV, and in the eighteenth century to another Jesuit, Père Gabriel Brotier (1723–89), whose nephew sold it to Rundell and Bridge.

From a ring at the top hangs a cross and then ten *Ave* beads, ending with a large bead for the *Pater Noster*. This is hinged and opens to reveal even more intricately carved scenes than appear on the outer faces of the beads above. All are carved with the apostles, prophets and sybils, with relevant texts, and scenes from the Old Testament.

The English royal arms appear in the *Pater* bead, and the letters 'he 8' and 'k.a.' for Henry VIII and Katherine of Aragon. The rosary must therefore date from after their marriage in 1509 and almost certainly before the start of divorce proceedings in 1527.

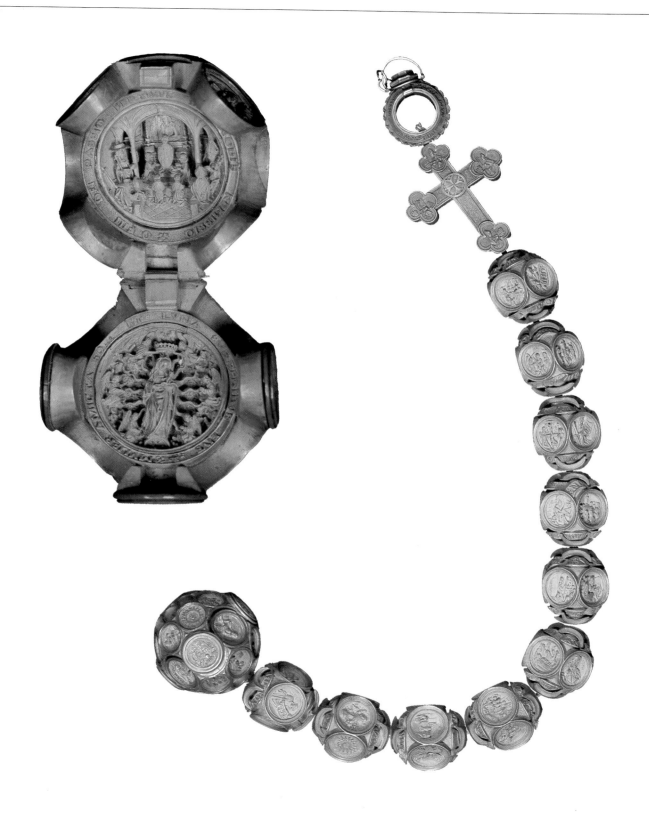

Grinling Gibbons (1648–1721)
A Carving of a Lace Cravat

Limewood, 57 × 37 cm

The carving also includes a woodcock, leaves and a portrait
medallion which may be of Gibbons himself. It is the only
authentic example of the great English carver's work at
Chatsworth, although for many years the elaborate limewood
carvings that decorate the walls of the State Rooms and the
Chapel were believed to be by him. Those, however, were
certainly the work of the London team of Thomas Young,
William Davis and Joel Young, and of the local carver Samuel
Watson (see also pages 73 and 75), as the first Duke's building
accounts show. Another carving of a cravat by Gibbons is in
the Victoria and Albert Museum, London.

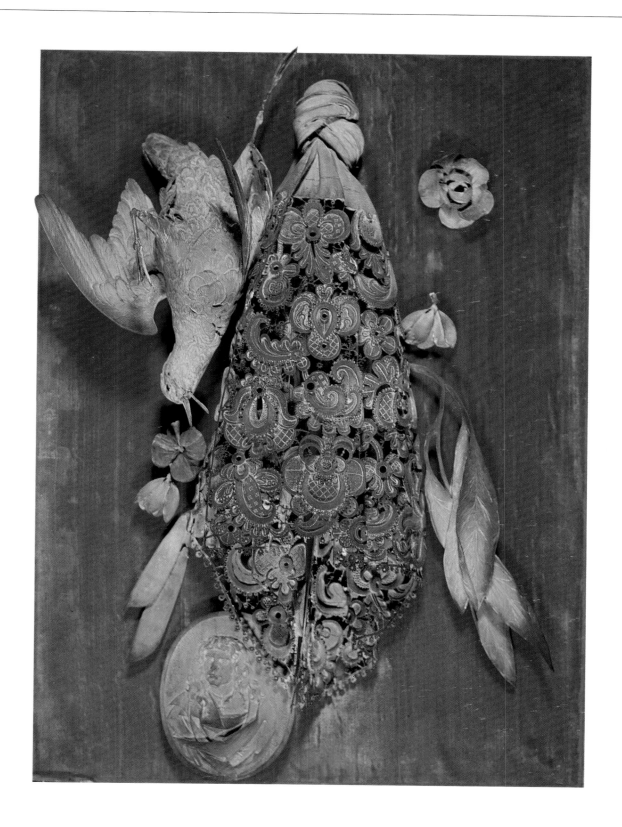

German, c. 1909
A Märklin Bi-Plane

Tinplate, celluloid and clockwork, hand-painted cream,
43.5 cm wingspan

The wings and tail surfaces are celluloid panelled, with a
celluloid propellor, rubber-tyred wheels and positions inside
for two aviators. The aeroplane itself was manufactured in
1909 and modelled on the Wright Brothers' bi-plane of the
period. It was produced in very small numbers and this model
is now considered one of the scarcest of all tinplate toys.
Märklin is the best known firm of toy-makers in Germany and
was first established in Göppingen by Theodor Märklin
(1817–1866) in 1859. A new company, Gebrüder Märklin,
was set up in 1888 and the firm entered its most celebrated
phase, concentrating on transport vehicles in tinplate, in the
years leading up to the outbreak of the First World War.

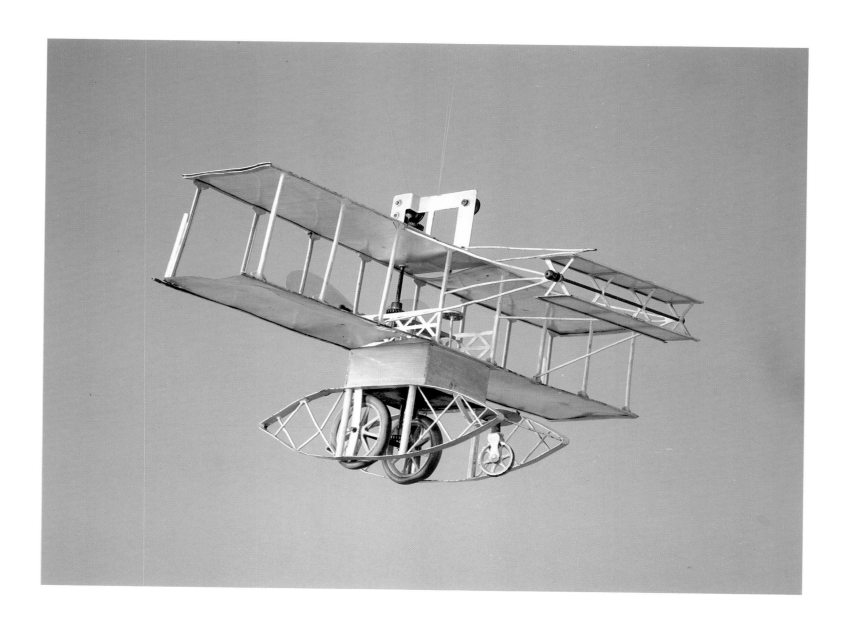

ACKNOWLEDGEMENTS

Tony Marshall had the idea for this book and he took nearly all the photographs. I would like to thank him and his colleagues at Chatsworth for their help and good nature over the disturbance of their domains while the photography was done. In particular, I thank Christine Robinson, housekeeper, and her staff, and Ian Fraser-Martin, silver steward. Christine Marshall helped her husband put it all together.

The forewords to each section, and the captions, are the work of Peter Day, keeper of the collections. He, in turn, thanks Michael Pearman, librarian and archivist at Chatsworth, Arthur Grimwade, Diana Scarisbrick, Jonathan Alexander, Anne Somers Cocks, Hugh Roberts and John Kenworthy Browne (all valued friends of this house) for scholarly information provided over the years on their specialist subjects.

Once again my grateful thanks are due to Helen Marchant, who somehow makes sense out of the mess I give her and types it at incredible speed.